The Pivot of the World

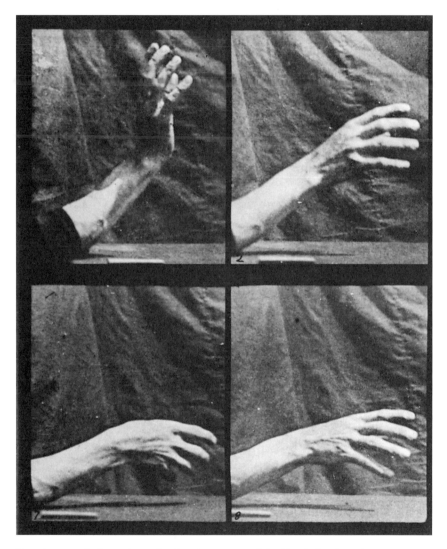

Frontispiece: Eadweard Muybridge, *Movement of the Hand; Beating Time*, ca. 1884–1887, detail of frames 1, 2, 7, 8. Courtesy of George Eastman House, Rochester, N.Y.

The Pivot of the World

Photography and Its Nation

Blake Stimson

The MIT Press
Cambridge, Massachusetts
London, England

MIT Press books may be purchased at special quantity discounts for business or sales promotional use. For information, please e-mail special_sales@mitpress.mit.edu or write to Special Sales Department, The MIT Press, 55 Hayward Street, Cambridge, MA 02142.

This book was set in Stone Sans and Stone Serif by SNP Best-set Typesetter Ltd., Hong Kong and was printed and bound in the United States of America.

Library of Congress Cataloging-in-Publication Data

Stimson, Blake.
 The pivot of the world : photography and its nation / Blake Stimson.
 p. cm.
 Includes bibliographical references.
 ISBN 0-262-69333-X (pbk.)
 1. Photography—Social aspects. 2. Photographic criticism. I. Title.

TR183.S75 2006
770—dc22
 2005051703

10 9 8 7 6 5 4 3 2 1

For Louise

It is much more difficult to believe that the forms of thought which per-
meate all our ideas whether these are purely theoretical or contain matter
belonging to feeling, impulse, will—are means for us rather than that we
serve them, that in fact they have us in their possession. What is there
more in us as against them? How shall *we*, how shall *I*, set myself up as
more universal than they are?
—G. W. F. Hegel, 1831

My body is the pivot of the world.
—Maurice Merleau-Ponty, 1945

Contents

Acknowledgments

My first forays into this project on the 1950s were developed during the early days of my graduate study at Cornell University, only to be set aside for more focused attention on the art of the 1960s. I will return to the later period in studies to come but felt the need, first, to work out my understanding of its immediate prehistory, the last gasp of an older ambition before it gave up the ghost in order to be reborn as the new, in the finished form you hold here. With this project now complete, I continue to believe it fundamental to ground my understanding of the very forceful influence of the subsequent art-historical period marked so brightly and distinctly by pop art on one end and conceptual art on the other.

During its brief life at Cornell, this project benefited in countless direct and indirect ways from, first and foremost, the learned, sensitive, and agile critical attention and support of Hal Foster. My thinking will be influenced forever by that attention. Susan Buck-Morss was also a constant inspiration and mentor and served as a reviewer of this project at its earliest stage. Other teachers who touched on or inspired the project in particularly important ways at Cornell were Emily Apter, Peter Hohendahl, and Eric Santner. So, too, the project would not be what it is without the rich exchanges among a small graduate student cadre of Hal's students: Helen Molesworth, Peter Brunt, Lawrence Shapiro, Frazer Ward, and Charles Reeve were all invaluable interlocutors and good friends.

The research and writing of this project in its mature form was supported generously by the University of California Humanities Research Institute; the Clark Art Institute; research and publication grants from my home institution, the University of California, Davis; and the goodwill of my colleagues in the Art History Program. I am very grateful to David Theo Goldberg, Carrie Noland and the Gesture group in the first and to Michael

Ann Holly, Keith Moxey, Mark Ledbury, Gail Parker, and my colleagues in the Spring 2004 research program at the second for their support and enthusiasm. Particularly valuable as well in ways both specific to this undertaking and more generally here at UCDavis have been ongoing spirited conversations about shared concerns with Neil Larsen, John Hall, Benjamin Orlove, Clarence Walker, Douglas Kahn, and Simon Sadler.

The ideas presented here in final form have been read or listened to and commented on generously and graciously by a greater number than could possibly be listed. Such responses have been invaluable to the development of the project, both because of the suspicions, concerns, critiques, and questions raised that helped me to better understand the limits and possibilities of my own aims as well the simple affirmation that comes from an engaged audience or reader. This was so at all public venues but especially the case for lively audiences at University College, London, the Tate Modern (for which a version of chapter 3 has since been published), and the Clark Art Institute. I am thankful in this regard particularly to Andrew Hemingway and his "Marxism and the Interpretation of Culture" seminar, to Steve Edwards and Dominic Willsdon at the Tate, and to the Clark leadership already mentioned above.

Valuable readers and attentive critics of the manuscript in part or full have included Alexander Alberro, Sherwin Simmons, Roger Rouse, and Gail Finney, who is publishing a version of chapter 3 in her *Visual Culture in 20th-Century Germany: Text as Spectacle*. The manuscript was also commented on generously and helpfully by two anonymous readers for MIT Press and by several more anonymous external readers for an academic review and by my thoughtful and supportive colleagues in the Art History Program at UCDavis. I am grateful to them all, as I am to two research assistants, Fauna Taylor and Rebecca Arnfeld. So too I am indebted to Roger Conover at MIT Press for his support of this project.

Finally, I express special thanks to two friends who supported me with undue grace during a personally significant stretch of this undertaking: Melissa Chandon and, already cited above for his intellectual contribution, Neil Larsen. To both, as Neil likes to say, *un abrazo*. Most important of all, this book is dedicated to my dear daughter, Louise.

Prologue: Lost in the Middle

Writing at the dawn of the 1960s, prominent American historian, veteran cold warrior, soon-to-be librarian of Congress, and aspiring public intellectual Daniel J. Boorstin lamented the impact of photography on society. He was concerned that photography's mechanically achieved democratization of image making also served to cheapen and falsify both individual and collective experience, both sense of self and sense of community. "As individuals and as a nation, we now suffer from social narcissism," he diagnosed in his popular book *The Image or Whatever Happened to the American Dream*: "We have fallen in love with our own image, with images of our making, which turn out to be images of ourselves." The problem, he reasoned in the psychosociological language of his moment, was one of boundary confusion or loss of differentiation between authentic and inauthentic, self-generated and other-generated forms of representation. "Images," on the one hand, and "the way we think of ourselves," on the other, he wrote, have "become merged" and in so doing, the American dream of self-realization was squandered. The sheer glut of photographic imagery, its ease of production, and its centrality in cultural self-understanding had overwhelmed identity by infecting it with the mechanical qualities of the photographic process and thereby was draining it of humanity. Full of period psychodrama and period ambivalence about mass culture, he declared that this shared pathology was "the monotony within us, the monotony of self-repetition."[1] That alienated condition was born of the brute material, machine-enhanced fact of photography, he reasoned, of the scary realization that we "live willy-nilly in a world where every man" had been mechanically endowed with a new and disturbing capacity to be—of all things threatening—"his own artist."[2]

This fear, of course, like the euphoric this-*is*-the-American-dream flip side of the mass culture Boorstin was critiquing, is as old as photography itself, but in the 1950s, it had a special, pressing currency. Photography's "deepest identification," as another critic put it at the time about mass culture more generally, "rests largely on the least individualized and most anonymous aspects of ourselves." As a medium of representation, it was too flat, too quick and too easy, and thus the social identification it offered was based not on identity but instead on "dissociation of personality," on "social anonymity."[3] This heightened period perception of a loss produced by photography is the subject of this book. In particular, I look at a series of photographic responses to this perceived condition that were markedly different from Boorstin's paranoid repudiation, on the one side, and the gleeful indulgence of that same condition by the booming postwar advertising, propaganda, photojournalism, and photo-hobby industries, on the other. Rather than simply reaffirming either modernism's "hollow cry" of loneliness and isolation, as one writer has termed indulgences like Boorstin's, or its jaunty flip side, the "defiant boast" of self-determination that served as the engine of the image industry that Boorstin presumed to critique, the series of photographic developments investigated here will be shown to have drawn a promise of postwar political renewal, even a sense of moral obligation, from this bonding in anonymity, the experience of "monotony within us, the monotony of self-repetition."[4] The same superabundance of images that fueled the rapid expansion of mass culture into new geographical, social, and psychological zones and that so worried mass culture critics like Boorstin, the same sense of being carried away by a flood of photographic views, the same fear of seeing one's own fleeting reflection everywhere that would return just a couple of years later as pastiche in the work of artists such as Andy Warhol, Edward Ruscha, and Gerhard Richter, was seen to have unique purchase on—indeed, it was assumed grandly, that might even provide a *remedy* for—the largest, most pressing problems of the day.

This sense of promise or mandate is circumscribed by a very specific and narrowly delimited history, one that is remote and whose main characteristics are quite foreign to us now. As an ambition, it gave rise to a peculiar and distinctive form of late modernism, a form that I will be describing in detail here. In brief, the principle of alienation diagnosed as "social narcissism" or "social anonymity" or "self-repetition" and understood to be

generated by the ubiquitous and never-ending flood of snapshots, advertisements, and other photographic documents, was thought to bear within it the possibility of a new political identification, the possibility of a civic-minded collective self-understanding that would generate a new postwar, postmodern citizen of the world. Ultimately, the promise of this condition was that, when exercised properly, it could be a means of salvation from the horrors of the recent past and a means to prevent them from recurring. The goal was not so much a new, improved, transnational identity—realized in a socially contracted ethic or shared vision of the past or future—as it was a system of political belonging driven by a sense of identity-in-crisis, a system built on a shared fascination with, and shared fear of, *non*identity. The disease, so it was assumed in a once momentarily prominent but now long-obscure form of homeopathic reason, was also the cure.

This was no simple concession to the status quo, however, no simple capitalist realism in the manner that was soon to dominate artistic developments. The promise driving this series of photographic imaginings was not yet based on the market's peculiar brand of social poison as cure for that of the nation; it was not yet based on the promise of the consumer as redeemer of the citizen made pathological by the failure of political or other ideals. (Such would be *hetero-* or allopathic, anyway, not homeopathy and thus generated by a whole different course of reason.) Instead, the photographic ideal investigated here was still very much a manner of midcentury existentialism or phenomenology or philosophical humanism, a manner of viewing that actively sought to build its own *ism* or systematic doctrine of being in, and knowing of, the world into the experience of vision it represented.

Viewed from a more familiar perspective, this is just another way of saying that the promise of photography's mechanical reproduction had not yet become camp—that is, it had not yet come to derive its critical distance by rejecting the Enlightenment aim of deep productivist reason, structural, systemic understanding, and universal self-realization, by turning away from that inner causality to passively mirror, surf, and pastiche the outer surface of the world.[5] In retrospect, thus, we might say that the photographic sensibility investigated here arose as a transitional form of political subjectivity, one that was en route from the residual shared passions of the citizen to the emergent and increasingly isolated

self-interests of the consumer, en route from Vertov, say, to Warhol or from the engineered neurosis of mass politics to the manufactured hysteria of mass culture. For a moment, however, it had its own distinctive and alternative agenda that was neither strictly civic-minded nor strictly consumerist, its own version of late modernism that is lost from view if we shift our historical gaze from the cohesive mass of the moderns to the fragmented social imagining of the postmoderns too quickly. Under investigation here is this alternative role allotted to culture as a third distinct system of social organization that flashed up brightly but briefly between two more forceful and better-understood positions.

Nearly half a century now after its moment, as peoples and cultures around the globe have increasingly acclimatized to an ever broader, ever thicker, and ever deeper media-distributed, market-based world order from their various vantage points at the center or periphery of that order, the promise of such an alternative agenda seems far-fetched at best. In one form or another, people the world over have now long accepted a fundamental geopolitical principle: the battle that was once defined according to the three-worlds developmental model of the cold war and its aftermath and that was momentarily refigured after September 11, 2001, as "the clash of civilizations" is now no longer a battle for the souls of the yet-to-be-industrialized or yet-to-be-democratized between competing materialist philosophies of how best to manage the processes of industrialization or how best to understand and realize the promise of freedom. Instead, it has been reworked as a battle around identity: between the materialist political subject now reduced far more radically than before to the self-interested consumer and its idealist other, between economic man as the global political subject par excellence and various forms of political being drawn from religious doctrine, racial and ethnic categories, and political ideology.[6] Insofar as this battle between materialism-cum-consumerism and idealism-cum-identity-politics has been polarized as such—that is, as a battle between competing and mutually exclusive desires rather than a battle over the best system to achieve the same modernist aims—other attempts to develop a global political subject, such as the brief development discussed in this book, have become unintelligible.[7]

We might begin to uncover this lost promise that photography was momentarily assumed to have by reintroducing the thick sense of immediate intelligibility and epochal importance of this question about political

subjectivity for the period studied here. There are many examples to be drawn from, but I start with just two, both from the end of the period in 1962. The first is a warning issued by Theodor Adorno in which he insisted that the question of political subjectivity was the linchpin for "averting the most extreme, total disaster," the question that "everything else must crystallize around." The "forms of humanity's own global societal constitution threaten its life, if a self-conscious global subject does not develop and intervene," he wrote; the "possibility of progress, of averting the most extreme, total disaster, has migrated to this global subject alone."[8] The second is taken from the founding neoliberal manifesto *Capitalism and Freedom* by Milton Friedman. Surprising, perhaps, to our post-1989 geopolitical assumptions, Friedman's text, no less than Adorno's, was fraught with anxiety over the prospects for political subjectivity. Freedom, he wrote, is being "threatened from two directions." The first of these was obvious, coming as it was from "the evil men in the Kremlin who promise to bury us." The second, however, was more subtle and insidious and more in keeping with the deep terms of Adorno's analysis. "It is the internal threat coming from men of good intentions and good will who wish to reform us," he warned.[9] Both thinkers were battling with the problem of what Friedman called the "concentrated power" of goodwill and good intentions within social forms; both understood the battleground to be what Adorno called the "self-conscious global subject." The question of the proper social economy of subjectivity most conducive for the pursuit of freedom from that concentrated power was the pressing issue at hand for both, even if, of course, it was a question for which they did not share a common answer.

The polarized consumer-versus-idealist, postmodernist-versus-modernist worldview that emerged with fresh force in the wake of the period addressed in this study is not strictly new to the past half-century. In one sense, it is as old as the mix of capitalism and enlightenment. Indeed, the capitalist-realist political justification that took on new momentum at the beginning of the 1960s on behalf of the consumer as exemplary global subject was largely consonant with, if never exactly the same as, the form of political subjectivity at work in the photographic developments discussed here. That battle for justification, in short, turned on whether the political passions so fueled by nationalism during the war might be redirected most effectively to the production of a new world government or to a new world

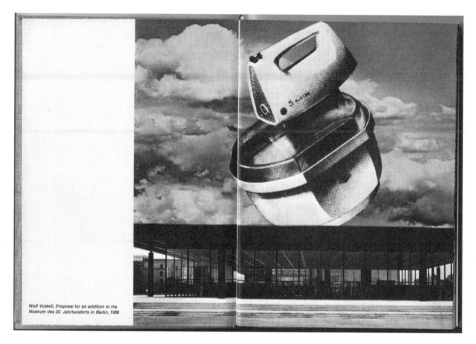

Figure 1

Wolf Vostell, *Proposal for an Addition to the Museum des 20. Jahrhunderts in Berlin*, 1968. From Wolf Vostell and Dick Higgins, *Fantastic Architecture* (West Glover: Something Else Press, 1969). © 2005 Artists Rights Society (ARS), New York/VG Bild-Kunst, Bonn.

market. The question was, what would better hold at bay the dark passions of the nation: the modern form of belonging given by the promise of progressive reason or postmodern longing given by the promise of a growing economy and growing variety of consumer goods? The consonance of justifications that emerged in response to this question meant in significant measure that the residual modernist political efforts on the part of the 1950s photographic projects and intellectual endeavors investigated here contributed to, or at least were easily folded into, the neoliberal consumerist postnationalism that emerged in full force in the 1960s.[10] So it was that the dialectic of enlightenment, as Adorno and Horkheimer had named this consonance in 1944, carried onward. "The only kind of thinking that is sufficiently hard to shatter myths," they had warned, "is ultimately self-destructive."[11]

The original early modern philosophical argument underlying that political justification was outlined a quarter-century ago by Albert O. Hirschman in his incisive study *The Passions and the Interests: Political Arguments for Capitalism before Its Triumph*. Passion as a political force, Hirschman observed, came to be understood by a governing political theory as destructive by definition while at the same time reason came to be seen as ineffectual at curbing that destructiveness. Once these two assumptions were in place and both passion and reason were neutralized as potential bases for correct political subjectivity, he summarized, "the view that human action could be exhaustively described by attribution to either one or the other meant an exceedingly somber outlook for humanity." The solution to this dilemma was as ingenious as it was instrumental: in lieu of a strict reliance on either reason alone or passion alone, the concept of interest would come to serve through a kind of synthesis: "as the passion of self-love upgraded and contained by reason, and as reason given direction and force by that passion."[12] Acting by one's interest was to be a means of channeling passion with reason and in so doing redirect and productively exercise its inescapable force while tempering or at least minimizing its violence.

The work investigated in this book had similar aims for its own moment, but its methods were different. Each of the three projects studied here—Edward Steichen's exhibition *The Family of Man*, Robert Frank's book *The Americans*, and Bernd and Hilla Becher's ongoing typological study of aging industrial architecture—sought to temper or redirect collectivist political passion without relying solely on the limited utility of reason, but they did so with a relation to the world that was not yet reduced to self-interest. Each sought to develop a means of effectively channeling the passions of nationalism into alternative forms of political belonging, alternative forms of political subjectivity not wreaked with the travesty of national or racial chauvinism but also not inflicted with the impoverished social imagination forced by the concept of interest. As a group, they carried forward the dream of public life—of nation—but they protected themselves with equal ardor from the ways that dream had become nightmare in the recent past. One way to describe their shared undertaking, thus, is to say that they worked the affect of belonging: they sought to develop and refine the emotional experience of relating or connecting to a group.

The real work of these projects, thus, was aesthetic or affective or embodied, but that does not mean that such engagement was not already deeply and meaningfully philosophical—and this so in a manner very different from other moments in the recent history of art. The period as a whole was saturated with extraordinary ambition. In this regard, they were in keeping with a range of scholarly projects whose intellectual goals seem beyond the pale of much of what might be reasonably imagined now: Marcuse's magisterial 1955 *Eros and Civilization,* for example, or Bataille's grand 1949 *Accursed Share*, or Sartre's attempt to reconcile existentialism and Marxism in his 1960 first volume of the *Critique of Dialectical Reason* subtitled *Theory of Practical Ensembles*, not to mention the prolific writings of Adorno and Merleau-Ponty from the period that will figure more prominently as symptomatic period texts in what follows. But as we will see, the "social narcissism" assumed to be given by photography provided a special resource or instrument for retooling the relations between passions and politics, a special way to imagine and develop such "practical ensembles" that exceeded the means available to sociologists, philosophers, and others retricted to rational self-understanding.

The ambition in question was an upshot of a particular historical moment, a liminal moment between new and old forms of political belonging when the big questions about political subjectivity that have given form to modernity once again could be asked. The distinctive means by which the passion of belonging was to be redirected and the characteristic ends toward which it was effectively routed is the primary question addressed here. *How to experience the other anew?* each of the projects asked, how to rework the relations between individual and collective, between subject and society, in a manner that somehow did not overdo either? This, in a nutshell, was the problem, and it was complicated equally by its residual modernist impulse to centralized social planning and systematic understanding and its emergent postmodernist impulse to reject that god's-eye view and give itself over—"willy-nilly," in Boorstin's cavalier phrase— to the flux below.[13]

The innovative solution for these photographers, as it was for a wide range of other public intellectuals, was developed first from abstract formal means. In the words of one leading urban theorist, for example, it was to elaborate "an intimate, visible linkage from fine detail to total structure," to synthesize "a *whole* pattern, a pattern that would only gradually be

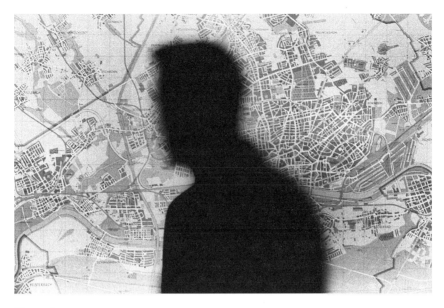

Figure 2
Robert Freeman, untitled photograph reproduced in *Living Arts* 1 (1963): 83. © 2005
Artists Rights Society (ARS), New York/VEGAP, Madrid.

sensed and developed by sequential experiences, reversed and interrupted
as they might be" in a "continuity in which each part flows from the next
[providing] a sense of interconnectedness at any level or in any direc-
tion."[14] Working out this pattern, this local-global plan, this form of social
totality visible only while being performed by its participant-observers on
the street below, was the primary aesthetic problem that drove the series
under consideration here and that distinguishes it both from the idealizing
and all-embracing god's-eye-view of the prior modernisms that it sought
to move beyond and from the fluid, savvy, and ever partial shopper's-eye-
view postmodernisms that would supersede it.

There was no little delusion, no small amount of the "social narcissism"
that Boorstin feared, driving this ambition. Despite its folly, however, this
aim will be understood in what follows to be epic in its potential. Or,
rather, I will be arguing that it is precisely because of its folly—the grandi-
ose, epical character of its self-imagining, the deluded superhumanity of
its presumption to remake the world that was long ago squeezed from view
by the two more dominant perspectives on either side of its historical

emergence—it has something to offer now. We can consider the same issue differently (and thereby, perhaps, get a better sense of a key or hook that might serve now) if we see this dream as a piece with two greater and more consequential humanisms of the midcentury: the civil rights movement and the decolonization movement. These were heady days when an "emancipatory ideology," as Prasenjit Duara puts it about the decolonizers, could seek simultaneously and equally "to liberate the nation and humanity itself."[15] These were heady days when political vision was understood to appeal directly to something universally human and primordial, heady days when a speech could bypass the emotional sentry of cynicism and resonate deep to the core with a banal refrain like "Let freedom ring!," heady days in which enlightenment seemed once again to be momentarily relevant.

Of course, the civil rights challenge and decolonization were both world-changing social and political movements in ways that the modernist intellectual and artistic fancy discussed here was not. It might be said that the social movements succeeded ideologically and the impulse described here failed because the former had workably particular concepts of nation to offset and implement the unworkably general abstraction of human rights or "humanity itself" or freedom or enlightenment, whereas the latter remained mired in an airy modernist universalism. Like the Prussian state for Hegel, enlightenment was imagined to be made concrete and particular, however imperfectly, in American black nationalisms of various sorts and in the cultural neotraditionalisms that energized movements for national sovereignty in Asia and Africa. Their cultural means—slave spirituals, homespun, sarongs, talking drums, and the like—performed much of the ideological work necessary for decolonization and nationalization by particularizing identity, by giving it new autonomy from the global narratives of colonialism and the transcontinental slave industry.

From our perspective now in the midst of another period of dramatic and far-reaching geopolitical realignment and political-psychological reconfiguration, however, these advances might also be seen to have their limits, and the most general questions—those for which identity politics became the answer—might be raised again. How to give social form to autonomy, to human self-realization, to freedom? How to define, experience, and exercise anew the relationship of individual to collective belonging? This book is a look back to a moment when those questions were still

being grappled with, a moment before the answers hardened into concrete identities, institutions, and critiques and before the questions themselves came to seem the province of youth or a delimited historical period or naiveté. For a moment, photography bore the promise of doing the same sort of ideological work that spirituals, sarongs, homespun, and the like performed—the work of enlightenment realized as identity, as nation—but now on a global scale.

This was and is a hopeless contradiction, of course, a hopeless attempt to reconcile universal with particular, to put to rights otherness and identity, and, at its most ideological, it did little more than cultivate the denial that bent over backwards to welcome the first forays of the everything-is-a-commodity worldview and its resentful, reactive other that we are so familiar with today.[16] But the photographic projects considered in this book at least hoped that they could do the opposite, that they could embody contradiction and take as the core of their nationhood the irresolution between general and particular, between collective and individual. They thought, in other words, that photography's social narcissism, its capacity to give form to "the least individualized and most anonymous aspects of ourselves," would allow them to live abstraction like Gandhi and his followers lived *satyagraha*, to embody nonidentity like Gandhi and his followers embodied nonviolent noncooperation. Photography was to be their primordial cultural expression, their existential homespun for the postwar world, their deepest expression of political subjectivity globalized by the prospect of a nuclear World War III.

It was a grand dream of renewed human vitality, but it passed in a flash as what now seems its inevitable endgame—the deadened contradiction of the global consumer and her fundamentalist other—welled up in its stead.

Introduction: The Photography of Social Form

"Nationalism," historian Hans Kohn wrote in a book published in 1944 and reprinted repeatedly throughout the late 1940s and early 1950s, "is an idea, an idée-force, which fills man's brain and heart with new thoughts and new sentiments." It was a form of thought and sentiment that had reached its historical breaking point, however. "Once it increased individual liberty and happiness; now," Kohn argued, "it undermines them"; now, he insisted, the "individual liberty of man has to be organized on a supranational basis."[1] Against the rising fear of nuclear war and the fluctuating passions aroused by the emergent anticommunist bunker culture, many journalists, academics, and other commentators from around the noncommunist postwar world came to approach the question of political identity with a similar appeal to supranationality. In essays and speeches by American public intellectuals, for example—"Toward a New Concept of Man" by philosopher Irwin Edman, or "Modern Man Is Obsolete" by *Saturday Review* editor Norman Cousins,[2] or "The Real Problem Is in the Hearts of Men" by leading world government advocate Albert Einstein, to name just three—the passions of political subjectivity were intentionally and explicitly redirected from nationalism to a global frame.[3] "Our problem," wrote the period's named "greatest living political philosopher of America,"[4] theologian Reinhold Niebuhr, "is that technics have established a rudimentary world community but have not integrated it organically, morally, or politically."[5]

There are many others, of course, including many whose names have lived on in larger ways, that also developed their voices after the war from the same keen awareness of the failure of modern political subjectivity and the pressing urge for a new universalism but used the consensus as an opening to found their sense of purpose on less ambitious but more viable

social institutions rather than on the unlikely dream of world government or ill-conceived universalizations of the old proletarian movements (such as the short-lived, predictably named "Human Front").[6] Martin Luther King, Jr., used the Southern Christian Leadership Conference as a platform, Dag Hammarskjöld the United Nations, and the young Tom Hayden Students for a Democratic Society to develop forward-looking roles and universalist ideals for political being, for example, while many others critically examined existing institutions in search of the break point of existing political life, of existing forms of political subjectivity: Hannah Arendt commenting critically on the Jerusalem trials, for example, or more generally on the "banality of evil," or on the new state of Israel, or Frantz Fanon bringing the distinctive form of critical thinking from his postwar European education to bear not only on the legacy of the European colonial powers occupying his native Algeria but also on the pan-African response to colonialism. All of these figures and many, many others took as their root concern the question of a postwar "new concept of man" and assumed it to be the single most pressing issue of the day.

Fanon may best illustrate this shared ambition because of the scope of the intellectual perspective that he brought to it and because of his position as a spokesman for the most sweeping of all such political changes. "The white man is sealed in his whiteness" and the "black man in his blackness" in a vicious circle of "dual narcissism," he wrote in 1952, for example. Only by tending to this "set of defects left over from [modernity's] childhood"—like the psychoanalyst tends to traumas from her analysand's past—will modern man be able to assume "the universality inherent in the human condition."[7] Europeans "never stop talking of Man," he wrote later; "today we know what sufferings humanity has suffered for every one of their triumphs of the mind." The only solution, for "Europe, for ourselves, and for humanity," he insisted, was to "work out new concepts, and try to set afoot a new man."[8] Or we can look to Fanon's influence on Jean-Paul Sartre as he cautioned his contemporaries not to miss the opening to a new universalism given by the war, decolonization, and the bomb. "In other days France was the name of a country," he wrote in his preface to *The Wretched of the Earth*. "We should take care that in 1961 it does not become the name of a nervous disease."[9]

Regardless of whether these public intellectuals were able to realize a viable political platform to support their response to the global problem,

all agreed that what was desperately needed was that which their prewar forebears had first called a "new man." Any effective thinking about geo-politics in the early postwar period, it was assumed, would have to begin by developing a postmodern version of that new man, a new political subject that could comprehend, negotiate, and navigate the postwar sense of the obsolescence of modern political structures and passions, the pressing fear of nuclear war, and the accelerated globalization of the economy driven by technological advance and the new entrepreneurial Pax Americana. What was desperately needed, they all agreed, was a world community integrated organically, morally, and politically through the development of a new idée-force that gave form to new thoughts and new sentiments in the figure of a postmodern, postnationalist citizen of the world. The old model, Sartre had written at the war's end, had developed a subject who "wants his personality to melt suddenly into the group and be carried away by the collective torrent," a subject who has "the atmosphere of the pogrom in mind when he asserts 'the union of all Frenchmen.'"[10] Modern nationalism, in other words, was assumed to have made itself obsolete, to have become decadent, self-absorbed, self-destructive, fascistic, but that did not mean it had been fully superseded. It still threatened to burst forth from its moral and military repression after the war; it still might well up at any moment and bring on the horror of World War III.

In order to be effective, in order to move forward, the new global subject would need a political bond that was so broad and deep, so forceful and passionate, that it would effectively supplant the old longings, the old "atmosphere of the pogrom" that had enabled the dire consequences of the war, with a new form of enduring social fulfillment. There would have to be a new globalism, it was assumed during the moment studied here, that could stir the soul as deeply and meaningfully as the old nation-alisms. Repression of those desires was dangerous at best. This book is about a series of intellectual and artistic struggles with this seeming necessity, a series of attempts to imagine photography as a means for working through the affective content of such a changing relation to the world and for exploring new forms of political subjectivity, new ways of picturing individual identification as a force that could give newly meaningful and satisfying psychosocial form to political being in the postwar world.

At the center of this development was a constitutive contradiction, one that (as should be clear by the end of this book) carries on today in a variety of forms. While its founding impetus was to declare modern man to be obsolete, its emergent postmodernism was still based on the residual and still fully modernist, fully nineteenth-century, formal principle of the system or plan. Political subjectivity, it was assumed by the list of period thinkers above and by their photographer-contemporaries discussed below, is always constituted in and through systemic relations, and those relations are governed by a consistent and recognizable plan. It was a function of the "group", in Sartre's terminology, rather than the "series": its systematicity was organized toward active and effective self-realization and was not "practico-inert."[11] Central to this principle or plan was the promise and the threat of political desire, of channeling an "idée-force which fills man's brain and heart with new thoughts and new sentiments."

Drawing on the influence of its heady years of artistic and mass-cultural prominence following World War I, photography after World War II was assumed to have special capacity to explore such constitutive principles of relationality in an experimental or laboratory fashion by working and reworking the systemic principles that structure or destructure the ever-growing archive of pictures. Art's "function," Moholy-Nagy could still say (in a manner reminiscent of his writings from the 1920s)[12] during a 1943 lecture on the contribution of the arts to postwar "social reconstruction," is to work "the relationships of the individual to the world," to serve as an "intuitive recreation of the balance between the emotional, intellectual and social existences of the individual." Photography, he assumed, was to be the lingua franca of that re-creation, the medium of choice for working out the new postnationalist relation of part to whole, individual to group, and thus invaluable for developing the new, postwar New Man.[13]

Pictures can be arranged, so it came to be thought by the post–World War II development studied here in a manner not so different from the post–World War I political imagination of Moholy or Malevich or Lissitsky or Herbert Bayer or August Sander (or, for that matter, Leni Riefenstahl or Joseph Goebbels), like the social engineer can arrange people. Political imagining and photographic imagining, it was thought, might be worked out together or mapped onto each other by homology or through a form

Figure 3
Edward Steichen and assistant Wayne Miller laying out *The Family of Man*, 1954.
Photo: Homer Page.

of structural or systemic correlation. Social form and visual form, it was still believed in a way that it would no longer be just a few years later, were interrelated plastic media that were to be molded in tandem according to an overall design or plan or shape of the modern world. Photography, it was thought, could serve as a laboratory for social reconstruction. One way to describe it is simply to say that this was the Enlightenment's last great hurrah for the visual arts—the last moment where it tried to be David's *Marat* or Courbet's *Burial* or Manet's *Dejeuner* or Seurat's *Bathers* or Picasso's *Demoiselles* or Lissitsky's *Prouns*. This was, in other words, the last moment for a long while in which art presumed to have a say in the future, the last moment before it fell back on finding its own voice only in detachment and critique.

1

In its original 1940s impetus, the rhetorical construction of this supranational ambition was explicitly and self-consciously public in orientation and as such was broadly noble, eager, and magnanimous in spirit.[14] By the end of the 1950s, however, the liberal ideal of a single global political identity and a single global political authority seemed not only hopelessly utopian but also indistinguishable from the newly aggressive transnational cultural imperialism of American industry, or "Coca-Colonialism," as the French first termed it shortly after the war (and Billy Wilder came to lampoon it in his 1961 globalization send-up *One, Two, Three*).[15] By the end of the decade, the promise of a world citizen suddenly seemed to find its organic, moral, and political bearing in nothing more or less than the role of the consumer, and the early postwar promise of political liberalism working out a new plan and a new subject found itself to be indistinguishable from the triumphant emergence of economic neoliberalism. The specter of *l'américanisme*, which heretofore had been seen to threaten only culture, now suddenly seemed to be available as a superior social mechanism for foreign policy and state diplomacy and, ultimately, as a model for emergent political subjectivity for the postwar period's new "new man."[16]

The foremost symbolic expression of this alternative globalism was given by Vice President Richard M. Nixon's 1959 epoch-defining challenge to Premier Nikita Khrushchev that the cold war contest be based no longer on "the strength of rockets" but now instead on "the relative merits of washing machines." This later globalism, a globalism that uses the sway of its markets to fill "man's brain and heart with new thoughts and new sentiments" more than the reach of its political promises, is a paradigm still very much with us, of course, despite periodic returns to the older form of relations-by-rockets.

A distinctive photographic sensibility developed in the midst of the transition from one form of the postwar new man to the other, from the broad and airy political reckoning of the global citizen earnestly debating the best form of government with his fellow citizens around the world, to the narrow economic calculations of the global consumer assessing the cost or benefit of the latest washing machine for her bottom line. In the interim moment between public-political and private-economic formulations of the constitutive medium of the postwar, postmodern new man,

culture briefly flared up as a historically distinctive and potentially domi-
nant third term, as an alternative medium through which the new subjec-
tivity could flow and give itself definition in the play of relations between
self and other. Not tied directly to the rules of the marketplace or to those
of nation-states, this notion of culture was thought to have its own rules
and dynamics that could govern, or at least modulate, the relations between
people and provide the appropriate measure of postnational belonging.

Culture, it was thought, could constitute a third realm, a "public sphere"
or would-be global salon where the exchange of ideas and sentiments was
to take place at a sufficient distance from both the bureaucratized exercise
of political power by party and state and the privatized exercise of eco-
nomic interest in the day-to-day business of family life, marketplace, and
civil society. In the words of one period scholar responding to the clarion
call for a new postwar political subjectivity by looking back to eighteenth-
century bourgeois *Öffentlichkeit*, or public sphere, culture could provide
something distinctive and important: it could serve as a "training ground
for critical public reflection" and, in so doing, open up new forms of relat-
ing to the world. Art—if reclaimed "as a serviceable topic of discussion
through which a publicly-oriented subjectivity" communicates with
itself—could open up opportunities for new forms of public opinion
"emancipated from the bonds of economic dependence" and political
determination and thus from the impoverishment of social imagination
born of the instrumental perspectives of narrow private interest and
bureaucratized public authority.[17] Photography more than any other
medium, so the series of developments examined here came to assume,
could serve as just such a form of art that might be reclaimed for—and
might redeem—the postwar world.

2

From its beginning, photography as a medium has maintained a privileged
relation to modernity and carried a special claim on globalization. Its
history is full of manifestos like this one by Alexander Rodchenko: "Art
has no place in modern life. It will continue to exist as long as there is a
mania for the romantic and so long as there are people who love beautiful
lies and deceptions. . . . Every modern cultured man must make war against
art as against opium. . . . Photograph and be photographed!"[18] Such claims
for photography's distinctive modernity have never been based on only its

advanced technology but have relied also on assumptions about its advanced politics, on its promise to be representation without bias, representation without "beautiful lies and deceptions," representation, ultimately, without subjective expression, instrumental motivation, or national or other political identification.

This heady claim for the capacity of representation to escape the opiate of identity is, of course, a myth as much as any other made in the name of art or reason, free enterprise or the nation-state, but it is a myth that carries a different sort of status, a different relation to identity: it promises its own distinctive form of universalism, its own distinct form of truth free of "beautiful lies and deceptions," and its own distinct form of belonging. This myth was made available for special service in the 1950s as the ideological battles of the cold war came to be waged more and more in the domain of culture and as the concept of nation came to be more and more dislodged from the concept of state. This myth had specific regional origins, of course, but, with the assistance of the U.S. Information Agency (USIA), the UN, and the Coca-Cola Corporation, among many others, it quickly took hold around the world. It is this myth and the sense of belonging it implied, distinct from those of race, language, region, and other national markers, and distinct from that of the transcultural marketplace, that I am calling photography's "nation."

The three projects studied here—the large and widely viewed exhibition *The Family of Man* developed by Edward Steichen beginning in the early 1950s and first shown at the Museum of Modern Art in 1955; Robert Frank's published series of photographs, *The Americans*, culled from some 600 or more rolls of film shot in 1955–1956 and first published in 1958; and the collaborative document of aging industrial architecture from around the Western world of Bernd and Hilla Becher initiated in 1957, first exhibited in 1964, and carrying on today—each in its own way returned to the prewar avant-garde claims of Rodchenko and others in ways that their fine art contemporaries did not. While photographers and painters alike did share in and benefit in various ways from what one cold war bureaucrat called "the tremendous importance of the arts . . . as an antidote against collectivism," they approached that role differently.[19] Both art and photography bore a complicated relationship to the cold war conceptualization of "collectivism" (burdened as it was with period contradiction that

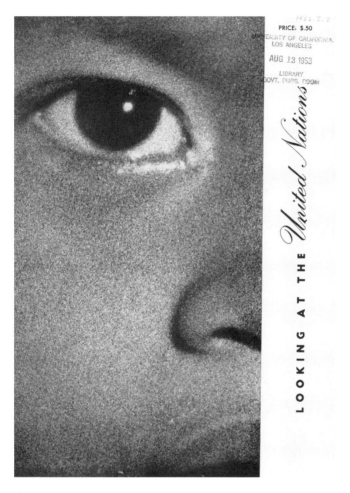

Figure 4
Cover, *Looking at the United Nations*, 1952.

relied on the assumption that the collectivisms of fascist nationalism and communist internationalism were indistinguishable).[20] All of the developments in both art and photography had deep collectivist roots and vigorous anticollectivist inducements, but each group developed the legacy of those roots differently. Each worked out the contradictions of the period in a distinctive way.

"In any view of the American cultural situation," Lionel Trilling could still write without hesitation in 1966, providing some sense of the burden

faced by the period studied here, "the importance of the radical movement of the Thirties cannot be overestimated. It may be said to have created the American intellectual class as we know it in its great size and influence. It fixed the character of this class as being, through all mutations of opinion, predominantly of the Left. And quite apart from opinion, the political tendency of the Thirties defined the style of the class—from that radicalism came the moral urgency, the sense of crisis, and the concern with personal salvation that mark the existence of American intellectuals."[21] The photographic developments studied here, like those in painting, were born of that intellectual class as it confronted radically transformed possibilities for political imagination given by the postwar world, but the response was different. In the climate of such contradiction, the increasing social isolation of the affective content of art—in the work of an emergent leader like Jackson Pollock, for example, or in that of a residual leader like the social-cum-"personal" realist Ben Shahn, or in the post-1930s, social-cum-art photography of Aaron Siskind or Minor White—was available ready-made for appropriation as just such an antidote to collectivism conceived tout court. Art, as understood by this waning political consciousness, tendered the personal as a solution to the social, the artistic as consolation for the political, the self as a way out of the pressing problem of the collective.

The photography studied here held out a different promise, a different antidote to the problem of collectivism. Instead of the increasingly lonely artist-conjuring-the-world solution, the three photographic projects offered an opening to negotiation or conciliation with collectivism, a manner of tapping into collective expression and identification in a manner that shared in its recognizable affective force while still effectively tempering its potential for political violence. Importantly for the analysis I am undertaking here, that promise was tied to photography's status as a discrete medium, as an art form different in kind from painting and other higher, finer forms. The three projects at the center of this study were intimately interconnected, and each used its distinctively photographic qualities as a means to grapple with the problem of a postnationalist, postcommunist political subjectivity and the pressures it faced in the mix with the emerging, newly cosmopolitan consumerism. When linked together as a sequence, these three projects provide a unique and historically specific story to tell, a story about the changing possibilities for political affect, a

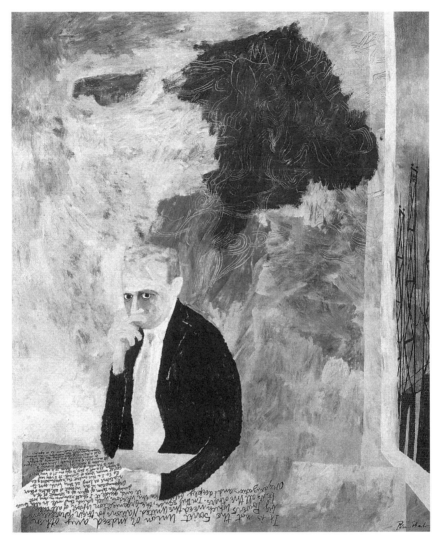

Figure 5

Ben Shahn, *Portrait of Dag Hammarskjöld*, 1962. National Museum, Stockholm, Copyright © Estate of Ben Shahn/Licensed by VAGA, New York, N.Y.

story about the experience of political subjectivity at a crucial transitional moment in the development of the postwar world.

In order to get to the particular historical dynamics at work in the complex of political identity under consideration, I focus primarily on a set of aesthetic issues raised by the three projects, on the ways that photographic form was made available to cultivate particular bodily responses in its beholders. It is in the distinctive character of aesthetic experience that photography was able to conjure in this moment that the rub of local and global, individual and collective, subjective and objective, of identity and history, will be understood to be given flesh or body. It is here, in the aesthetic experience given by an exhibition or a photography book, where viewers were asked to experience themselves through photography's mythical modernist promise of mechanically realized democracy, that the position Merleau-Ponty named the "pivot of the world" will emerge as a momentary ideal. It was "Photography," in Edward Steichen's words, experienced as "a collective offering," photography experienced as "giving an account of itself."[22] *The Family of Man* was a "radical departure," according to Steichen, insofar as it stressed "photography . . . recording the world" rather than the vision of "a particular photographer."[23] It is here in the abstraction of photography as an autonomous agent unto itself, the abstraction of photography "giving an account of itself," I will be arguing, that new thoughts and sentiments, new versions of a supranational idée-force for political subjectivity, were to be imagined, cultivated, experienced, practiced, and processed as a "training ground for critical public reflection" addressed toward the pressing geopolitical issues of the day. It is here, in other words, that photography realized itself as a nation, as "an idea, an idée-force, which fills man's brain and heart with new thoughts and new sentiments."

3

On the one hand, this question about photography as nation is historically specific and narrowly confined to the period in question; on the other hand, it is also by definition a broader question about the role of art and the experience of beauty in history. "The object of art—like every other product—creates a public which is sensitive to art and enjoys beauty," it has been said by one notable aesthetician, creating not only "an object for the subject, but also a subject for the object."[24] Changing patterns of

aesthetic experience are generally socially and historically significant in this way—like every other form of product innovation, new art forms produce new subject forms—but perhaps most dramatically so in times of political upheaval when social norms are most vulnerable to substantive change.

Such changing patterns, of course, are the business of art history as a discipline—at least for those practitioners who attend to the aesthetic as an analytical category—and it is the business I undertake here. Generally, it is in the context of wars, revolutions, and economic downturns and upturns that political subjects most experience the aesthetic as a vehicle for either opportunity and renewal or threat and travesty. If we stick with the modern models that emerged out of the Enlightenment (which, I will be arguing, we should), the aesthetic functions as a distinctive form of experience by virtue of being charged with unspecified vulnerability and danger, with openness, willing or unwilling, to the possibility of another self and another world.

Almost any example from the history of modern aesthetic theory will do to model this openness so the late-eighteenth-century origins of the tradition are most appropriate as a starting point. Human existence is marked by two contradictory demands, wrote Friedrich Schiller just five years after the French Revolution, for example: one that "insists upon absolute *reality*" in an effort to turn "everything that is mere form into world," and another that "insists upon absolute *formality*" in order to "eradicate in himself everything that is merely world."[25] Reason and desire, *res cogitans* and *res extensa*, "objective man" and "subjective man," as Schiller called them in his formulation of the core conceit of modern aesthetics, expose themselves to each other and do battle to determine the meaning and significance of the subject's experience of world. The realm of the aesthetic, this tradition insists, is the liminal space where reconciliation and negotiation between the two, between subject and object, become available.

This same baseline account of aesthetic experience developed in the eighteenth century was still being laid claim to as the entry to truth and autonomy during the period studied here: the moment of feeling the pleasure of beauty or the fear of sublimity does not "trigger personal, otherwise repressed emotions," Theodor Adorno insisted against the banal and individualized pop-Freudian understanding of aesthetic experience. "Rather,"

he continued, this is "the moment in which recipients forget themselves and disappear into the work; it is the moment of being shaken. The recipients lose their footing [and] the possibility of truth, embodied in the aesthetic image, becomes tangible." This loss of footing is the intercourse of Schiller's objective man and subjective man; it is, Adorno concluded, "the eruption of objectivity into subjective consciousness," the moment when the subject loses herself, her subjectivity, and becomes an object.[26] The historically specific aim or opportunity seen in the meeting of objectivity and subjectivity in the aesthetic experience given by the photographic projects under consideration is the topic of study addressed here.

Such philosophical accounts of aesthetic experience are abstract and off-putting but they are fundamental to the historical understanding necessary for this undertaking. What the aesthetic as a distinctive realm of experience offered to photographers and their audiences in the 1950s was a means of renegotiating how individuals experienced the character of their membership within larger communities. The issue for this study, thus, is not about photography providing an "antidote" to collectivism, as the cold warriors urged for art; it is about photography articulating new relationships to collective identity, new solutions in response to the old collectivisms. Aesthetic pleasures were to be the means for just such renegotiations: like the eighteenth century's bourgeois *Öffentlichkeit*, the experience of beauty was to serve as a "training ground for critical public reflection," and beauty was to be experienced as an ideal against which lived reality could be critiqued. As such, the art part of these projects necessarily served to negate existing forms of belonging. For these photographers, however, this moment of negation went hand in hand not with any imagined neoliberal individualism as a default ideal but instead with a corresponding urge to develop new, alternative forms of collective identification, to develop a new, new man that still held firm to the old Enlightenment promise of collective self-realization.[27]

The means to these ends was understood at its most primary level to be about forgoing staid, brittle, and failed models of political subjectivity in favor of new, more fluid, adaptable, and agile ways of thinking about the interrelationship of individual and group, but it was never meant to simply forgo the analytical aims of science in favor of some manner of soft, expressive immediacy that serves only to affirm the individual self. It was to

experience the world not as a singular, rationalizing, god-like, knowing subject or as a singular, rationalized, cog-like, known object, but to experience subjectivity as contiguity and continuity with the world of objects, to experience the world as a subject that can know and intervene by embodying that continuity, that objective totality. It was, in other words, to experience objectivity as a universal identification, to experience the objectivity of "photography itself" as one experiences nation.

4

Part of photography's significance as an artistic medium has always rested on its devaluation of individual pictures in favor of an increased valuation of the mechanical reproducibility of all pictures. Photography's distinctive aesthetic appeal can be best understood if we consider it in broad terms as heir to two earlier epochs: first, a vast premodern, preindustrial, prephotographic period when detailed visual representation was itself a narrowly class-bound luxury and form of authority and thereby signified value as such (with social status, institutional affiliation, and artistic value being largely inseparable); and, second, a modern period in which detailed visual representation came to be common under the aegis of the technical revolution of photography and other mechanical means of representation and reproduction opening a demand (if art was to retain its claim to exceptional status, to being a sign of cultivation and learning) for recalibrating the visual register of artistic value away from the simple existence of detailed representation as such and toward the properties peculiarly available to the older, premechanical media, particularly the plasticity of form and retroactively realized potential for abstraction given by painting. (This latter development, of course, was responsible for opening the breach between artistic value and social status and between the bourgeois patron class and the bohemian avant-garde.)

In the wake of these first two, we can speak of a third period, a postmodern period, in which photography has slowly come to take up the role that modernism forever struggled with—that is, the painting of modern life. In so doing, photography conceived of as an art form and experienced as an aesthetic property or medium exposed modernism's constitutive denial on the level of form and forced a shift of the measure of artistic value away from radicalized versions of the old, premodern technologies

Figure 6
László Moholy-Nagy, *The Law of Series*, 1925. Museum of Modern Art, New York. Permission granted by Hattula Moholy-Nagy.

(in painterliness and abstraction, for example) to registers of photography's own distinctive properties. Those registers—the potential for nearly unrestricted distribution made available by mechanical reproduction, for example, or the prospect it holds out that anything and everything can be easily photographed—have come to serve as the dominant formal markers of artistic value, much like the simple presence of an art object once was, or like abstraction and painterliness once came to be.[28] With these changes, the modernist claim to avant-garde exceptionalism has progressively lost sway, and the measure or marker of artistic value has increasingly come to be found in mundane ubiquity, the formal property proper to photography more than any other.[29]

Photography had its initial moment of real artistic hegemony following World War I, when it first asserted its own formal standards as the register of artistic value in the work of photographer-artists such as Paul Strand or László Moholy-Nagy, Gustav Klutsis or John Heartfield, August Sander or Albert Renger-Patzsch, Walker Evans or Dorothea Lange. Its distinctive qualities signified something very different during this period, however, then from what they would come to mean after World War II. The promise given at both times was, in the terminology of the earlier moment, to be "straight" or *sachlich*, to reintegrate the subjectivism of "art" with the objective historical conditions of "life." By embracing the mechanical quality of photography, its documentary capacity and its easy reproducibility, art could embrace modernity without falling back on the peculiar form of self-aggrandizing denial in existential painterliness or universalist abstraction that had burdened its claim to modernism from the beginning. By embracing mechanical reproduction, it had been routinely assumed since the 1920s, art could supersede itself, supersede its own denial, which had given definition and purpose to its modernism.

How the idea of photography qua photography, photography that embraced and exploited its status as a mechanical medium, was deployed as a quality and as a value after World War I is well understood and has been much discussed. That the character and aims of this value changed dramatically as the mechanically endowed objectivism of the 1920s "engineer generation" became that of the worker-identified "red decade" in the 1930s has also been much studied and is generally well understood.[30] How that value—the value of the machine, we might call it—was deployed anew in the decade and a half immediately following World War II is the less

ENCO, TUCUMCARI, NEW MEXICO

HUDSON, AMARILLO, TEXAS

Figure 7
Ed Ruscha, *Twenty-Six Gasoline Stations*, 1963, detail. © Ed Ruscha.

considered question that will structure and stimulate my investigation in what follows. As the 1950s became the 1960s, that value became something yet different again (although, like the earlier period, more familiar to our retrospective understanding) in the work of figures like Robert Rauschenberg, Andy Warhol, Gerhard Richter, and Ed Ruscha, a distinction I will also be holding on to and developing at length.

Like their prewar predecessors, the three projects studied here developed seriality as a primary photographic form. As is often the case when this formal capacity is featured, meaning came to be derived from the relations between pictures as much as or more than from the individual pictures themselves. In this manner, the total meaning taken from the series adds up to more than the sum of its parts. In addition to the objects or people or scenes photographed, one is also given an image of what Moholy-Nagy called "the law of the series." The three photographic projects discussed here emerged out of an already established genre of linking photographs together. That genre—I will be referring to it as the photographic essay—

drew its initial impulse within the history of photography equally from the category of social photography developed by Progressive era reformers such as Jacob Riis and Lewis Hine, and from the human and animal loco-motion photographs of Eadweard Muybridge, Etienne-Jules Marey, Albert Londe, Thomas Eakins, and others.

These influences were synthesized after the war and subsequently adapted to both the emerging photography-based mass media and to various contemporary artistic practices, given critical-theoretical foundation by intellectual luminaries like Sergei Tret'iakov and Walter Benjamin, and institutionalized as a government and party style in various national con-texts in the 1920s and 1930s. This form achieved its grandest expression in interwar Russian and German propaganda exhibitions. It was adopted and then transformed by Edward Steichen in the 1940s when he hired Herbert Bayer as his exhibition designer whose resumé included similar work on behalf of both labor unions (the *Baugewerkschafts Ausstellung*, or Building Workers Unions Exhibition with Walter Gropius, Marcel Breuer, and László Moholy-Nagy in Berlin, 1931) and the Nazis (the *Deutschland Ausstellung* or Germany Exhibition in Berlin, 1936) prior to his 1942 ode to the Allied war effort, *The Road to Victory*, which would in turn serve as the model for *The Family of Man*.

There has been little scholarly attention given to the photographic essay as a distinctive form. One of the best attempts to grapple with this problem pins its origin to a precise moment. "In the period between late 1928 and early 1930," writes Michael Jennings, "a new genre emerged in Germany: the photo-essay."[31] As convincing as this account is in its reading of the photography books published during this period by Albert Renger-Patzsch, Franz Roh and Jan Tschichold, and August Sander, I will aim here to open up that origin narrative and locate the emergence of the photographic essay earlier and more generally within a broader array of historical developments and within a more deep-seated set of social and cultural ambitions. From this vantage point, the development of the photographic essay will be seen as inextricably bound to the emerging experience of photography "giving an account of itself," as Steichen would later sum it up, or, more concisely still, photography understood and experienced not as this or that photograph or even this or that photographic practice but instead as photography representing photography itself.

5

As a distinctive form, the essay draws its primary genealogical determinants initially from Montaigne and then from the Enlightenment philosophers. As a method of inquiry and exposition, it fleshes out its structure and shape through a process of groping toward conceptualization and articulation of its observations about the world rather than by trying to pin them down according to a pregiven method and set of established concepts or by presenting them as direct expressiveness that bypasses mediation through innovation. The essay, in other words, feels its way subjectively toward understanding about its object of investigation rather than through either the systematic analysis of science or the expressive enunciation of art. As such, the essay does not aim for rigor and incisive particularity in the manner of the thesis or study or dissertation, and it never approximates the depth and universality that artworks or poems or musical compositions often aspire to through the use of symbol or allegory. Instead, the essay works between fact and symbol, between comprehension and intuition, between objective understanding and subjective realization in a manner that marks it as a third term, as an alternate way of experiencing and situating one's relation to the world. Fact pitted against symbol and symbol against fact, it arises out of a keen awareness of the limits of both. The essay is itself a performance of subjectivity, but one that is neither nominal nor voluntaristic because it is developed only in and through its relation to the world it investigates, only as a process of coming into objectivity. It is in other words, analysis realizing itself as a subjective condition.[32]

Writing on this question at the same moment that the photographic projects studied here were being developed, Adorno positioned the emergence of the essay at the split between art and science born of "the objectification of the world in the course of progressive demythologization."[33] The two poles of Adorno's critique generally were positivism (or the reduction of understanding to the concept) and aestheticism (or the reduction of understanding to appearance or impression), but he assumed the utmost importance for both. The truth was to be found in the mix, in the meeting of the two in the essay form. "Aesthetic experience is not genuine experience," he wrote, "unless it becomes philosophy."[34] So too, he insisted, aesthetic experience is "not accidental to philosophy." Philosophy when

it is done right measures itself by art just as much as art realizes itself in philosophy: "What the philosophical concept will not abandon is the yearning that animates the nonconceptual side of art."[35] Not attempting to be either a philosophical system itself or the revelation or raw innovation of art, the essay instead, according to Adorno, "is radical in its non-radicalism," that is, radical "in refraining from any reduction to principle," whether that principle is born of the disembodied empirical truths of science or the embodied expressive truths of art.[36] Instead, it occupies a middle ground immanent to both poles that allows it never to be reduced to either.

When the essay betrays that refusal of radicalism, betrays its own internal checks and balances, it attempts either to become science or to make conceptual understanding over into art. In this latter failure, the essay-become-art (or bad art) attempts a false reconciliation by becoming "washed-out cultural babble" that refuses to "honor the obligations of conceptual thought" and turns for its reconciliation to an "aesthetic element" that "consists merely of watered-down, second-hand reminiscences." The essay gone bad—Heidegger was Adorno's principal example—is conceptual understanding trying to be aesthetic experience, science playing at being art: "From the violence that image and concept thereby do to one another springs the jargon of authenticity, in which words vibrate with emotion while keeping quiet about what has moved them."[37] The essay done right, in contrast, was a form of understanding groping toward articulation by working the split, by honoring the claims of both art and science without collapsing either into the other. In so doing, the essay becomes true only "in its progress," only in and through its internal development from one word to the next, from one concept to the next, from the check of aesthetic experience played off against the balance of rational cognition: the elements of the essay, the concepts and affects given in words, sentences, and paragraphs—or, for our purposes, in photographs—"crystallize as a configuration through their motion."[38]

As it emerged at the end of the nineteenth and the beginning of the twentieth centuries, the photographic essay defined itself, knowingly or not, around this formal criterion. "What the pictures say," one historian has written insightfully about Walker Evans's classic essay *American Photographs*, for example, "they say in and through the texture of relations which unfold—continuities, doublings, reversals, climaxes, and resolu-

tions."[39] The idea that a series of pictures linked together could constitute an essay in all the richness of the form was widespread by 1937 when Evans's book was published. Henry Luce could comment that same year, for example, that what *Life* had learned was that a photographic series can "picture the world as a seventeenth-century essayist." Indeed, the best could "give an impression," he argued, "as personal and as homogeneous as any thousand words of Joseph Addison."[40] The photographs collected together in essay form thus were assumed to be able to develop together as a series of interrelated propositions or gestures in the manner that an argument or persona realizes itself in the world, in interactive performance, and thereby "crystallize as a configuration through their motion." The photographic essay, when done right, would take on a life of its own.

This sense of motion or unfolding of relations between images by linking photographs together in a series was first elaborated and systematized by Eadweard Muybridge and Jules-Etienne Marey and their followers in the 1870s, 1880s, and 1890s. At this early moment in the development of the form, the motion given by the photographic series was still on the side of science, on the side of systematic understanding, still determined by a pregiven hypothesis and by the assumption that the emerging apparatus of serial photography would itself be simply and transparently neutral, that it would not endow its content with its own proprietary meaning. Following on these epistemological assumptions, the methodology of serial photography was initially developed in a corresponding manner, and the relations between photographs were defined mechanically and not yet allowed to develop on their own as a semi-independent (or interdependent) discursive medium. Seriality first gave to photography new vigor as a pseudoscience (setting the stage for, among other things, pictorialism's rejoinder with various blurring techniques giving new vigor to photography's status as a pseudo-art) and served as linchpin in what Allan Sekula once called photography's "philosophical shell game." From the beginning, as he put it, photography has been peculiarly "haunted by two chattering ghosts: that of bourgeois science and that of bourgeois art." Its primary ideological function is to produce "the apparent reconciliation of human creative energies with a scientifically guided process of mechanization" by ever-swapping one shell for the other, one chattering ghost for the other.[41]

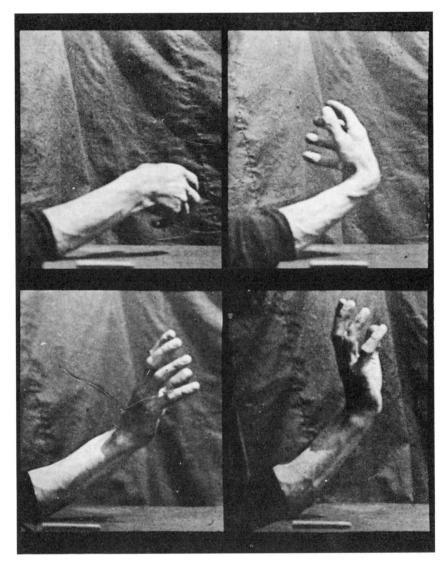

Figure 8
Eadweard Muybridge, *Movement of the Hand; Beating Time*, ca. 1884–1887, detail of frames 3, 4, 9, 10. George Eastman House, Rochester, N.Y.

6

While the door was open for the photographic essay to develop, the tension between conceptual and aesthetic understanding of serial form could not emerge without a poetic alternative to contradict photography's new role as pseudoscience. What Muybridge and his colleagues had achieved was a parsing of experience into analytical segments; what was needed in response was for those segments of experience to be sutured back together again into an affective unity or common thread of feeling or being. This was achieved in various ways, most prominently in theory by Henri Bergson and his many followers and most significantly in practice by film.

Serial photography has regularly been said to be like film or to be a precursor to film. The experience one gets in the movement from one image to the next to the next to the next, in a Muybridge series, for example, has routinely been understood to be cumulative, to develop as a synthetic experience of continuous time. "Each sequential element is perceived not next to the other," as one classic account of film form has it, one that has also been used to explain the workings of the photographic essay, "but on top of each other. For the idea (or sensation) of movement arises from the process of superimposing on the retained impression of the object's first position, a newly visible further position."[42] This routinely assumed conflation of the photographic essay with the prehistory of film is misleading and collapses one distinctive historical formation into another.[43] The similarities between the two forms are clear, but the idea and sensation of movement associated with film were, in fact, very different in kind from those offered by serial photography. We need only point out, for example, that the photographic essay is different from film precisely because it does *not* place each subsequent image on top of that which comes before it, that each image in the series, each instant in the representation, is preserved rather than being displaced by its follower.

We can put this difference most starkly with a simple comparison. A composition of still photographs in principle can be arranged into essay form in the manner outlined above—one that is "radical in its nonradicalism," radical because it refrains from "any reduction to principle" or "system" or "method," as Adorno put it—by entering into a dynamic rela-

tionship that gives its truth only in the process of the unfolding. Film, on the other hand, by its eighteen or twenty-four frames per second, its slow or fast motion, its freeze-frames, its material-temporal form, *cannot*—for film as a form is inescapably beholden to a rigid expository structure, to the succession of one frame after the next and the next and the next. In the words of one thoughtful scholar of the emergence of film form, it systematizes and structures "life itself in all its multiplicity, diversity and contingency," and in so doing, that multiplicity, diversity, and contingency are "given the crucial ideological role of representing an outside," a "free and indeterminable" relation to time that serves as the "paradoxical basis of social stability in modernity."[44]

The motion of film through the projector thus unavoidably takes on a function above and beyond that given by the movement of the essay: it gives rigid form to time and set temporality to form, and this addition endows film form (regardless of how plastically it is conceived, regardless of the degree to which other forms of time—narrative time, the time of the film crew or actors, the original temporality of the film itself—are challenged) with the radicalism that Adorno called system, principle, and method. The film viewer is given a set, invariable chunk of time that is divided up and rewoven, first spatialized and then retemporalized, according to the filmmaker's or editor's system or method. What the viewer receives is a packaged composition of time, a pictorial, window-on-the-world expression of the experience of time.[45] Adorno makes the same point by comparing the achievement of film to one of its literary contemporaries: "The less dense reproduction of reality in naturalist literature left room for intentions: in the unbroken duplication achieved by the technical apparatus of film every intention, even that of truth, becomes a lie."[46]

Film, in short, limits the performative unfolding made available in the photographic essay by its mechanization of the unfolding itself. Whether it wants to be or not, film makes itself over into a one-sided conversation—as we will see below—by collapsing the analytical, atemporal space opened up by the abstraction of serial photography back into a false synesthetic naturalism of time.[47] What is lost in this suturing is the moment of science, the moment of opening up the space between subject and object, between hypothesis and empirical investigation, between theory and praxis, or the space that opens to the investigation of existing habits

of perception. What is lost is the investigation into the hidden structures of movement through space and time, hidden factors available only to the analytical gaze of scientific method.

The key difference between serial photography and film can be understood by looking at what motivates the seriality in each. In the first attempts to use serial photography to capture motion and narrative sequence, the aim was not to reproduce life as experienced in time but instead to see what cannot be seen by the naked eye, to see what can be seen only when time is stopped. Muybridge's study of a horse gallop is the foundational case in point: the camera was brought in to give visual testimony to what the eye on its own could not see by disarticulating the sequence of events, by breaking the narrative apart into discrete moments, into discrete photographs. Such abstraction, of course, is the province of science and the partitioning of time made available by still photography that allowed the close and detailed analysis of the sequencing from frame to frame, and that mechanically amplified "the power of our sight" as applied to the depiction carried within any individual frame would realize its most significant purpose in scientific management or Taylorism. The stop-action and action-trace capacity of photography could break movement down into its constituent parts and flows and chart those movements so that parts and paths through space and time could be renarrated or rechoreographed by being put back together in better, more fluid, and efficient systems of labor and organization, systems that were clearer and more focused in their sense of purpose.

This rationalization of vision in the systematic photographic series developed by Muybridge, Marey, and others and its later industrial applications thus gave form to one side of a divide or debate over how the experience of time and space was to be best understood. That side argued for the mechanical, analytical understanding of movement, for breaking it apart into its constituent parts—its frames, as it were—and charting those individual, abstracted parts like points along a curve. Each point, each frame, was thus available to analysis because it had been frozen by the camera and the collection of points mapped as an itinerary. There it could succumb to a calculus, an analytical derivation of the conflict of the various innate and environmental determinants that animated its movement through time. There it could succumb to a rationalization of the lived experience of time as it has been analyzed endlessly by Foucault and his followers.

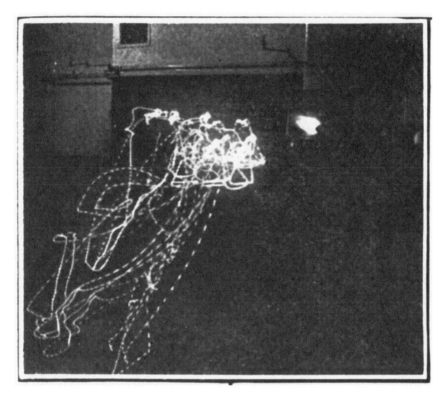

Figure 9
Typical Chronocyclograph of the Motion and Fatigue Study of a Bricklayer, Laying Three Bricks in the Old Method. From Frank B. and Lillian M. Gilbreth, *Fatigue Study: The Elimination of Humanity's Greatest Unnecessary Waste: A First Step in Motion Study*, 1916.

The other side of this divide, the side that can be broadly identified with film rather than photography, sought to counter what one commentator has called the "spatialized duration," or the stopping of time so that the spatial coordinates and material conditions of one instant can be examined in depth.[48] In lieu of the series of frozen instants, this second side, the side given by film, sought to posit an alternate account of the experience of movement and duration that understood its meaning and vitality as a function not of the analyst's charting the coordinates of movement through space but instead of the vitalist's reanimating of those coordinates in time, of representing movement as flows and patterns of time by experiencing them as energy rather than as the effects of energy given in the transition from one frozen instant to another, one point in space to another.

Figure 10
Marcel Duchamp, *The Passage from Virgin to Bride*, 1912. Museum of Modern Art,
New York. © 2004 Artists Rights Society (ARS), New York/ADAGP, Paris/Succession,
Marcel Duchamp.

The photographic essay was born of the promise of another kind of truth from that given by the individual photograph or image on its own, a truth available only in the interstices between pictures, in the movement from one picture to the next. At the moment when photography became film, however, a new question opened up that threatened to undermine its promise before it had even really emerged: How best to realize that movement? How best to develop the truth content of the exposition itself? Would it be with the spatialized time of the photographic series or with the retemporalized space of film as a form? The leading icon of the broad-based critical response to the photo-scientists like Muybridge and Marey, the photo-engineers like the Gilbreths, and the legion photo-essayists that would come was Bergson, and his inspiration carried far and wide in the literary and artistic culture of the first decades of the twentieth century.[49] So, too, this critique was evident in the work of many of Bergson's heirs: in Duchamp's famous pastiches of the chronophotographic and chrono-cyclegraphic methods (most notably in the work done during the period of his *Nude Descending a Staircase* series), for example, or in the work and writing of that other greatest visual symbolist of things-in-motion, Umberto Boccioni: "Any accusations that we are merely being 'cinematographic' make us laugh—they are like vulgar idiocies. We are not trying to split each individual image—we are looking for a symbol, or better, a single form, to replace these old concepts of division with new concepts of continuity." Boccioni was clear about his debt to Bergson on this pursuit of singular expressions of continuity and equally clear in his choice of quotations for his critique of the likes of Muybridge and Marey: "Any dividing up of an object's motion is an arbitrary action, and equally arbitrary is the subdivision of matter. Henri Bergson said: 'any division of matter into autonomous bodies with absolutely defined contours is an artificial division,' and elsewhere: 'Any movement viewed as a transition from one state of rest to another, is absolutely indivisible.' "[50]

The problem was what Bergson called "social life," or the abstraction of experience into socially and culturally determined analytical categories. That "which is commonly called a *fact* is not reality as it appears to immediate intuition," he insisted, for example, in his brilliant *Matter and Memory*, "but an adaptation of the real to the interests of practice and the exigencies of social life."[51] Philosophy, like science itself and the scientific or pseudo-scientific photography of Muybridge and Marey, carves out discrete, socially

defined concepts, facts, and images from the continuous flow of experiential reality: "Scientific thought, analyzing this unbroken series of changes, and yielding to an irresistible need of symbolic presentment, arrests and solidifies into finished things the principal phases of this development. It erects the crude sounds heard into separate and complete words, then the remembered auditory images into entities independent of the idea they develop."[52]

What philosophy (and representation generally) was to do under Bergson's lead thus was to "get back to reality itself," that is, to retemporalize experience or put back into fluid motion that which had been broken apart into discrete parts or put back into time that which had been spatialized and therefore to redeem experience from the abstraction it has suffered in the hands of reason.[53] In so doing, the modern subject would benefit from a kind of redemption, a regrounding in the world: "Subject and object would unite in an extended perception, the subjective side of perception being the contraction effected by memory, and the objective reality of matter fusing with the multitudinous and successive vibrations into which this perception can be internally broken up." Truth, as he would have it, becomes the experience given to the perceiving subject in its most immediate, unarticulated form if one approaches that experience under the rule of one methodological principle: "Questions relating to subject and object, to their distinction and their union, should be put in terms of time rather than of space."[54] This temporalization was the theoretical underpinning of the false naturalism that would be given form by film.[55]

At issue dividing Marey and Muybridge's "spatialized duration" from Bergson *durée* or retemporalization of fragmented space was how experience was to be given to knowledge. What, in other words, was to be the experience of the representation of experience? Was time to be stopped, divided, distributed, and analyzed in a laboratory setting to prepare for some future reconstitution of the whole out of its component parts? Or was it to be experienced anew as its own entity reborn as a flow unto itself never visible as such, in a "state of rest" or any time a single frame becomes discernible?[56] Was it, in other words, to be the stilled, spatialized domain of photography or the retemporalized domain of film? What was gained and what lost by the temporalizing of still photography, by introducing the "idea (or sensation) of movement aris[ing] from the process of super-

imposing on the retained impression of the object's first position, a newly visible further position"?[57]

Serial photography was conceived from the beginning as an analytical project, and from the standpoint of the photographic essay, the filmic weaving together of eighteen or twenty-four individual photographs per second set that project back rather than advancing it. Marey was adamant on this point already in 1899: "Cinema produces only what the eye can see in any case. It adds nothing to the power of our sight, nor does it remove our illusions, and the real character of a scientific method is to supplant the insufficiency of our senses and correct their errors."[58] Filmic time can be slowed and altered in any number of other ways, of course. But insofar as it continues to be film (and does not come to a stop, that is, to the condition of still photography), it gives in its form the principle and the experience of time. Time thus occupies the role of an unavoidable formal principle for film regardless of whether that temporality is somehow naturalistic or not, and in so doing it reproduces a specific illusion in the association of filmic time with lived time. The detail given in each frame of film is subordinated to the temporal hegemon of eighteen or twenty-four frames per second with each frame relentlessly giving way to the next and the next and the next in a singular naturalized temporality.[59]

7

The photographic essay is thus a form that holds onto the opening up of time, the "spatialized duration," given by the experiments of Muybridge and Marey. It draws its meaning from the back-and-forth interrelation of discrete images that is eliminated when those images are sutured together into film. The photographic essay form also relies on—and draws its meaning and purpose from—a similar opening up of space into discrete and differentiated units.

The root of this formal principle is drawn from the same period and can be seen in the foundational social photography of Jacob Riis. This quality in Riis's work—primarily, its division of space into that of our half and that of the other half—has often been the hardest part of his work to reconcile. For example, his legacy, as one reviewer had it in 1995, is often assumed to be found in a tradition of "heart-rending images that transform the poor from faceless abstractions into human beings, just as his own did in the 1890s" or his work is critiqued for not achieving this transformation.[60] Riis

himself, however, provided a more accurate account of the affective and aesthetic appeal of his undertaking, one that has no truck with such heart-rending humanization. "The beauty of looking into these places without actually being present there," he wrote, "is that the excursionist is spared the vulgar sounds and odious scents and repulsive exhibitions attendant upon such a personal examination."[61] The beauty on offer, the aesthetic experience given by the pictures, in other words, was assumed by Riis to be a function of the beholder's experience of distance from the slum dwellers and the squalid conditions in which they live rather than that of transforming them into "human beings" on par with the viewing audience. What Riis offered by his own account was a kind of abstraction: an armchair beauty, a pictorial beauty, a shocking beauty packaged for a respectable class with the bright surface sheen of safe distance given by the medium of photography itself. It was, in short, an abstraction of the other—a making "faceless" of the poor—not a humanization, and this spectacularization wrought with the gaze of the comfortable classes in mind reinforced rather than ameliorated the divide between our half and theirs, between the propertied and the propertyless, given already from the start in Riis's celebrated title, *How the Other Half Lives*.

As we might well expect, Riis's publisher understood this clearly enough, at least if we judge from how the book was promoted. "No page is uninstructive," the press release acknowledged grudgingly with a double-negative setup for what it really wanted to say, "but it would be misleading to suppose the book even tinctured with didacticism. It is from beginning to end as picturesque in treatment as it is material." Indeed, according to this short pitch to the book-buying customer base, while Riis admittedly could be understood as "a philanthropist and a philosopher," more importantly he was, "in a word," an "artist" as well.[62] Riis, it would seem, had no problem with such characterizations. Photography, he wrote at a later date, should not be explained in terms of "formulas, learned, but so hopelessly unsatisfying" in the manner of, for example, the scientist's "butterfly stuck on a pin and put in a glass case." Such classification on its own misses something fundamentally truthful about the butterfly available not in the Latin of the scientist but instead only in the butterfly's own language. The scientist cannot know this language—"Only the poet does among men."[63]

There are many ways to be both "not uninstructive" (or carry a didactic message) while still being an artist working in the realm of the picturesque,

Figure 11
Lewis Hine, *Spinner in a New England Mill*. Courtesy George Eastman House.

of course. In the end, it might be said, it all depends on how the photographer works the sympathies of his audience, how he produces the poet's experience of knowing the language of the butterfly, or other object of his photographic gaze. In one way or another, such has always been the mission of social photography. For example, a photographer can seek out children as signs of vulnerability and generally sympathetic subjects, and the beholder is likely to respond in a knowing way as someone who has young children or siblings or friends. In so doing, the experience that is given is that of the "poet," in Riis's terms, rather than the scientist's formula or a subjective experience rather than an objective one. Or the photographer can develop a personal relationship with his subject long enough to cultivate a sympathetic exchange of knowing or mutually respectful looks, or seek out signs of prideful and productive orderliness of daily life, as was the habit of Lewis Hine. Here the relative strength of the subjects photographed is measured against the demands of the world they live in, and sympathy is cultivated relative to their degree of autonomy. (Hine's photographs of child laborers from the first two decades of the twentieth century can be compared in this regard with his heroic images of industrial workers from the 1920s and 1930s.) In so doing, the beholder is called on to take up a sympathetic and responsible relationship to the subject photographed in the manner of a parent or benefactor, to sympathize though a process of judgment that calls the viewer to assess and to aid, if necessary, the photographed subject.

Or, on the contrary, a photographer can seek out signs of plainly evident human suffering in the manner often preferred by Dorothea Lange, say, or W. Eugene Smith or Sabastião Salgado or many, many others. Raw expressions of emotion, bodies writhing in pain, dead and dying bodies, undernourished or sick bodies, cracked and worn hands, feet or face, signs of war or other forms of active, immediate violence—any form of bodily, affective expressiveness is very effective in a natural, immediate, and human manner at drawing a viewer to sympathetic identification. Indeed, it is routinely through bodily expressiveness, through gesture of various kinds regardless of whether it indicates sickliness (often preferred by the documentary tradition) or vitality (typically the domain of advertising), suffering or joy, that processes of identification take place between the viewing subject, the photographer as subject, and the subject photographed. It is through gesture, through bodily movement, for example,

Figure 12
Jacob Riis, *A Flat in the Pauper Barracks, West Thirty-Eighth Street, with All Its Furniture*, from *How the Other Half Lives: Studies among the Tenements of New York*, 1890.

that the beholder can best mimic or imagine undertaking the same action with sympathy and that a shared sense of humanity and identification between viewer, photographer, and subject is most forcefully given form.

By contrast, the off-putting abstraction, or distancing or othering in Riis's images is dramatic. Because his work predates that of Hine and the tradition that follows, it is often assumed that Riis's humanism (or that of his period) was somehow not so advanced, that he was able to represent suffering well enough, but in retrospect, he fell short on representing the common humanity of those who suffer.[64] We can put this as a question: What is the relationship between the photographer and her subject, or, put more generally, what is the relationship of representation as human-izing identification to representation as dehumanizing abstraction given in the relation of photographer-subject to photographed object? Ethnographic photography, medical and scientific photography, criminal and surveillance photography, pornography and photographic erotica, tourist photography, even journalistic and documentary photography gen-erally have all been scrutinized for the gaze given by the camera and the exercise of power it realizes. In the radical form of this argument, subjectiv-ity is assumed to be the site of power and authority, and in the photo-graphic relation, it is the privilege of the photographer. Objectivity or object-ness is the position given to that which is photographed, and the scientific and pseudoscientific pursuits outlined above lend themselves to properly social forms of the exercise of power. Thus, Muybridge and Marey are assumed to pave the way not only for film but also to Taylorism and Fordism by further enabling the processes of alienation that turn workers into machines; or Sir Francis Galton and Duchenne de Boulogne are under-stood to lay down the conceptual bases not only for visual classification in medicine but also for the racial classification of Mengele and Himmler.

Such critical accounts of photography's role in the development and exercise of power are correct, certainly, and a version of such an argument will be taken up in more detail in the next chapter. What I want to empha-size here, however, are Riis's efforts to bar the expression of humanity from his pictures, to bar the subjectivization of the other half. This was achieved by his particular photographic and presentation techniques and achieved a partitioning of the experience of time, and particularly of space, into social categories. The primary distinction is between our space—assumed

to be that of the salon—and the space of the other half—assumed to be the space of the tenement. Time too is partitioned. First, there is the distinction between the two halves: the assumed temporality of the property-owning classes—that is, in perpetuity—and the day-to-day temporality of the other half. That second temporality is further partitioned in a way that the first is not: into the two cents per night for the warmth of an all-night tavern or the five cents for a bunkhouse bunk. In so doing we are given a clear sense of the lived spatial and temporal conditions of the other half, and that sense of space and time is given clear class coding. Riis is rigorous in forcing his subjects to conform to that spatiality and temporality by not allowing their humanity to emerge, rising up to mingle with ours, and thereby transcend their lived conditions. With the flash-frozen and stolen image, the subjects photographed were given no opportunity to orient themselves to the camera, and their organization in space and time presented itself strictly as a function of those conditions rather than by the subject's self-presentation or even being organized according to the conceptual frame of the observer. As one historian has characterized it, Riis's photographs are "a catalog of individuals crushed by narrow alleys, of people clustered tightly while working in dilapidated rooms, of individuals thrust into the darkness of tenements."[65]

As we look into the sense of space and time represented, our view is forced away from the humanity of the subjects photographed that would transcend the world they inhabit and away from the humanity of our own gaze upon them that would share in that transcendence outward to the environmental conditions in which they live. In so doing, both gaze and object of the gaze are rendered discrete—our half and the other half—abstract, quantifiable, and analyzable. Quality of life is given a measure, and the distance between our half and the other half takes on material analytical form. Giving this point of view a historical register in the opening paragraphs of *How the Other Half Lives*, Riis cites a 1857 report to the legislature: "As business increased, and the city grew with rapid strides, the necessities of the poor became the opportunity of their wealthier neighbors, and the stamp was set upon the old houses, suddenly become valuable, which the best thought and effort of a later age have vainly struggled to efface. Their '*large* rooms were partitioned into *several smaller ones*, without regard to light or ventilation, the rate of rent being lower in proportion to space or height from the street; and they soon became filled

*Tenement of 1863, for twelve families on each flat.**
D, DARK. L, LIGHT. H, HALLS.

Figure 13
Jacob A. Riis, "TENEMENT OF 1863, FOR TWELVE FAMILIES ON EACH FLAT. D. dark. L. light. H. halls," from *How the Other Half Lives: Studies among the Tenements of New York*, 1890. Courtesy Museum of the City of New York.

from cellar to garret with a class of tenantry living from hand to mouth, loose in morals, improvident in habits, degraded, and squalid as beggary itself.' From this criminal greedy development and poor planning emerged the central locus of the modern social world: "It was thus the dark bedroom, prolific of untold depravities, came into the world."[66]

Within the received tradition of social photography, the critical-analytical value of such abstraction is often lost from view, and the appeal to the humanity of the photographed subject shared in common with photographer and viewer comes to the fore as a criterion of success. In this account, either Hine's methods are given critical leverage over Riis's, or the bald inhumanity of Riis's photographs is lost to a false projection. The loss of this inhuman abstraction is the loss of an index of history, the loss of a manner of historical consciousness: "Even the most abstract categories, despite their validity—precisely because of their abstractness—for all epochs, are nevertheless, in the specific character of this abstraction, themselves likewise a product of historic relations, and possess their full validity only for and within these relations."[67] Or, as one latter-day commentator put it more succinctly, "The essential economic relations are those which underlie and express themselves in the form of class conflict. These are the essential elements that must be isolated and analyzed through the method of abstraction."[68] What bourgeois abstraction provided that bourgeois humanism could not is the expression of the underlying essential economic relations in the form of class conflict, whether it wanted to or not. The dark bedroom, or shelter, or tavern rented for a few cents per night or a few dollars per week, "prolific of untold depravities," served Riis as the site of that abstraction, as the expression of the essential elements that needed to be isolated and analyzed.

8

Riis thus can be seen to be a social photographer in ways that Hine and many of his followers cannot: as an abstractionist, as someone whose primary aesthetic impulse was to break apart the visual social world he looked upon into discrete analytical categories—dark rooms and light rooms, our half and the other half, life analyzed and life lived—rather than with the aim of using sympathy or empathy to suture together each scene photographed into a humanity common between subject, photographer, and audience alike. In this sense, Riis was fully a product of nineteenth-

century system building, of knowledge as power, of Foucauldian discourse and archive in a way that Hine was not. His was an analytical, sociological vision, a vision that arose out of his work as a police reporter and was fully compatible with the new criminological methods emerging along his side.

That said, Riis was also deeply antipathetic to this model of knowledge on its own. He was a "poet" and an "artist," he said, and, as he complained, for example, to Lincoln Steffens, "The day of scientific method has come, and I am neither able to grasp its ways, nor am I wholly in sympathy with them. Two or three times a week I am compelled to denounce the 'sociological' notions of the day and cry out for common sense."[69] His common sense, however, was complex. While he had no sympathy for isms of any kind and "no stomach for abstract discussions of social wrongs," his understanding of those wrongs was no simple ethical judgment either.[70] Neither flatly moralistic nor flatly sociological, Riis's understanding was based on a rich sense of the social, one that has rightly been characterized as aesthetic, and it was this pictorial sensibility, the distance provided by his vantage point situated securely in the bourgeois salon, that afforded that richness.[71] The view he provided studying tenement life from the salon was one of the metropolis as a whole. He described the city's other half to his privileged audiences as the bowels of a larger organism visible only from a distance, from the cerebral and sentimental space of the salon itself, the heart and mind of the larger metropolitan organism, rather than something that could be comprehended by close inspection of only a few newsworthy case studies, a few dysfunctional or diseased parts. The dark bedroom, like the salon, could not be imagined or understood on its own but had to be conceived of as constitutive of a larger social organization.

The problem for representation was "the mad whirlpool of feverish metropolitan life in which only the sum, not the individual counts," and seeing that sum, getting a picture of the whole, was his task as photographer and journalist.[72] "These," he told his bourgeois readership in tantalizing salon form, "are the sights to be encountered there" in the bowels of the other half: "The sultriness of those human beehives," the tenements, "with their sweltering, restless mass of feverish humanity; the sleep without rest; the silent suffering and the loud; the heat that scorches and withers, radiating from pavements and stone walls; the thousand stenches from the street, yard and sink; the dying babies whose helpless wails meet with no

Figure 14
Herbert Bayer, exhibition viewing design diagrams from his *Fundamentals of Exhibition Design*, 1937, reproduced in his preface to Erberto Carboni, *Exhibitions and Displays*, 1959.

comforting response; the weary morning walks in the street, praying for a breath of fresh air for the sick child; the comfortless bed on the flags or on the fire-escape."[73] Indeed the scourge was taking over and threatening the larger social fabric: "Where are the tenements of to-day? Say rather: where are they not? . . . The tenements to-day are New York, harboring three-fourths of its population. When another generation shall have doubled the census of our city, and to that vast army of workers, held captive by poverty, the very name of home shall be as a bitter mockery, what will the harvest be?"[74] It was this "very name of home" that was at stake for Riis, and he tried to make that clear to his audience. Home was soon to be awash with the "sea of a mighty population." Mixing his metaphors and playing his crowd, Riis insisted that this mighty sea and "the swell of its resistless flood" were held in check only by the "galling fetters" of the tenements, and these restraints would not hold. The gap between the classes in which rage flourishes, "widening day by day," had to be bridged, Riis concluded, by "a bridge founded upon justice and built of human hearts."[75]

What Riis wanted for his social photography was a model of experience that, as he says in his opening lines to *How the Other Half Lives*, "ought to be worth something to the community from which he drew it, no matter what that experience may be." That experience was drawn from two communities conceived as one—from Riis's half looking on from the comforts of its salons and from the other half in its dark, airless taverns, shelters, and tenement bedrooms. The commonality of that experience was not figured as a homogenous humanity in the manner of Hine and his followers, but instead as a form of tension seeking out reconciliation. There was a swooning quality to this experience, but it was not a swoon of empathy or sympathy, a swoon of being awash in a sea of mutual humanity. Instead, what was given was a sense of self and a sense of otherness, a sense of our half and the other half bound together by a common economy. It was an economy of affect, for sure, an economy of rage and of fear, of defensiveness and of a sense of having nothing to lose, but it was also an economy of space, of comfortable salons and uncomfortable tenements. Insofar as it involved the production of otherness, it was also an aesthetic economy of abstraction. Social tension between the bourgeois half and the other half needed to be given avenues of expression, and giving form to that expression as aesthetic experience was Riis's goal. Political subjectivity was given in his social photography as the experience of the welling up of the

"untold depravities" of the horde in the dark, airless tenements and those impulses being accepted, accommodated, and somehow redirected in the genteel space of the salon.

All aesthetic experience involves the channeling of some manner of tension or energy between the beholding subject and beheld object. But unlike the channeling of libidinal energies inward into the individualized experiences of sympathy and empathy by the humanist tradition in photography, the paths of energy and identification given by Riis reached outward to social identifications. The narrative time of that transfer of energy was spatialized, and its spatial divide was never transcended through the production of a common humanity. The beholding subject and the object beheld, as they would come to be later developed in the modern propaganda form, were interpellated as social forms, as classes, as specific positions within the larger social order and the relations between subject and object, like Riis's relation between the two halves, would come to be a primary plastic medium of the genre. The placeholders for this distinctive form of channeling were initially derived from the abstract partitioning of space and time of Muybridge and Marey. Once abstracted into discrete serial units, those units could abandon their strictly analytical function and be put back together into new narrative and economic forms.

What the very different abstractions of Muybridge and Riis provided was a relationship to the world not subordinated to a timeless humanist universalism as it would become in Hine and his followers, or to an unstoppable, indivisible temporal unity in the manner advocated by Bergson and realized in film. What serial form provided was the experience of the partition itself, the experience of difference rather than sameness, the experience of differential form rather than synthetic form. Both the all-encompassing timelessness of humanism and the all-encompassing "timeness" or temporalization of film served to subjectivize representation; they rendered the experience of representation mimetic or equivalent to the experience of temporalities of subjective experience itself. Serial photography, when it is was experienced as such and not as still photography or as film, pushed representation toward objectivity rather than subjectivity, toward lived sociality rather than lived individuality, by distancing itself from the temporalities of personal experience. By spatializing the representation of experience, it forced an articulation of change and continuity from one picture to the next while still holding both in view as static, independent entities. In so doing, the photographic essay rent an

analytical partition into the we're-all-human experience of unity and the it's-all-flow experience of continuity, thereby posing a very different model of being in the world than that being developed by Bergson and elaborated in film and that carried forward by the humanist photography of Hine and his followers. Instead of merging with the world, the beholder moved from one fixed image to the next, from one circumscribed social space to the next, from one bounded class perspective to the next, in a way that never lost sight of the structuring partition in between. In short, the photographic essay understood as a way of looking at the world rendered experience analytical rather than mimetic. In so doing, it socialized representation rather than nationalizing it and collectivized the form of belonging rather than individualizing it.

9

The promise of retooling the relationship between overall structure and individual detail in artistic form and with it, by homology, reimagining those same relations in social form—between the viewing subject and the social world they inhabit—is nothing new or exceptional. This is one of the plastic means that artists and their patrons have at their disposal and one ambition that reoccurs regularly in the history of art. Ultimately this is art's modern claim to exceptional status, its claim to genius or universality, its claim to be art. The formal means for such retooling is as much the province of film and of all time-based media (which use the balance of detail and structure to develop rhythm, pacing, narrative, and timing) really, as it is the province of photography, painting, and other plastic arts where relations of figure to ground, deep to shallow space, highlight to shadow, thick media to thin, fine detail to overall form, can be worked to develop different sensations, sensibilities, moods, and understandings of the experience of being in the world. Indeed, such is potentially the province of any representation. What counts is only the hubris to make it stick, the claim that says to the beholder, "This is a representation of social form," this is the revolution, the new man, the modern, this is a new way to be in the world or an affirmation of an old way. The question, for our purposes here, concerns the system or structuring principle that gives such form as technique, that coordinates particular to general, fine detail to overall plan, and the social imagining that dwells there.

From the beginning, the photographic essay assumed a dynamic of serial relations between pictures that inscribed patterns of embodied looking for its beholders. The beholder, it was thought, like the photographer, had to imagine herself in the world, moving from this space to that, from the comforts of the salon to a grim, unilluminated tenement bedroom and back again. Turning the beholder's attention this way and that, from a focus on deep space to shallow space, from dark to light, from overall form to fine detail, holding onto the differential moment between pictures, the serial form engaged the beholder differently in its movement from picture to picture than the single Renaissance image had or than film or humanist photography would in its turn. Rather than a simple identification with the image of the other, a simple replacement of one image by the next and the next and the next, the movement of the beholder's eye, head, and body in the interstices between pictures came to be a central factor in the design concept as the photographer or exhibition designer came to orchestrate those patterns of bodily movement and with it the affective range of responses. As Edward Steichen would put it about his *Family of Man* exhibition, while photography was a "great and forceful medium of mass communication" on its own, it could be greatly enhanced by working the relations between pictures where "resources are brought into play that are not available" otherwise: the "contrast in scale of images," for example, "the shifting of focal points, the intriguing perspective of long- and short-range visibility with the images to come being glimpsed beyond the images at hand—all these permit the spectator an active participation that no other form of visual communication can give."[76]

The three projects to be studied each grappled with this set of terms in different ways. The two later projects responded directly to the first, and all three shared a common ambition: each set out to collect images from the world that were elemental to any postwar political ideology—images of common human emotions and desires in the one, images of entrenched local strongholds and resentments in the next, and images of aging icons of modern social progress in the last—and experiment with new forms of belonging by rearranging and reorganizing those elements. Each in its own way understood political identity to be a system that manages the tensions and synergies between its constituent desires, resentments, and ideals, and all three drew much of their aesthetic qualities and ambitions from that understanding. Each in its own way sought to address the fantasies and

phobias so present from the prewar past—the Enlightenment ideal of progress, for example, or simple hatred, xenophobia, and chauvinism, or the amoral technological progress that had made itself available to the gas chambers and the atomic bomb—by imagining them as active voices in artistic arrangements that were to serve as models for the political identities of the emerging postwar present. Each constructed "a complex of concepts interconnected in the same way it imagine[d] them to be interconnected in the object," that is, in the world.[77] Each created an arrangement of photographs that itself served as a homology for imagined social form.

The operative aesthetic experience that provided the sense of lived sociality for each of the three projects studied here was located in the movement—the pivot—from one image to the next, one moment to the next, one form of social imagining to the next. In this way, each sought to use its particular means, its particular sensitivities and expertise, to work through the problem of political subjectivity—the problem of how to belong in the world and how to constitute new forms of such belonging. In this way, they were of their shared moment, itself a pivot or transitional instant that allowed for rare openness to big philosophical questions, questions that it might be said can only ever be addressed at such historical turning points. The "most intimate vibration of our psycho-physical being already announces the world," is how Merleau-Ponty described this sensitivity at the close of his *Phenomenology of Perception*, for example.[78] It is a measure of the projects studied here and the moment that gave rise to them—a measure of their distance from our own moment now—that not only could that most intimate vibration be sensed at all, much less dwelled in, but that it would be given any credence in the first place. "For what else can there be (says everyone) *besides* representation?" notes one commentator about the obsolescence of this perspective. "What could" it possibly mean "to represent representation's opposite—'lived experience,' for instance, or 'imagination,' or, worse still, 'poetry'?"[79] In just a few short years, the externality of the sensation Merleau-Ponty described would be reinternalized, the world kept out and the self in, and the minor disturbance of social form announced by a minuscule vibration from the deep recesses of being, if it registered at all, would be dismissed (competing for the beholder's attention as it was with all varieties of commodified experience including, without doubt, far too much Coca-Cola) as little more than mass-cultural gas.

Photographic Being and *The Family of Man*

The Family of Man has long been something of a chestnut for historians and critics of photography. Roland Barthes, Allan Sekula, Christopher Phillips, and others have shown convincingly the various ways in which the exhibition was, despite its magnanimous goodwill, flatly ideological and politically opportunistic. Sekula described it in 1981, for example, as "an aestheticized job of global accounting, a careful Cold War effort to bring about the ideological alignment of the neo-colonial peripheries with the imperial center."[1] He and the others (together with those who have worked more broadly on the Museum of Modern Art's [MoMA] cold war programming) have provided a substantial body of research supporting such a large claim for the political imbrications of what was, after all, merely a photography exhibition and, in several key respects, an unexceptional one at that.[2] Indeed, this body of research has been so compelling and the exhibition itself has come to seem so banal, so institutional, so implicated in the mass-cultural dynamics of its period for such a long time now that even considering its status as art in any of the usual modernist or other senses has seemed something close to absurd, if not simply unimaginable.[3]

For example, the aestheticization that Sekula concerned himself with in his landmark essay has been assumed by all the critical commentators without exception to be of the type associated with *Life* magazine, say, or maybe *National Geographic*, or better still, that of *Family of Man* sponsor Coca-Cola's monthly publication, *Coca-Cola Overseas*. The exhibition has embodied for all of the more critical accounts what Phillips calls the "familiar mass-cultural phenomenon whereby very real social and political anxieties are initially conjured up, only to be quickly transformed and furnished with positive (imaginary) resolutions" and not the more typical (high-

cultural) MoMA fare of surrealism, for example, or abstract expressionism, or even of the appropriations taken from *Life* and *Coca-Cola* and similar sources that were the mainstay of the leading artistic movements that developed alongside *The Family of Man* during its planning in the early 1950s and its decade-long exhibition run from 1955 to 1965.[1]

From the beginning this critical thinking has typically assumed the rhetorical structure of Jacques Barzun's 1959 review. "*The Family of Man* gave visual pleasure coupled with a philosophy of life," he began graciously enough before cutting back to his real concern—that the "ground of that philosophy is best indicated by the cant phrase 'the human condition'"—and relegating the question of visual pleasure that had been allowed equal measure in his gambit to mere courtesy.[5] As one art historian said to me not long ago about *The Family of Man*, for example, one who is well known for his fresh insights into the coupling of visual pleasure and life philosophies in well-trammeled topics, "We already know about that."

One common assumption about the exhibition's success underpinning most of the criticism is that it relied on just the sort of middlebrow candyfloss that liberal bourgeois culture has always been made of—allusions to common joys and sorrows, accomplishments and traumas—that its visual pleasure merely reaffirmed the time-honored petty bourgeois life philosophy of a sentimental, expressive, and essentially private subject, a subject who experiences herself housed in the family structure and at a mythical remove from any day-to-day, nine-to-five calculations of the marketplace or street. The "bleat" to "not forget humanity," as Adorno once characterized the moral claim of this subject, has long been a staple for the scorn of cultural criticism, and that scorn can come easily and appropriately when considering *The Family of Man*.[6] This critique did not emerge with Adorno or in response to the exhibition or with the midcentury mass culture debate, however, but instead has been central to modernity from the beginning. Hegel could complain with equal scorn in 1807, for example, that the "heart-throb for the welfare of humanity" is always inadequate and misguided as a form of critical consciousness and, by definition, inevitably devolves into cynicism and despair. By overreaching with sentiment as compensation for abandoning reason, he argued, the liberal's bleeding heart enters into an endgame and "passes into the ravings of an insane self-conceit, into the fury of consciousness to preserve itself from destruction." It attempts to be rid of the contradiction between its

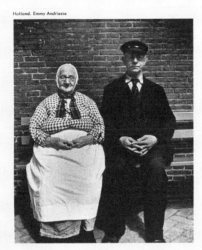

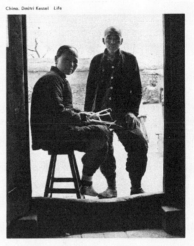

We two form a multitude.

We two form a multitude.

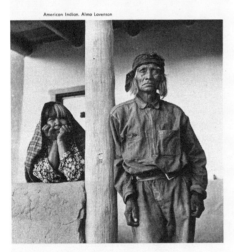

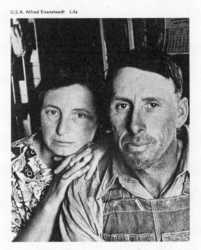

We two form a multitude.

We two form a multitude.

Figure 15
"We two form a multitude" spread from the book version of *The Family of Man*, 1955.

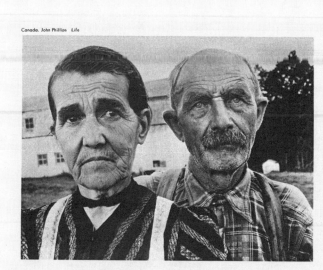

Canada. John Phillips Life

We two form a multitude.

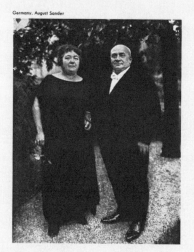

Germany. August Sander

Sicily. Vito Fiorenza

We two form a multitude.

We two form a multitude. Ovid

183

Figure 15
(continued)

workday desk chair actions and its after-hours armchair sentiments by "expelling from itself the perversion which it is itself, and by striving to look on it and express it as something else." The instrumental reason of commerce and politics is thus cast off from the aesthetic and moral response as "a perversion of the law of the heart and of its happiness, a perversion invented by," it imagines, "fanatical priests, gluttonous despots and their minions, who compensate themselves for their own degradation by degrading and oppressing others, a perversion which has led to the nameless misery of deluded humanity."[7] It is, in other words, a form of crisis-mongering for a bourgeoisie, a form of cynicism and despair that can be forestalled only by the ideological substitution of the privatized drama of the human condition for the public affairs of civil society and state.

Figure 16
Viewers at *The Family of Man*, Moscow, 1959.

On the one hand, the existing accounts of the exhibition that draw on this critical analytical tradition are correct: such a standard bourgeois abstraction was indeed put on display. *The Family of Man* was certainly judgment made into a "bleat" or art made into kitsch, and it performed its task well, compensating for the history of its day, for "the ideological alignment of the neo-colonial peripheries with the imperial center." The young Hilton Kramer was typically incisive on this point, decrying the exhibition in 1955 as "a self-congratulatory means for obscuring the urgency of real problems under a blanket of ideology which takes for granted the essential goodness, innocence, and moral superiority of the international 'little man,' 'the man on the street,' the abstract, disembodied hero of a world-view which regards itself as superior to mere politics."[8] To get a sense of this, we need only look at any example from the copious bleating that pervaded the show's conception, promotion, and reception; the award given to Steichen by the Urban League for "making mankind proud of his humanity" should suffice for a single illustration.[9] In this sense, Robert Frank's critical rejoinder to the exhibition in *The Americans* (representing very well, it might be said, Hegel's "perversion which has led to the nameless misery of deluded humanity") and the displacement of Steichen's sensibility in the Museum of Modern Art's photography galleries by John Szarkowski's predilection for the wry and often caustic commentary of photographers such as Lee Friedlander, Diane Arbus, and Garry Winogrand, seems in retrospect an inevitable outcome.[10]

On the other hand, however, this account can only claim to explain the response *intended* for the exhibition's audience; it does not necessarily explain the audience response itself. My goal here will be to try to open up that crack between intention and actuality to see if another account of the exhibition's appeal might be sustained. The governing critical assumption about that reception since the exhibition first opened in 1955 has been that "the Midcult audience always wants to be Told," as Dwight Macdonald put it, "and the photographs were marshaled to demonstrate that although there are real Problems (death, for instance), it's a pretty good old world after all."[11] A life philosophy was prescribed by a prominent institution, and an audience in need of solace took comfort in the shelter of denial made available by its feel-good authority. The old opiate of the masses, we are to understand, was updated and reworked for a postnationalist, postreligious nuclear world.

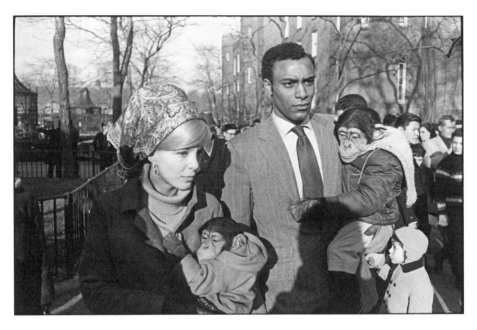

Figure 17
Garry Winogrand, *Central Park Zoo, New York City*, 1967. © The Estate of Garry Winogrand, courtesy Fraenkel Gallery, San Francisco.

Such an authorial voice was indeed put on display. The cover of the book version of the exhibition, for example, unabashedly declared it *"the greatest photographic exhibition of all time"*, and its numbers were bandied about incessantly from the beginning: 503 photographs taken by 273 photographers from 68 countries seen by 9 million exhibition-goers in 37 countries—and that does not include the untold millions who did not see the show but have seen the book (4 million copies were sold through 1978, and it is still in print) or any of the more than 300 prints made of the 26-minute documentary film of the exhibition that was translated into 22 languages and screened in more than 70 countries in 1957 alone.[12] The exhibition's aim from the beginning was to be a blockbuster, in other words, and one early commentator, jumping the gun a bit, went so far as to prophesy for the book that "judging from advance sales, *The Family of Man* will become as much a part of the family library as the Bible."[13]

The injunction from the exhibition to its audience was also given voice not just by the participating photographers or Edward Steichen or by the

Museum of Modern Art but instead eventually came to emanate from the U.S. government. Five duplicates of the entire exhibition, the documentary film in all its different languages, and all subsequent travel to venues around the world were funded and organized by the USIA. As such extensive investment suggests, the exhibition fit well with the USIA mandate. "There is little doubt that the success of the exhibit contributed to U.S. prestige and to an identification of the U.S. with values highly prized and deeply held by the German viewer," noted the Bonn embassy in a communiqué to the USIA offices in Washington.[14] It matched squarely with U.S. foreign policy, formalized first in 1953 and then reaffirmed in 1957 by President Eisenhower, to develop new forms of propaganda without "the 'propaganda' tone."[15]

Given this exceptional backing, the exhibition developers and promoters can be said fairly to have conjured the great crowds of spectators it drew around the world (as was suggested in the photograph of a seemingly endless crowd chosen for the endpapers to the deluxe version of the book and used to frame the entrance of the exhibit), but this realization only begins to help us understand how and why that conjuring worked, how and why the injunction was accepted. Such critical assumptions about the authority of mass culture and the passivity of mass audiences, about the audience that "always wants to be Told," it has been assumed for a long time now under various legacies of the readerly critical practices of poststructuralism, are too brutish and unwieldy, that they foreclose too quickly on the power of interpretation available to any audience. The original "death of the author" argument (with its corresponding birth of the reader) given by poststructuralism and carrying forward in a whole variety of critical practices will, however, be too strong in its emphases for the purposes of the analysis here because it sidesteps the appeal of the exhibition that will serve as the center of my analysis. ("It is on the face of it perverse," Fredric Jameson writes in one critical account of the opportunity missed by such arguments, "to not hear the great modernist evocations of subjectivity as so much longing for depersonalization, and very precisely for some existence outside the self, in a world radically transformed and worthy of ecstasy.")[16] So too, the underlying critical assumptions of more recent ethnographic efforts associated broadly with cultural studies to distinguish critical from uncritical responses among audience subgroups sidestep

the complexity and ambivalence of the exhibition's allure and influence, the way in which difference was a condition assumed to be internal to the viewing subject and not a sociological or anthropological attribute of this or that subject position.

We might state the problem baldly by simply asking what made *The Family of Man* good propaganda. What made it convince as broadly and deeply as it did? Why the huge success of a show that by many standards was thoroughly banal and thinly sentimental, an exhibition "conceived," by Steichen, "as a mirror of the universal elements and emotions in the everydayness of life—as a mirror of the essential oneness of mankind throughout the world"? My aim, in other words, is to look beyond the critical focus on the exhibition's role as part of a larger project of cultural imperialism helping to breach the iron curtain and other boundaries between political territories and penetrate import restrictions, cultural taboos, and other boundaries protecting economic markets. We may grant with Sekula and the others that it served as a sort of humanist Trojan horse sneaking American-dominated economic globalization and political hegemony past restrictive political boundaries in the belly of a maudlin cultural embrace, but that gives us only the most rudimentary details of how that ruse worked.[17] How, I ask, did the exhibition craft its embrace as effectively as it did? How did it inflate its audience's sense of its own importance and magnitude so that it might accept such a capacious sense of self, a universal self complete on its own without the benefit of some foreign other?

It is important to realize, for example, that despite the family name and the cloister it implies and despite the banality of the humanist sentimentalism that was the show's hallmark, it was attempting to be a view out onto the world, not one that was seeking to shield its eyes in the newly enhanced privacy of suburbia. It generated this view through a mechanism of denial, to be sure—its view was based on the active suppression of public political and economic questions and a corresponding elevation of private life as the sphere of global social form, on a "bleat to not forget humanity"—but its ideological agenda was aimed at dovetailing the split in the liberal subject, not opening that fissure anew. It sought to reconcile difference and sameness by colonizing the public world of politics and commerce and incorporating it into the domain of the private, not to demarcate a discrete "family values" norm as a means of disavowing or demonizing

the "perversions" of difference. The private realm of individual life, it naively assumed, could trump the public realm of politics and economics. In so doing, the family concept developed by the exhibition took on a new imperial function—one not dissimilar to grand ambition of the aesthetic in its early, heady days in the eighteenth century—and was blown out of all sense of its traditional proportions.[18]

Since the time of Kant's 1784 "Idea for a Universal History from a Cosmopolitan Point of View" or his 1795 *Perpetual Peace* with its conjecture that "the homage which each state pays (at least in words) to the concept of law proves that there is slumbering in man an even greater moral disposition to become master of the evil principle in himself (which he cannot disclaim) and to hope for the same from others," assumptions about universal subjectivity have been a mainstay of political modernization.[19] However, later critics were surely correct that as long as the state form exists, the greater moral disposition Kant hoped for will remain merely a dream, a vision of enlightenment yet to be realized in some ever-distant utopian future. "The political entity, presupposes the real existence of an enemy and therefore coexistence with another political entity" wrote one such critic. "As long as a state exists, there will thus always be in the world more than just one state. A world state which embraces the entire globe and all of humanity cannot exist."[20]

How then did the exhibition work to persuade its audience to imagine abandoning its long-compelling modernist political identifications based in the differential logic of othering, on the social, cultural, and political differences between nations and states, and adopt the homogenized, cotton-candy fantasy of globality? In a sense, the question raised here is the same as that introduced by a USIA official in his internal report on the exhibition's run in Mexico City, even if it was born of a different political motivation: "How does the emotional experience of the visitor translate itself into political motivations?" he asked.[21] How, we might add, did the exhibition translate political motivations into emotional experience?

There are a variety of ways for understanding the psychical payoff that comes from the experience of belonging. Convincing models exist to describe the experience of family, for example, or nation, or the experience of being colonized or enslaved or imprisoned or tortured, or to describe the experience of being a subject to a king, a subject to a deity, or even a universal subject of Reason.[22] However, we do not have the same means

for understanding the experience of political subjectivity that is *not* defined by nation, class, ethnicity, family, or any other mark of distinction, or by the super-identity-political criteria of morality and reason, which define themselves against immorality and irrationality. There is no readily available notion of subjectivity understood in global terms as identity without difference, as cultural self-affirmation achieved autogenetically without the benefit of othering, without the benefit of one nation understanding itself against another. What would it mean, in other words, to experience political identification realized through a process of cultural homogenization rather than heterogenization? This chapter thus is about one moment of the coming into being of such a subject culture and thus, at least potentially, about one foundational moment for the global subjectivity that is a root condition, or at least a root presupposition, for our lives today.

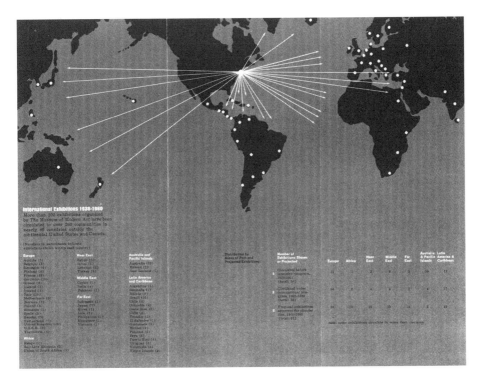

Figure 18
Museum of Modern Art diagram showing distribution of its exhibitions through its international program from 1938 to 1960, a program that received funding from the USIA.

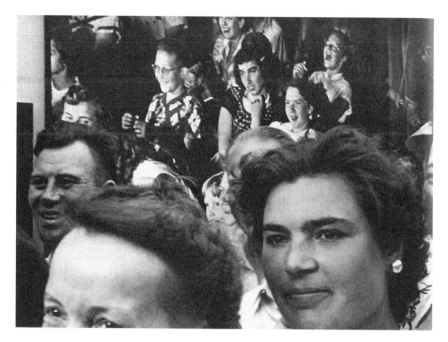

Figure 19
Edward Steichen, photograph of audience and installation of *The Family of* Man,
Moscow, 1959. Permission of Joanna T. Steichen.

I want to introduce the relations between the exhibition and its behold-
ers that I will be attempting to describe with a pair of images. The first is
meant to suggest the sort of critical analysis taken up by Sekula and others.
It is a diagram showing MoMA's distribution of its exhibitions through its
international program, a program that received most of its funding from
the USIA. However, we can take the graphical information it provides as a
more or less accurate representation of the many destinations of *The Family
of Man* exhibition, which, after it left New York, also was funded by the
USIA. The second image, meant to suggest my approach, is a photograph
that was taken by the exhibition's curator, Edward Steichen, at its 1959
Moscow showing. You will observe that the vantage point assumed by the
photograph is that of the pictures in the exhibition looking out at their
beholders from the wall where they hang. Steichen described the experi-
ence of this view as follows: "I have watched the reaction of the various
peoples and found that, regardless of the place, the response was always

the same. I finally came to the conclusion that the deep interest in this show was based on a kind of audience participation. The people in the audience looked at the pictures, and the people in the pictures looked back at them. They recognized each other."[23]

What will concern me here is that gaze of the inanimate photographs described by Steichen, their power of "recognition." What the photographs see looking out from their place appended to the wall, you will notice, is not only their beholders before them and looking back at them, but those same beholders blending into, becoming lost in, or merging with the pictures on the opposite wall behind them. Beholders and beheld not only recognize each other in the manner of a face-off between two opposites, between an I and a thou or an us and a them; they each enter into the space of the other—they both become part of a common crowd. "Will it not prove necessary, "one philosophical primer of the period asked," to begin by laying out and making clear the diverse modes according to which consciousness is 'interwoven with the world'?"[24] It is the distinctive historical character of that interweaving or coming into shared identity and the role played in enacting that merger by the pictures' address or hail to their beholders that I will be analyzing.

10

One model for thinking generally about the interweaving of consciousness and world that may come quickly to mind for many readers is Michel Foucault's much-discussed theory of the archive. I will not rehearse this argument beyond summarily noting its governing distinction: modern power is said to both exercise its authority and realize its iconic stature as power through its archives or systems of knowledge more than through its systems of force. As one secondary account of Foucault's core image has it, for example, this form of power advances "by distributing bodies in space, allocating each individual to a cellular partition, creating a functional space out of this analytic spatial arrangement," and producing a form that is "both real and ideal: a hierarchical organization of cellular space and a purely ideal order."[25]

For our purposes, such an image of social management achieved through the organization of spatial systems and knowledge categories is already broadly suggestive of the distinction made in the Introduction between

the social imaginary given by photographic form and that given by film. Photography's special faculty for rapidly and precisely parceling the visual world—in, for example, the singular direction and momentary temporality of the photographic gaze, the cellular partitioning performed by the photographic frame, the analytical spatial arrangement facilitated by the camera's freezing of action, and the images made "both real and ideal" in their photorealism and in their fixed abstract, two-dimensional spatial organization—is understood to be distinct from, if not fully opposite to, film's rejoining of those parcels. Thus, as it has long been argued, photography and archive emerged together in the nineteenth century as complementary analytical forms that have often been synchronized in the production and exercise of modern power.[26]

This concern with the intersection of knowledge and power necessarily goes hand in hand with another equally Foucauldian focus, albeit one born of a slightly later moment. We "know from experience," Foucault himself noted in 1978, "that the claim to escape from the system of contemporary reality so as to produce the overall programs of another society, of another way of thinking, another culture, another vision of the world, has led only to the return of the most dangerous traditions [that is, to those traditions that served as the founding impulse for the projects investigated here] . . . to the programs for a new man that the worst political systems have repeated throughout the twentieth century."[27] This insight about photography as social form being split between a simple mechanism for social management, on the one hand, and a utopian reaching, on the other, has been developed nowhere more authoritatively than in Sekula's writings, as, for example, in this early account: "The model of the archive, of the quantitative ensemble of images [note the proximity to the model of the essay outlined above], is a powerful one in photographic discourse. The model exerts a basic influence on the character of the truths and pleasures experienced in looking at photographs."[28]

Sekula's two main Foucauldian emphases are not given frivolously here: truths and pleasures both are fundamental to the experience of looking at photographs and for photography as a form of modern power. Sekula elaborates on that moment of the embodiment of abstraction in another context: "The *private* moment of sentimental individuation, the look of the frozen gaze-of-the-loved-one, [is] shadowed by two other more *public* looks: a look up at one's 'betters' and a look down at one's 'inferiors.'"[29]

We can add to this account without disputing it that looking up and looking down are also no different from a third, equally common, equally implicated, public look, one that will be particularly important for the analysis here: the look across of mutual recognition.

Each of these shadow looks blurs the boundary between public and private, power and sentiment, politics and biology, by mixing truths with pleasures. When this mix of public and private, status and sentiment, is brought together with the atomistic, modular form of photography, according to Sekula, "the function of the photograph" is rendered "as a universally exchangeable 'abstract equivalent' of its worldly referent," that is, as homologous to "the circulation function of paper currency."[30] In so doing, as the root argument has it, the material relation between individuals as social beings is confused with the social relation between things as objects and alienation or self-abstraction or the peculiarly modern form of subjugation ensues. As the autonomy promised by modern democratic political subjectivity born of identification with the social contract is displaced by identification with one's position within other systemic relations—in the market economy, most prominently, but also in popularized scientific understanding and other process-based relations or discourses (defined by Foucault as "a group of rules that are immanent in a practice")—human value comes to be measured not by criteria determined through democratic political processes rising up to the standard of transparent negotiation between human desires and needs but by criteria internal to other, extrapolitical social systems that have taken on (ideological) valorization processes of their own.[31]

Insofar as value accrues for photographs with the accretion of systematicity itself (rather than around what it will exchange for in the marketplace, say, or what information or other use value it provides), then, in this sense, Daniel Boorstin's postmodernist argument was right: the unending flood of photographs does take on a life of its own. It takes on the status of an "image world" increasingly independent of its referents as photographs come to influence other photographs and the capacity for representing the material conditions of life and thus the capacity for autonomy or self-determination is diluted, dispersed, and displaced by the glut of representation. Put in Boorstin's terminology, this was the problem with the logic of image rather than that of representation; or, put in more detailed terminology, this was a problem of the play of signifiers taking

on an independent life of their own. In the process, embodied human use and the production of meaning that aims at realizing that use as value disperse in the ether of circulation and exchange, and value is extracted by other means. "We are not clear where the air conditioning ends and the Muzak begins," was how Boorstin put it. "They flow into each other."[32] Abstraction, or the moment when subject is made over into object, is understood by this now-well-worn convention as depoliticization, as a splitting of the Enlightenment promise of autonomy into reified public and private forms. Processes of social interaction are routed from political relations to more controllable social structures and practices that draw their particular form of knowledge—their "instrumental reason" as the Frankfurt school named it or "discourse" as per Foucault or "system" as per Habermas—from the capitalist economy and its epiphenomenal echo (its "mirror of production," Baudrillard called it) in other systems of understanding.

All such systems of self and other understanding—from criminality to governmentality to identity to sexuality to well-being to being itself—are assumed to progressively lose their lifeworldly subjective acumen to the rising flood of their own objective systematicity, their own autonomy as processes.[33] "Amid the network of now wholly abstract relations of people to each other and to things, *the power of abstraction is vanishing.*" Power, so the standard postmodern argument goes, is not achieved by institutional authority—by police or army or government, say—but by the dilution of existing patterns of authority through the industrial deluge of things: "The estrangement of schemata and classifications from the data subsumed beneath them, indeed the sheer quantity of the material processed, which has become quite incommensurable with the horizons of individual experience, ceaselessly enforces an archaic retranslation into sensuous signs.... If one strove to understand such [signs] by thinking, one would fall helplessly behind the runaway tempo of things."[34] The modern promise that once existed to empower the masses through production, we have long assumed, has proved only to be far more forceful at disempowering through consumption.

The Family of Man has been taken to be a figure for this turn since the beginning. As Sekula has put it recently, "'The exhibition moves from the celebration of patriarchal authority—which finds its highest embodiment in the United Nations—to the final construction of an imaginary utopia

that resembles nothing so much as a protracted state of infantile, pre-Oedipal bliss.' [He is quoting his own earlier account here.] This infantilism is consistent with the demise of political subjects in the classical enlightenment sense, and the emergence of new consumer subjects."[35] The latter-day alienated form of the producer is the consumer, so the argument goes, regardless of the level at which one consumes, and it is this that usurps, undermines, infantilizes the role of the citizen. The individual consumer is a player in a game, and the rules of that game come to delimit the scope of one's desires. Gone, as a result, is the subject of reason seeking to open out self-understanding to a common future, and in its stead is the good shopper maximizing individual gain. Consciousness interwoven with the world in and through reason and its promise of shared understanding and aims is little by little eroded by the progressive instrumentalization and individualization of reason. The public sphere is "structurally transformed."[36]

This critique is all well and good—and indeed serves as an accurate account of the infantlization of political subjectivity that *The Family of Man* seemed to mark so well—but it is also useful to recall that there have always been two sides to such objectification or abstraction or alienation, two sides to experiencing one's subjectivity or one's value as a thing at the mercy of a process rather than as self-determination. This was built into the theory of alienation from the beginning, even if it has not always made it into some of the later formulations. "If all capital is objectified labor which serves as means for new production," for example, "it is not the case that all objectified labor which serves as a means for new production is capital."[37] In other words, the self-abstraction made available as objectified labor has an additional, extraneous function or consequence: its organization of labor is social as well as economic; it can be used equally well to understand oneself as a commodity competing for isolated object value in the marketplace or as a class competing for collective subject value in history. This positive potential for abstraction was, Marx declared, "the great civilizing influence of capital."[38] Self-abstraction was fundamental, and in the end, it was assumed to be the source of enlightenment. "When the worker cooperates in a planned way with others," *Capital* tells us, when he imagines himself as a constituent part of a larger productive social form, "he strips off the fetters of his individuality, and develops the capabilities of his species."[39]

The old claims about systematic social progress and systematic under-
standing riding out its last legs from the nineteenth century—developing
the capabilities of the species, and all that—still seemed credible during
the 1950s in a way that they soon would not. The locus of potential for
systematicity, however, was not assumed to be in the neat correspondence
of the component parts, of the cleanly compartmentalized fit between one
cog and the next, one social category and the next, all visible to some
master blueprint and realized in a smoothly- functioning social apparatus,
as it had been imagined in various ways up through the war. The beginning
of this turn can be seen already in the position laid out by Clement
Greenberg in 1939 when he called for an exploration of "aesthetic experi-
ence as met by the specific—not the generalized—individual," but it had
not yet developed into the promise addressed here.[40]

What gradually developed after the war was that the notion that the
promise of a systematicity could reside in the fluid interstices between the
component parts divorced from any neat meshing of one cog and the next.
That intermediary space, the lubricant in between that not only facilitated
the relations between parts but also enveloped and sealed those relations,
was assumed to be both the medium that had enabled the great horrors
of the past and that which could open up redemption for the future. It
was clearly there—in the viscous in-between, in the medium of the corpo-
rate social bond itself—that the problem of nation had to be addressed.
The affective primordial goo of that bond in between one subject and the
next, one concept and the next, one image and the next, of the medium
through which consciousness interweaves itself with the world, thus
momentarily took on independent value and was imagined to be a primary
site of intervention and historical change. In Boorstin's terms, this was a
culture, a moment, that both loved and hated the fact that they could not
tell where the air-conditioning left off and the Muzak began, or rather,
both loved and hated the meeting point between the two: the flowing
together and intermingling itself, the slippage from one experience to the
next, more than either clearly imagined consciousness or world on its own,
bore both the promise and the threat of great historical change.

11

The question of how to rework that interweaving of consciousness and
world is not small one. Jacques Ellul would describe the tenacity of the

problem with period sweep in his 1954 book, *The Technological Society*: "A nation that has been subjected to a totalitarian propaganda barrage is unable to get its bearings in a direct and natural way after the barrage has ceased; the psychic trauma was too profound. The sole means of liberating people from 'ideas' so inculcated is through another propaganda campaign at least as intense as the first."[41] Such intense counter-propaganda like the original propaganda it seeks to undo, achieves its ends less by reasoned persuasion and more by redirecting desire. To such an effort at redirection we now turn.

As an art museum exhibition, *The Family of Man* was unconventional, at least according to what we are used to now. There were no names or artistic types allowed to stand out as such—no impressionists, modern primitives, or abstractionists, no Picassos, Matisses, or van Goghs—nor was there a catalogue of documents of the marginalia of modern life—no police pictures, medical documents, period pornography, and the like. There was no glorified artist or movement to be invested with ideals of creativity, marginality, or profundity, or any glorified anonymity elevated to a symptom of its time. Rather than being ordered by artist, school, period, influence, or stylistic category, or by some other category taken from one modern discursive enclave or another, the photographs were systematically organized in sections around predetermined universal themes: lovers, childbirth, mothers and children, children playing, disturbed children, fathers and sons, the family of man central theme pictures, agriculture, labor, household and office work, eating, dancing, music, drinking, playing, ring-around-the-rosy, learning, thinking and teaching, death, loneliness, dreamers, religion, hard times and famine, man's inhumanity to man, youth, justice, and more. So too they were bunched together, often edge to edge, rather than being allowed to stand alone with ample wall space in the modern manner emphasizing the authorship of the artist and the aura of the art objects or, contrarily, their autonomy as facts. Instead, the work of hobbyists was mixed with that of established artists, art with documents, and there were no wall labels identifying photographers or subjects. The exhibition prints were enlarged to sizes determined by Steichen and made by museum technicians rather than by the artists themselves. There was no care for the concept of the vintage print, bearing either the older authenticity of the artist's hand or newer of an actual historical record drawn from the authenticity of a real, historical filing cabinet.

This breach with museum protocol did not sit well with many of the leading figures in the art photography community who prided themselves on what Ansel Adams called (in a reference to the traits that Steichen's sensibility lacked) "subtle qualities of the image and fine print."[42] From the very beginning, Steichen's appointment at the Museum of Modern Art had been criticized strongly by leading art photographers: Harry Callahan, Helen Levitt, Brett Weston, Willard van Dyke, Edward Weston, and Ansel Adams all wrote letters to the museum in protest.[43] Adams, in particular, was incensed and even threatened a "window breaking spree" at the Museum of Modern Art to protest the "glorification of the empty" by the "stupid fools" who had hired Steichen.[44] Steichen's 1945 exhibition *Power in the Pacific*, he wrote to Beaumont Newhall, was "slick," "superficially moving," and "conscienceless ballyhoo," an exhibition, he said (indicating, perhaps, just how wide and deep the rhetorical conventions of mass culture critique had permeated), that would "simply hypnotize the mass of spectators."[45] It was, he said later, an "illustrative use of photography," one aimed at "the swaying of great masses of people."[46]

But this is not to say *The Family of Man* did not have its own artistic pedigree, and in a sense Adams was right about its ideological sources. With its monumental photographs associated with exhibition themes, its innovative design, and its downplaying of artistic names in favor of the exhibition's message, it was an exhibition that fell squarely in the propaganda tradition, like those designed by Lissitsky and Herbert Bayer such as for the 1929 *Pressa* exhibition and the 1936 Nazi *Deutschland Ausstellung*. That its politics was an avowedly antipolitics—"We are not concerned with photographs that border on propaganda for or against any political ideologies," stated the exhibition's first press release in no uncertain terms—did not make it any more or less agitprop.[47] As one newspaper reviewer put it bluntly, *The Family of Man* was "propaganda that reveals the universal in man."[48] Or, finally, Hilton Kramer put it so: "As so often happens in our culture when art abandons itself to journalism, its mode of articulation has a distinct ideological cast—in this instance, a cast which embodies all that is most facile, abstract, sentimental, and rhetorical in liberal ideology."[49]

Its prewar roots came first from what was distinguished as "The New Photography." The governing premise of this distinction was that photo-

graphy could focus on qualities that were somehow strictly photographic and thereby distinguish itself from older, pictorialist art photography as well as from other artforms. Much the same terminology had already been used in Europe, in Werner Gräff's 1929 book of photographs *Es kommt der neue Fotograf!* for example, where he argued, "Rules based on painting cannot be applied to photography," and in the heralded *Film und Foto* exhibition, also of 1929, which included news, scientific, and advertising photographs in addition to those by art photographers. Photography could claim a privileged affiliation with industrial modernity because of its status as a mechanical form of representation and images that emphasized "photographic qualities" that took on an iconic role: the machine facture itself, above and beyond any image content, could stand as a representation of modernity and carry its claim to progress.

The Family of Man, like the more expressly political exhibitions of Lissitsky, Bayer, Goebbels, and others, and like several other exhibitions organized by Steichen for the Museum of Modern Art, had a central subject or theme that organized its content and layout and distinguished it from the question of modernist photographic vision or the idea of the individual photographer as expressive subject or agent of social change. Like the political exhibitions, its emphasis was to turn the viewer's attention away from issues of individual craft and artistry and instead produce a corporate vision. Steichen's goal, wrote one critic, was to produce a "composite effigy of the human race" that required a form of photography that "tolerates a bit of odd perspective (photographers will lean out of windows occasionally, it seems) but no nonsense with symbolism, distortion, combined images, or anything else that might suggest an individual point of view behind the camera." Like the political exhibitions, psychological questions were at least apparently deemphasized. As the same reviewer notes, there were "no Oedipal shadows in this sharply focused world."[50]

The key to the exhibition's effectiveness as agitprop was not only to simplify the subject but also to make it active rather than passive. The modern exhibition, Bayer wrote in 1938, "should not retain its distance from the spectator, it should be brought close to him, penetrate and leave an impression on him, should explain, demonstrate, and even persuade and lead him to a planned and direct reaction." In other words, he

continued, "we may say that the exhibition design runs parallel with the psychology of advertising."[51] So too Ralph Steiner was appreciative of the power of the exhibition as medium. "The photographs are displayed by Bayer as photographs never have been displayed before," he wrote, they "assault your vision."[52] Or, finally, as Steichen himself said about Bayer's design for the *Road to Victory* exhibition, "Here were photographs that were not simply placed there for their aesthetic values. Here were photographs used as a force."[53]

Unlike the New Photography exhibitions of the 1920s, the goal of *The Family of Man* was to use the force of propaganda to turn the beholder's attention away from photography as an expression of modernity's techno-logical progress and industrial development, away from photography as an expression of individual expertise and political conviction, away from photography as an expression of the state. In this sense, the exhibition had no use for and no faith in the social and political consequences of industrial development, no use for the idea of technologically driven progress. In order to understand this exhibition's draw, then, to appreciate the distinctive character of its seduction, we must assume that it offered a different sort of museum audience experience, something other than the usual modernist romance with genius or mastery, and something other than the avant-garde ideal of a modern, technologized, and politi-cized mass vision. *The Family of Man*, in other words, wanted neither side of modernism's political subjectivity; it wanted nothing of the cherished individualist and mass psychologies that together had served heretofore as recto and verso of the social psychology of modernity. Its aim instead was to use the full propagandistic force of photography not to endow the real, living institutions of state or industry (or, as in days long gone by, church) or to somehow mechanically endow human potential with a "new vision," but instead to give embodied bearing, distinction, and purpose to an abstraction, to photography "giving an account of itself."

12

Instead of turning on the question of individual man versus mass man, as Clement Greenberg and a whole generation of mass culture critics had, or on the opposition between enemy and compatriot that had driven the war, *The Family of Man* sought its structuring opposition elsewhere. Its system

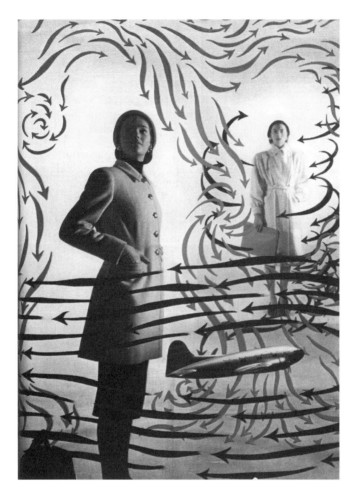

Figure 20
Herbert Bayer, set design for travel clothing shoot published in *Vogue*, February 1, 1945. The caption reads: "TOMORROW'S TRAVEL. The arrows indicate air-currents, pressure areas, and mark the 'state of the road' for flights into the future. The coats are travel coats for today and tomorrow. White, because air-travel is clean as air. Fleece . . . because you'll need it."

of self and other was defined first and foremost by process rather than static opposition, by the flow of identifications from one position to the next and the next and the next. "The exhibition demonstrates that the art of photography is a dynamic process," Steichen wrote in his introduction, and on one level, its was a flow-of-life dynamism like any other—yet one more version of Bergson's *durée*.[54] After the war, however, the old vitalist argument for the temporality of "extended perception" against the tightly bounded spatiality of the image as fact took on different parameters as a popular-cultural form.[55] In *The Family of Man*, like much of the culture that it arose from, the old vitalism was mediated and in a sense governed by the counterpoising effect of a pop version of the Heideggerian phenomenological "everydayness" thesis or what Steichen called the "universal elements and emotions in the everydayness of life." Against the ideal of energy as the motor and medium of life with the beholder understood to experience her being most fundamentally when she experiences the flow of that energy was an alternative account of the beholder being in the world, of Being that emerges set off *against* time, of being there (or *Dasein* rather than *durée*), which itself emerges as a general truth, of everydayness as itself an ontological category.[56] This was really a matter of rhythm or cadence with the beholder asked to strike hard a resonant spatial note of thereness in one instant and immediately take up the temporal extensions of perception in the next.

This conflict of experience for the beholder found its apogee not so much in the intensity of experience in front of an individual photograph or in the experience of a continuous flow carrying him along from one to the next and the next and the next, but instead in the empty spaces between photographs, at the pivot point where the beholder turns his body and his attention from one image to the next. At the center of this experience, where it achieved its greatest intensity, was the experience of identity as loss. Asked to identify strongly with one picture and then abandon that identification for the next and the next and the next, the beholder experiences as a central component of the process, of the "everydayness" of the exhibition, the letting go of the prior identification in order to adopt the later one. In the gesture of turning between pictures, in the interstice between one and the next as the beholder is letting go of one identification and taking up the next, the beholder is given the experience of noniden-

tity, of the loss of identity before it is regained. That letting go of one identification in order to open oneself up to another is an ecstatic release from the burden of identity and, more important for our purposes here, a traumatic loss of an old bond.

The experience of identity constructed around such a point-and-turn aesthetic has not often been associated with the mushy, self-applauding, feel-good humanism of *The Family of Man*.[57] We can begin to see it, however, by comparing it to two earlier related exhibitions, *Power in the Pacific* (1945) and *The Road to Victory* (1942). All three exhibitions were curated by Steichen and shared a common design principle initially developed by Herbert Bayer.[58] Bayer's design was based on a journalistic (rather than fine art) use of photographs deemphasizing authorship and craftsmanship and focusing instead on variations in scale, subject matter, and juxtaposition in order to dramatize broad and topical themes. All three also worked with the principle of an all-encompassing visual experience and the authority of large-scale images and downplayed the idea of the discrete visual object meant to be valued on its own. Where the wartime exhibitions were different from *The Family of Man* is betrayed already by the titles: the two earlier shows were understood to be very much a part of the war effort and as such were thought both teleologically (i.e., "to Victory") and instrumentally in terms of the accumulation of power around a single strategic site (i.e., "the Pacific"). *Power in the Pacific* and *The Road to Victory* both had very particular ideas about the social roles of their audiences: each interpellated specific sorts of beholders to integral but distinct and differentiated roles in the war effort. In *Power in the Pacific*, it was simple: either you were a sailor like those represented in the pictures, or you were a patriotic citizen back home showing your support and identifying with the Allied cause by attending the exhibition.

The Road to Victory, was a bit more complicated. Not limited to the boys at sea and those who were thinking of them back home, here a full array of the component parts that worked together to form the larger war effort was displayed—the farmer, the factory worker, and the nurse; the soldier on the front, the family back home, and the politician in Washington. Each one of these social categories (and many others) had its own picture in the exhibition, and in each case, its role supporting the war was made explicit. In both exhibitions, the beholder was called on to

identify his or her particular spot in the larger gear works of Allied righteousness and internalize the war-logic specific to that position. In *The Road to Victory* this meant, in effect, finding a single picture with which to identify: if I am a farmer, for example, I identify with the picture of the farmer and *not* that of the factory worker, the soldier, or the nurse—I have my place in the war machine and you have yours. As fellow audience members, we are differentiated beings who share a common cause, a common enemy. In psychoanalytical terms, this experience of the beholder offered by the wartime exhibitions might be labeled "identification with the law," or in sociological language, it might be called "the taking up of one's assigned place in the social order." The audience was hailed by the exhibition with great specificity, and, we might assume given the widespread support for the war effort, beholders responded to varying degrees in kind.

The Family of Man was different. First, there was no immediately apparent outside, no enemy or other. The group identity or "family" being produced was "Man" after all, not us or them. Second, the beholder was called on to identify with not just one picture or with one type of picture, but with each and every photograph in the exhibition. This becomes self-evident even now just flipping through the catalogue. "I was once a child like this one," the beholder is called on to reminisce. "I too will be old." "I am just like everybody else in the world because I also have a mother." But let me defer to Carl Sandburg's catalogue statement where he renders this response to the exhibition with much more poetic immediacy and pleasure than I ever could: "Everywhere is love and lovemaking," he says, "weddings and babies from generation to generation keeping the Family of Man alive and continuing. Everywhere the sun, moon and stars, the climates and weathers, have meanings for people. Though meanings vary, we are all alike in all countries and tribes in trying to read what sky, land and sea say to us. Alike and ever alike we are on all continents in the need of love, food, clothing, work, speech, worship, sleep, games, dancing, fun. From tropics to arctics humanity lives with these needs so alike, so inexorably alike."[59]

Everywhere everything is alike, he says, assuming the beholder to feel the pleasure of self-discovery in any and all contexts. Instead of saying, "I work with the other" (e.g., the factory worker, the soldier, the nurse) or "I am fighting against the other" (i.e., the enemy), the beholder at *The Family*

of Man is asked to say, "I *am* the other"; I am exactly the same as everybody else; I experience joy and sorrow, accomplishment and trauma, pleasure and pain with the people in each and every one of these pictures. Sandburg merely suggested what our response should be when he said, "You might find yourself saying, 'I am not a stranger here,'" but several reviewers of the exhibition were more forceful. One claimed, for example, that the pictures were "so vivid and real . . . that the visitor is quickly [made] a part of the life being shown," while another exhorted the beholder, "You yourself *will* be in each picture for you will be part of it because of what you are and what you have done in life."[60] The formal problem faced by the exhibition was how to develop these two contradictory certainties together: that of emphatically being *in* a given picture and that of emphatically being in *each* and every picture. As the beholder moved from one radically different sociohistorical context to another, he had to experience the peculiarities of its reality as his reality *and* he had to be able to move on, with equal personal conviction, to the next.

The formal conceits of exhibition design used to generate the strength of empathic response necessary to overcome this contradiction were best analyzed at the time by the photographer Barbara Morgan in an exceptional review titled, "The Theme Show: A Contemporary Exhibition Technique." The premise of her discussion was that *The Family of Man* represented a development in exhibition design so advanced that it was "no longer a mere technique, but a full-fledged medium of expression. A medium in which the creator can be as eloquent and forceful as he can in words, or music or in other visual images." The curator, in other words, was being promoted to the status of artist or designer or maybe, implicitly, PsyOps specialist, and this was a measure of the force of the techniques being used. "It is something for which we need a new term," she wrote, something even "as crisp as 'movies' or 'TV' . . . [something] that induces its own experience in the spectator." Her analysis was based on several visits to the exhibition to observe "the seeing pattern of the audience." In particular, she was struck by the sense of movement generated by the variations in scale and arrangement of the galleries and the individual photographs. The organization of the exhibition, she wrote, "allows the audience to flow at its own speed . . . viewers can mull, amble, bypass or sit; yet there is a forward pulse of dramatic progression. . . . The progression of architectural forms and spaces have been carefully designed to further

the meaning. . . . Transition from one theme to the next is effected by a variety of means. Love and Marriage flow directly to the Birth circle. The Death theme is like an isthmus, with family life as one continent, individual fate as the other. Floor-to-ceiling murals serve simultaneously as anchors and points of departure. . . . The scale shift from small-to-large, large-to-small, is a breathing rhythm—the systole and diastole of the organism—that keeps interest pulsing."[61]

Systole and diastole are as good as any other terms to describe the structuring opposition we are after here, and the expansion and contraction of aesthetic impact that Morgan describes can be taken not only as a description of one of the formal means of the exhibition—the way in which it regulates and narrates the family story, for example—but also as an aim unto itself. Against the old terms of mass man and individual man, enemy and compatriot, this exhibition (and the projects to follow) sought first and foremost as its social and artistic aim to internalize the problem of opposition, the problem of otherness. Its version of that internalized otherness was neither the psychosocial complex of threats associated with the cold war concept of the "enemy within," however, nor the strong sense of the alienation of mass man that emerged in response to Nazism, Stalinism, and other right-wing populisms of the 1930s and took on new dimensions and purpose with the "organization man" of the 1950s, but instead a different sore of otherness. Morgan's account provides a good sense of the effects Bayer sought in his original design program and much of what Steichen sought in his meticulous curating.[62] It is a strong description of the audience transformed into a single "organism," contracting and expanding as a single collective subject.

The effect of this internal dynamism on the beholder, she argued, was "emotional . . . exhaust[ion]." It was too much for a single viewer to take in: "When 500 pictures interact in significant layouts, the subjective range of their implications becomes enormous for any one individual." Instead, it was an exhibition that could only be experienced *en masse*, as part of a crowd, *its crowd*, with its own affective dynamic, its own distinctive group identity and psychology. As one analyst has put it, "Steichen placed the viewer firmly on the ground for The Family of Man—no ramps or unnatural perspectives. The people in the photographs should be met face to face. Both in New York and in Moscow the exhibition was designed to envelop

the viewer in a community rather than to invite the command of an all encompassing gaze."[63] Neither self nor other, neither identity nor nonidentity, neither *Dasein* nor *durée*, neither abstract being nor abstract becoming was to be allowed to claim priority. Instead, as the fantasy of the moment had it, both sides of the internal opposition were to be kept in play in order to create a new sense of being in the world, and with it, a new sense of belonging.

13

Thinking back on the early postwar period, we tend to remember most clearly the defensive reactions to the pervasive cold war hysteria, with McCarthyism and the bomb shelter bunker mentality leading the list. There was, however, a whole other set of symptoms indicative of the same hysteria in the liberal artistic and intellectual culture being studied here that was proactive in orientation rather than reactive, that was attempting to work out an end run around the same threats rather than digging in, weeding out the weak links, and fortifying. This broad-based, antinationalist, liberal humanist culture of globalization that developed right alongside McCarthy and the bunker industry was also different in kind from Nixon's famous proposal to Khrushchev (levied just yards away from the Moscow showing of *The Family of Man*) about the geopolitical merits of washing machines over rockets.

The goal of this globalist counterculture was not unity via a new world market but unification by means of a transnational political culture and new global political subject that would eventually support a world government. "How to define the subject of a united nations?" many public intellectuals came to ask. This difference between Nixon's position and Steichen's was appreciated by, among others, an editorialist for the *New York Times*: "The *anthropological* appeal of *The Family of Man*, that all people are fundamentally the same," the editorialist wrote, was replaced in the kitchen debate by "an *economic* assertion to which there was no acceptable rejoinder other than capitulation. . . . In this economic struggle, capitalism . . . would inevitably have the upper hand. . . . Why, Russians were coached by their American hosts to ask, 'are so few of these "gadgets" available in the land of "triumphant socialism"?' "[64]

There were, in other words, competing paradigms of what Republican presidential candidate Wendell Willkie had called in the 1940s (and popu-

larized through, among other institutions, the Museum of Modern Art) "One-Worldism." (Or we might use Willkie supporter Clare Booth Luce's critical characterization of Henry Wallace's competing late Popular Front version of the global narrative—"globaloney.") The difference of opinion that emerged during the war and continued to be worked out through the 1950s turned on how the new world order and the new global subject would be formed. Roughly put, the question was this: Was the medium to be high or low, culture or commodities, the exchange of ideas about the nature of man or about the relative merits of washing machines? The one side of this difference of opinion might be fairly labeled "neoliberal," the other something like "social-humanist." The *New York Times*'s editor called the appeal of *The Family of Man* "anthropological," but he or she was also clear on its relative political implications.

The key issue, at least in the minds of the latter group, was fear and how to manage it. "Whatever elation there is in the world today," wrote Norman Cousins, for example, "is severely tempered by a primitive fear, the fear of the unknown, the fear of forces man can neither channel nor comprehend. This fear is not new; in its classical form, it is the fear of irrational death. But overnight it has become intensified, magnified. It has burst out of the subconscious and into the conscious, filling the mind with primordial apprehension."[65] One form of dealing with this was to project that fear outward—onto an enemy or onto the old forms of social belonging that had led to and allowed the war and that needed to be displaced by the allure of the commodity. But another form of dealing with the anxiety of the period was simply to accept it, to internalize it, and make it over into your own. This approach had a double benefit: first, it avoided the problem of projecting threatening enemy status and, second, it provided an alternative form of equality across all manners of difference. The young Louis Althusser was very clear in a critical review of this phenomenon, which he disparagingly labeled the "'proletariat' of terror." He is adopting the voices of those he is critiquing here: "Man, know thyself: your condition is death (Malraux), is to be a victim or an executioner (Camus), is to draw steadily closer to the world of prisons and torture (Koestler), or to nuclear war, your total destruction, or to the end of what makes you man and is more than your life: the gaze of your brothers, your freedom, the very struggle for freedom." Summing up the foun-

Figure 21
Installation shot, bomb gallery, at *The Family of Man*. Photograph by Wayne Miller.

dational philosophical position and historical condition that unites these different period voices, he concludes, "we are madmen grappling on the brink of an abyss, unaware that *death has already reconciled us to one another.*"[66]

Anybody thinking about such problems in 1955—no matter how naive or idealistic, no matter how tortured by the postwar malaise—would also have to be thinking about the bomb. So was Steichen. "The greatest challenge of our time," said the press release for the exhibition, is "the hydrogen bomb and what it may mean for the future of the family of man." This concern was graphically represented near the end of the exhibit in a separate black-painted room illuminated only by a six- by eight-foot lightbox displaying a transparency of the H-bomb test blast at Bikini Atoll. It was the only color photograph in the exhibition, the only isolated image, the only darkened room, the only backlit display. The effect this picture was meant to have on the beholder's experience, I think we can assume,

was dramatic: suddenly coming face-to-face with a monumental, light, and color-filled mushroom cloud must have been a startling and, in its own staged and manipulative manner, traumatic experience in the context of an otherwise strictly mundane series of photographs. This juxtaposition of the singular and the multiple, of color and black and white, of the light-filled and the lit, of the apocalyptic and the everyday, was the means by which the exhibition offered its viewers a moral choice: nuclear holocaust was set up as the alternative to living the collective fantasy of a family of man; the grand and tragic finality of total destruction was posed dramatically against the simple pleasure of cherishing and preserving the practice

Figure 22
Spectators at nuclear test blast as pictured in *Life* magazine May 5, 1952. The accompanying article begins, "Last week, like animal trainers who at last are ready to show off a monster they have tamed, the men of the Atomic Energy Commission exploded an A-bomb for the whole U.S. to see."

of daily life. A USIA report on the showing in Mexico City described it like this: "The idea that the fission bomb may be just one other cause of death is nowhere suggested [in the exhibition]; instead the atom bomb becomes the brooding presence darkening man's mind, threatening its extinction. It is posed as an ultimate, a finality."[67]

Stated in such extreme terms, the beholder's decision would seem obvious and formulaic—life over death, peace over war, pleasure over politics—and so it was, but the exhibition also betrayed a sense that the choice, however obvious, was not simple. The bomb image, after all, was of a mushroom cloud at a test site not of Hiroshima or Nagasaki after the blast. It was photographed from a distance, as a sublime spectacle of the first order, as an *idea* of total destruction without any of the abject detritus, the burnted flesh, the broken families, the destroyed property, the lost and ruined lives. It was not simply horrific but also beautiful; it represented not only a threat but also—in a very ordinary sense—an attraction, a spectacle, a *fantasy* of death. The underlying trauma of the postwar period provided both displeasure and pleasure, and it was this ambivalence more than anything else that was the coin of aesthetic experience for the period in question.

The sexual component in this attraction—what Stanley Kubrick called "strange love"—has always been central cultural theme of the nuclear age. It is on view in spades in cartoons and pop music from the period, it was introduced in *Life* magazine just three weeks after Hiroshima with the death-like pose of an "Anatomic Bomb," and it is a central theme in the brilliant 1964 cold war psychodrama *Fail-Safe*.[68] The bomb was also evident in a more immediately intellectual vein in various efforts to think psychoanalysis and social theory together in more elaborate ways those provided by Freud himself from the mid-1950s through the early 1970s in many of the writers cited above, such as Brown's 1959 *Life against Death*; Marcuse's work generally, including his 1968 essay, "The Obsolescence of the Freudian Concept of Man"; Elias Canetti's 1960 *Crowds and Power*; and Deleuze and Guattari's 1972 *Anti-Oedipus*. It was there already in Paul Goodman's 1956 book, *Growing Up Absurd*, for example: "The desire for final satisfaction, for orgasm, is interpreted as the wish for total self-destruction," he wrote. "It is inevitable then, that there should be a public dream of universal disaster, with vast explosions, fires and electrical shocks; and people pool their efforts to bring this apocalypse to an actuality."[69] Of course, this fascination

was just an update of the old Romantic equation of sex and death, of losing yourself in passion and losing yourself by dying, but now it was ringing true with a new grandeur. Now it was technically feasible for that satisfaction to be total, for it to be fully free of the burden of procreation, of rebirth as the responsibility of death.

The Family of Man was very much a product of this culture. It shared a keen focus on its own traumas and a dutiful awareness of its own illicit desires. Within the larger economy of the exhibition, the "public dream" or "desire for final satisfaction" associated with the total annihilation of the H-bomb was given a pivotal narrative role. We can only speculate about what it meant to its audience. Certainly it posed a threat—the destruction of the family of man—but like the larger bomb culture from which it arose, it also served as a fantasy, a "strange love." In the first instance, it might have been a fantasy of the death of the enemy or of the death of otherness as such and thus alluded to the pleasure of release from all social and political tension; or it could have been a fantasy of the death of the self, offering a release from the burdens of individual guilt and worry about the bomb and the conflicts that gave rise to its use. In a sense, it does not really matter: either way, it worked its appeal. Death served an important function in the aesthetic economy of the exhibition: it gave it grandeur and joy. The moral force of the exhibition came down on the side of life, of course, but it also worked hard to make the beholder aware of the sublimity of death. In order to do justice to this period ideal of "strange love," to adequately understand how it did its work, how it seduced its beholders, we need to consider it in psychoanalytical terms.

Late in his career, Freud came to believe that something like the two pleasures I have described—the everyday pleasure of bonding with others in *The Family of Man* and the erotic appeal of a climactic release—motivated what he called, grandly and famously, the Life and Death instincts. We can figure these pleasures more simply and concretely for our purposes here by using Freud's earlier terms *fore-pleasure* and *end-pleasure*. Fore-pleasure was understood to realize itself in the production of sexual tension, the stimulation that marks the binding of affect around an object or relation, while end-pleasure was seen as an expression of the expenditure or release of that sexual energy. Central to the Freudian model of libidinal economy is the assumption that in human sexuality, there is no getting

away from the destructive, entropic force of end-pleasure or death; it forever circulates with the prior binding force of eros or life. Aggressiveness and destruction are inescapable moments in the economy of desire and are central to all human relationships.

Such a separation, however, is precisely what the exhibition sought to accomplish; such was its moral imperative: to rally collective psychical energies around the pleasures of life—those pleasures that renew and regenerate, those pleasures that maintain the viability of human existence through rebirth—while fully renouncing the pleasures of death represented by the hydrogen blast at Bikini Atoll. "I believe love should be the dominant and key element in *The Family of Man* exhibition, just as it is in the individual family," is how Steichen put it. War, which had always been a part of daily life, now needed to be renounced in the interest of self-preservation because of the prospect of total annihilation brought about by the bomb. As such, we might say, Steichen's antiwar effort was noble, even in a sense heroic, if we understand it to prefigure, for example, the "Make Love Not War" slogan of the next generation or, perhaps, even the rainbow multiculturalism of our own. But at what cost in Steichen's balance sheet?

Psychoanalysis has always insisted that the drive to death, the drive to discharge tension, the pursuit of "end-pleasure," must find expression somewhere. So it was in the everyday pleasure proposed by *The Family of Man. Everywhere*, said Sandburg, "is love and love-making," telling us that the pleasure of the exhibition was not singular and isolated but multiple and continuous. The pleasure did not come from recognizing oneself as distinct from the other that might lead to conflict and eventually nuclear war, but as the same, as an extension of the other, as a release from the tension of otherness. The exhibition offered no sense of history to frame that pleasure but presented it instead as unqualified immediacy. Witness, for example, the testimony of a reviewer for the Communist party's newspaper, the *Daily Worker*: "Suddenly you are catapulted into a world completely beyond your worries and concerns of the moment." The young Hilton Kramer got the stakes of that pleasure about right when he noted in his review of the exhibition's reception that "papers of every political description joined [in] the applause for an image of the world which relieved them of the necessity to think politically."[70]

The pleasure offered by *The Family of Man* and the earlier wartime exhibitions were both group pleasures; at their strongest, both must have produced the thrall of belonging and a willingness to sacrifice to a force larger than the self. In each case, it was the pleasure of the crowd that had driven modern mass politics. "Only together can men free themselves from the burden of distance; and this, precisely, is what happens in a crowd," is how Canetti described this thrall, this sense by which a crowd realizes its own power. "In that density, where there is scarcely any space in between, and body presses against body, each man is as near to the other as he is to himself; and an immediate feeling of relief ensues. It is for the sake of this blessed moment, when no-one is greater or better than another, that people become a crowd."[71]

If the earlier wartime pleasure was one of collective agency focused righteously on the instrumental production and exercise of political authority—in the smooth-running, team-operated war machine—the later postwar pleasure must be understood, at its base, to function in the opposite fashion: that is, its pleasure was located precisely in the *abolition* of that focused righteousness, *in the abolition of political identity itself*, in the euphoric slide from one identification to the next, and the next, and the next, until there were no longer any differences, any conflicts, that might develop into discrete political subject positions and thus ultimately develop into war, nuclear holocaust, and universal death. This was, no doubt, a giddy pleasure, a pleasure in the service of denial, a pleasure that allowed an audience traumatized by the horrors of the recent past to avoid acknowledgment of social difference and thus renounce the discourse of power and responsibility, the discourse of alliance and betrayal, which was likely to raise the threatening moral terms of complicity, blame, and guilt. It allowed them, in other words, to disassociate themselves from the horror of the bomb and the Holocaust by internalizing those conditions, by making them a part of their being.

The ego's acceptance or denial of power relations is central to Freud's distinction between Oedipal and narcissistic modes of identification. In normal Oedipal identification, the ego understands itself to be like its ideal object but lacking the total authority of that ideal. In Freud's normative example, the son understands himself to be like the father but also different; he both aspires to and is subject to the father's law. In narcissistic identification, the object is incorporated (rather than merely mimicked),

collapsing all difference (and, thus, all relations of power) between it as sovereign ego-ideal and the ego proper. Here the son is liberated from the father's law by becoming that law. That moment of incorporation is violent—the ego destroys its ideal in order to become it—but also pleasurable: "the ego ideal comprises the sum of all the limitations in which the ego has had to acquiesce," says Freud, "and for that reason the abrogation of the ideal would necessarily be a magnificent festival for the ego." But that "magnificent festival" is also unstable; technically, it is maniacal. Freud says, "The maniac plainly shows us that he has become free from the object by whom his suffering was caused, for he runs after new object-cathexes like a starving man after bread." Thus, we are to understand, in a narcissistic moment, the ego euphorically disengages from one object relation only to immediately resubject himself to the rule of another, repeating the process over and over again in a maniacal fashion. If its object relations stabilize and its cathexes adhere to a single object, the period of narcissism ends and the ego normalizes; otherwise the pathological mania continues.

Such was much of the aesthetic experience that *The Family of Man* offered. In front of each photograph, the beholder was seduced by the logic of a new ideal of familiarity and universal humanity. And yet by its very universality, the new object cannot maintain its elevated position as an ideal. In each and every case, the picture says to the ego, "We are the same," thereby demanding its own abrogation, demanding to be incorporated as the ego in its entirety. Whence the pleasure of the exhibition, the "magnificent festival"; whence its unabashed claim to be *"the greatest photographic exhibition of all time"* despite the utter banality of its constituent photographs. The political dimension of this pleasure was its instability. In psychoanalytical terms, it was not merely neurotic, like the conventional pleasures of love or the conventional pleasures of political identification, but instead offered to the beholder something like the pleasure of psychosis. It positioned its beholders to compulsively repeat the cycle of life and death, to rush through the cycle of binding of affect, of fore-pleasure and end-pleasure, and release for each of the 503 photographs, to experience again and again and again the moment's governing platitude: "death has already reconciled us to one another."

The Family of Man offered its audience a continuum of discrete moments of pleasure, of excitation and release, but those moments did not have the

historical frame that would allow them to endure, to grow, to develop into sustained and negotiated political and social relationships. The beholder thus was asked to move on to the next photograph and the next, "like a starving man after bread," as Freud says, ever eliminating the possibility of accumulation, of building a shared history, of negotiating a sustained sympathetic relationship with the other. As such, within its discursive domain, the exhibition inhibited the production of political identity, of identity based on difference, and, as such, inhibited all political relations.

What *The Family of Man* thus represented was a new, dispersed social subject as its model global citizen, one that was antipolitical in its primary emphases but was not yet fully individualist, consumerist, or smug in its neoliberal, global Americanism. It was an experience of ideological inter-pellation into the new world order, but it was decidedly not the same experience offered by an identification with the future of the Third International, for example, or the Thousand Year Reich or the Allied war effort. Nor was it an experience of the new market frontier staked and charted for conquest by Coca-Cola. Ideology worked its magic in a new and different way, but it was not yet *our* new and different way. Caught between the old collective ideals of nationalism, communism, anti-communism, and fascism on the one side, and the new mass psychology of consumerism on the other, caught between modernity and postmoder-nity, *The Family of Man* contributed powerfully to a culture of transition by introducing at its center a figure of death. It was a crowd or horde experience much in the manner of the old mass politics and the old pro-paganda, but it offered no unity to its global-subject-information: no program, platform, or ideology, no vision, no ground for identity (least of all, that of the traditional family), no history or critical agency. Like the figures of Leviathan, Liberty, or Worker that allowed their constituencies to say, "We are one in the name of our political ideal," so *The Family of Man* could say, "We are one in the name of *our* political ideal, we are one in the name of a new global citizen." That figure was different, however, by its degree of abstraction. With the death of political identity in all its sundry institutional forms as both the ethical bar it raised and the fantasy it exercised, it was realizable only as a figure of negation-in-process, as the death of man in any of its specific historical or political determinations.

The aesthetic experience it offered was a measured alternative satisfaction to the big release of final, unregenerative death by nuclear annihilation and was given as an emergency measure, as a provisional psychosis (rather than the provisional neurotic identity formation of various literary-critical forms, such as the readerly reader, grammatologist, deconstructor, or genealogist, that would develop in the next decade), as a homeopathic dose of the demon pleasure at a time of pressing need.

14

Dorothy Norman, an intimate of both Stieglitz and Steichen and the person in charge of *The Family of Man*'s captions, described the way she felt the exhibition as a whole appealed by saying that it was "more related to the motion picture tradition than to that of Stieglitz" and that Steichen "functioned as a kind of director."[72] Indeed, Steichen did function as a kind of director or editor or designer much more than as a curator in any traditional sense. Put most simply, he was less concerned with superintending the meaning and value of the images he presented and more concerned with giving them new, independent meaning and value. "The creation of this kind of exhibition," Steichen himself said, "is more like the production of a play or a novel, even a philosophical essay, than it is like planning an exhibition of pictures of individual works of art."[73] But these alternate descriptions of his role are limited as well. His aim in the end was really much bigger, really something more than managing and giving form to a cultural production: his ambition was instead on par with the accomplishment that Walker Evans had claimed for August Sander's *Face of Our Time* back in 1931—to accomplish "a photographic editing of society." This would be a function of, Evans continued, photography reconfigured as "a clinical process," of a kind of objective or scientific accounting of social form. The singular formal key to that reconfiguration was "the element of time entering into photography," he concluded, or photography transformed from a single-image medium into a serial form and conceived of not as single images but instead as a book or exhibition.[74]

The seriality at issue, however, was not really that of the motion picture, as Norman had suggested about *The Family of Man* or as has been argued about Evans's work, but was instead that of the noncinematic photographic essay.[75] "Finally," as Evans put it about Sander, "the photo

document is directed into a volume."[76] The difference between film and essay, as I argued at length in the introduction to this book, was at the center of how the element of time was treated. Steichen himself had a good sense of this. "In the cinema and television, the image is revealed at the pace set by the director," he wrote a few years after *The Family of Man*. "In the exhibition gallery the visitor sets his own pace." Indeed, photography is a special resource with a variety of special formal properties to be exploited, all of which allow a different, more plastic, and interactive use of time than is available to time-based media: "In the creation of such an exhibition, resources are brought into play that are not available elsewhere. The contrast in scale of images, the shifting of focal points, the intriguing perspective of long-and-short range visibility with the images to come being glimpsed beyond the images at hand—all these permit the spectator an active participation that no other form of visual communication can give."[77] Against the frozen time of the single image and the pregiven temporality provided by film, the photographic essay in book or exhibition form opens out to an interactive and dynamic relation between viewer and text. At least this is its promise.

It is this formal feature above all others that brought on praise from critics far and wide. "A dynamic process" is how Steichen himself characterized it, and many saw fit to follow suit.[78] "A dynamic language," repeated one typical account.[79] "An entirely different type of exhibition, where the individuality of the photographer was of less importance than the effect of the whole," wrote another.[80] All agreed it was the "most elaborate photographic layout in history,"[81] and the usual metaphors shifted generally from the traditional iconographical and scopic framing of the visual to the more collaborative and atmospheric language of the musical. "The result is symphonic," wrote one, for example, "with each individual contributor performing as the member of an orchestra rather than as a soloist, and with the editor in the role of composer, arranger and conductor."[82] It was on the general structure of the "activities, emotions and stages of life which each human being shares with other members of his kind, regardless of racial or national identity, cultural tradition or walk of life," wrote another, that "the infinitely varied counterpoint of specific human experience" was elaborated "in terms that summon the observer from his sense of personal humanness to consciousness of his identity with universal humanity."[83]

Bless thee in all the work of thy hand which thou doest.

Deuteronomy 14:29

Figure 23
Spread from *The Family of Man*, 1955.

In order for the pictures to take on relations between each other that would give expression to this universality, this sense of being as such, specific narrative and historical relations had to be downplayed or dissuaded and those relations opened up to generality. This created a formal problem: how to build a universalism out of building blocks that were so many particularities. The first thing to be avoided was the old model of the social type—the various worker categories from the interwar period, for example, or, had they been able to anticipate it, the identity political categories that would come in subsequent decades. The generality that would bring pictures together and people together in a shared sense of self thus could not be developed in the sociological terms of class or subject positionality but instead would need to be anthropological in the widest possible sense.

The blank or generic character associated with idealized representations of workers and other social types had worked well to convey the notion of

qualities general to that type, and they could be used to convey a common humanity (in the manner, say, that artists such as Keith Haring and Tom Otterness would come to do in the 1980s) but this would have carried with it stronger associations with the propaganda aesthetics of the previous period that the exhibition was trying to avoid. So too the exhibition had to avoid any representation of, or allusion to, what Hannah Arendt described as totalitarianism's tendency to make all laws into laws of movement: "When the Nazis talked about the law of nature or when the Bolsheviks talk about the law of history, neither nature nor history is any longer the stabilizing source of authority for the actions of mortal men; they are movements in themselves," she wrote in 1951. This distinctive twentieth-century form of terror was, she continued, "the execution of a law of movement whose ultimate goal is not the welfare of men or the interest of one man but the fabrication of mankind, eliminates individuals for the sake of the species, sacrifices the 'parts' for the sake of the 'whole.'"[84]

Instead, *The Family of Man* had to represent a corporate identity or image of social belonging that produced a clearly defined whole without appearing to do so at the expense of any of its constituent parts. This was its ideological and aesthetic mandate, and Steichen was clear about how this expression was to be obtained. The key was to rely on "photography itself." "as the means to represent" "'man' himself."[85] Such a bald antipolitical humanism was not peculiar to Steichen, of course, but instead was a period sensibility that extended across many different registers.[86] The question for our purposes is how the seemingly technical abstraction of "photography itself" was understood by Steichen and his audience to generate the humanist abstraction of "'man' himself." How was photography to work the discomfort of living in history and develop that discomfort as an independent social form, an alternative mode of collective self-realization to that provided by politics? How was photography, as Dwight Macdonald put it, to help people "transcend 'frontiers' to get to know each other in intimate, *personal* ways, forging reciprocal relationships 'outside' History"?[87]

In a sense, the answer was as simple as it was profound. What was needed and what photography could provide was an absent center, a placeholder or empty container that could be filled by any and all meaning. It could be a blank screen that could be projected on with any image whatsoever.

"Photography itself," in other words, held out the great humanist promise of being an empty signifier. The "grand canyon of humanity" is how Carl Sandburg described it in his prologue. "The human family in the silencing variety of its conditions," said one reviewer.[88] "Overwhelming," said another, adding that "the best way to describe most people's first impression as they walk through *The Family of Man*" was "the feeling of having stepped into the Grand Canyon or the Carlsbad Caverns or something equally monumental."[89] The show, all agreed, "packs a terrific emotional wallop,"[90] and that wallop was an experience of the infinity of all possible pictures. André Malraux had already described the basic aesthetic principle shortly after the war: "Classical aesthetics proceeded from the part to the whole. Ours, after proceeding from the whole to the fragment, finds a precious ally in photographic reproduction."[91]

At the center of the aesthetic experience on offer, thus, was the notion of the photograph as a blank screen with the "silencing variety" of all possible projections, all possible fragments, or the "grand canyon of humanity." "The universal becomes clear in the individual and in the particular," another reviewer wrote, and this was true because anybody and anything could be framed by the camera.[92] "Photography itself" was the universal that allowed for each and every particular to be realized. As Hilton Kramer put it, Steichen's "method of depicting this 'essential oneness' is to place in juxtaposition photographs from all parts of the world, playing up every superficial resemblance in custom, posture, and attitude." In so doing he succeeded in forcing a contradiction, "making abstract an art which relies above all on the *particular* for its integrity."[93]

That experience was ideological, for sure, but not in the sense Kramer intended. Instead, it was a way of viewing the world that would become axiomatic for the next generation of artists, the generation of Warhol and Ruscha and Richter and the generation of poststructuralist and postmodernist accounts of the "death of the author," "image world," and the like. The thesis that would span the modern-postmodern, humanist-posthumanist divide was that the parceling and atomization of experience promised by the concept of "photography itself" was the abyss, the absent center, the "silencing variety," the "grand canyon of humanity" from which the aesthetic experience of a new political subjectivity could circulate freed from the old threatening certainties of the past. The critical distinction between these two perspectives that we can rest with in retro-

spect does not concern the abstraction itself—each moment was as good as the other at reducing identity to image, reducing nation to Boorstin's "monotony within us, the monotony of self-repetition," reducing politics to culture—but instead concerns the ends to which that abstraction now might be put. Macropolitical or micro: Human self-understanding loses itself to very different ends in the infinite abyss of man himself than in the infinitely articulated array of subject positionality. These is no question that in both instances this loss is itself a kind of liberation and performs an invaluable critical function but the abstractions that stand in—being for the one and identity for the other—also promise different outcomes. It is that difference that should be considered now.

15

In his retirement beginning at the end of the 1950s and during the early 1960s, Steichen sought to further his explorations in the photo-essay form by making a study of a tree near his house. He worked on it for several years, photographing the same tree from every angle, during every season, and at all hours of the day. "First I worked into a sequence," he told an interviewer, "of rhythm and harmony which proved impossible to retain through projections of still shots." Realizing he had reached the limits of the photographic essay, he abandoned it and turned to film. Once "it starts to flow" on film, he said, "it will be alive all the time." His ambitions had been great for *The Family of Man*, but now they seemed even greater. "I have a lot of cockeyed ideas about this tree," he said. "I hope to get out of it the whole drama of existence and life."[94]

In the end, after four or so years of work on the project, he abandoned it, and some years before his death. It is hard to know why he did, but in retrospect the project seemed as though it must have been doomed from the start. The problem, we might speculate, was that he really had no properly negative moment to rely on, no gap or blank screen between the images, no room any longer for "photography itself." Each and every picture was to be about that same tree, and each and every photograph was to be taken by Steichen himself. As such, both object and subject were to remain rigidly consistent, without contradiction, and so all formal variation was left to the composition. In this sense, the switch to film made perfect sense: the displacement of each image with the next and the resulting confirmation of the unity of the experience made perfect sense for this

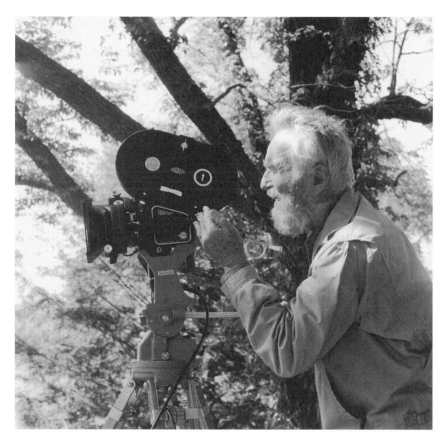

Figure 24
Edward Steichen with movie camera, Umpawaug Farm, 1959. Permission of Joanna T. Steichen.

project. It may have also been the reason that Steichen abandoned the project, for such an approach surely hollowed out all that had thrilled him and his audience with *The Family of Man*. "We learn by experience that we meant something other than we meant to mean," Hegel had written. "This correction of our meaning compels our knowing to go back to the proposition, and understand it in some other way."[95] This opportunity to go back to the earlier proposition, to circle back and reconsider an earlier image, an earlier idea, was not available to film. "I can no longer think what I want to think," is how one early commentator put it. "My thoughts have been replaced by moving images."[96]

Writing in his oft-cited 1978 exhibition catalogue *Mirrors and Windows: American Photography since 1960*, John Szarkowski introduced his curatorial argument by setting Robert Frank against Minor White as window against mirror. Frank was a "documentary-style" photographer, as Walker Evans once termed it, looking out onto the world, rather than an art photographer in the Romantic mold who looks out only to see a reflection of himself, Szarkowski insisted. Frank was a photographer of social form who opened his audience's eyes to "what was everywhere visible" in American society but "seldom noticed."[1] On the one hand, this characterization is true enough. After all, like any good visual sociologist or anthropologist seeking a descriptive system to draw meaning from the world in view, Frank pointed to a range of forms and habits mediating American social life in the 1950s: flags and politicians, actors and jukeboxes, cars and highways, race and racism, social engagement and social estrangement. On the other hand, there is something clearly amiss in this characterization of Frank as a would-be detached social observer. Perhaps more than any other photographer (more than Minor White, say), Frank was concerned with how the world outside expressed his sense of self inside. "I'm always doing the same images—I'm always looking outside, trying to look inside," he stated categorically.[2] Indeed, Frank has regularly been both extolled and condemned for his self-absorption in the face of the American social landscape, for the distinctively poetic disaffection he brought to the documentation of a distinctly unpoetic, distinctly vulgar social world. It was his vision that was news, not his reportage, is how one typical account has it, or, as another put it more pointedly, "In the case of Robert Frank, one wonders if his pictures contribute to our knowledge of anything other than the personality of Robert Frank."[3]

Martha Rosler would sum up this opposing view of Frank's art historical consequence as a window-cum-mirror bearer of self-absorbed artistic vision with the following summary verdict: "From an outward looking, reportorial, partisan, and collective [enterprise] to a symbolically expressive, oppositional and solitary one; the lionizing of Robert Frank marks [a] shift from metonymy to metaphor."[4] Such, we are to understand, is the legacy of Frank's influence: from the old artistic ideal of a singular form using its metonymical reach to extend beyond its proper boundaries to give expression to the whole—at its most ambitious reaching all the way out to what used to be called the "social totality"—to the less ambitious rhetorical maneuver of substituting one part of speech or sight as a stand-in for another part, one personal symbol or reaction or attitude or bearing to give expression as metaphor for another. Frank tells us something about what it is like to experience the social world as an individual, we are to understand, not what it is like to experience the world collectively as a social being—as a class, for example, or a race or a nation.

Such a loss of reach for documentary photography in its refashioning as art or "vision" or personal expression and expressiveness, however, may have been less a function of Frank's work itself than of the lionizing given in its reception. This, at any rate, is my thesis here. *The Americans* did mark a significant change in the history of documentary photography, certainly, but that shift from reportorial to expressive, partisan to oppositional, collective to solitary, metonymic to metaphoric, or from window to mirror was never the simple displacement of one mode by the other, as the lionizing has often made it seem to be, but instead was a mediation or negotiation between the two.

It is the specific character of that mediation that will be under investigation here, and, indeed, it is just such a synthetic or intermediary third position that promises to be the greatest critical legacy of Frank's work—far more, it will be argued, than Szarkowski's window-like Frank or the mirror that Rosler observes in Frank's reception. For example, Rosler herself, together with a variety of others who established their careers in the 1970s—Allan Sekula, Mary Kelly, Jeff Wall, and Michael Schmidt, among others—have regularly aimed at drawing a critical vantage point from working window against mirror and mirror against window in a manner that might well be said to be indebted to Frank. When asked recently by an interviewer about the core ambition driving her work, for example,

Rosler spoke directly to such an agenda: "How can I answer this question? Well, put so nakedly, I'm interested in meeting myself going around a corner. I need to have some bridge between experience and abstraction."[5] That bridge is the third position considered here. It is an aesthetic moment that reaches across the divide between the experience of self and the abstraction of the other, across the divide between observer and observed, subject and object, mirror and window, individual experience and social form. In Rosler's work as in Frank's, it is the moment of turning back from the look through the window to come face to face in the mirror with the anguished realization of the inadequacy of that look as bridge, to come face to face with the inadequacy of the descriptive system at hand.

Of course, this is not strictly new to the period of Frank or that of Rosler and her contemporaries. Such self-scrutiny and self-doubt conceived of as a motor of inquiry has been a cornerstone of the larger modernist tradition at least since the advent of Kant's critical philosophy. At its best, this

Figure 25
Martha Rosler, *The Bowery in Two Inadequate Descriptive Systems*, detail. This is one image from a series of photographs that are paired with texts used to illustrate the second inadequate descriptive system given in the work's title. Courtesy Martha Rosler.

self-scrutiny has opened out into dialectical reason and progressively expanding understanding; at its worst, when it has failed to find potential bridges or means of effective engagement through representation, it has closed in on itself and collapsed into brute cynicism and raw despair for the sensitive, or simple careerism and academicism for the oblivious. What will concern me here is not the self-scrutiny itself or its failure in various endgames but instead the way in which an artistic aim can persist in spite of or even because of that doubt, the way in which Frank's artistic inquiry returns to scrutinize itself in the mirror again and again and again in order to find a cleavage or fissure in its own limit condition that turns mirror into window opening out onto a sense of adequately comprehensive understanding.

Such a hope for, or insistence on, large comprehension—on the promise of an adequate descriptive system—is always an illusory and utopian goal. In effect, it is representation aiming beyond representation, photography aiming to be reality itself rather than its two-dimensional, tightly cropped, frozen-in-time representative, to be life as lived rather than life as recorded. Despite this overreaching, such an ambition is nonetheless important. At its best, it serves as the motor driving inquiry by setting the telos against which all actually existing attempts at representation are judged, against which all such attempts are found to be more or less inadequate. The drive toward such comprehension and its frustration along the way, the photographic ambition together with the realization of its inadequacy, thus will be the source of the "anguish" in my title, and its marker will be the way in which doubt about the capacity of the means of representation, of photography, to realize that aim is returned to again and again and again, the way it is worked and reworked to overcome its limits.

The specific locus of that agon or motor of self-critical interrogation and aspiration driving his obsessive engagement with the limits of his medium can best be found primarily in Frank's production of photographic *space*—in the space given form between photographer as subject and the photographic object at hand. As one Frank follower put it early on, the issue was not the social landscape and its elements "but rather a shifting complex of visual experience"; there is "continuous fusion of things seen," he continued, concluding that the "catalyst in the picture making process has been well defined by Robert Frank as 'an instantaneous response to oneself.'"[6] How, I will be asking, did Frank position himself and the objects

he photographed in the world? How is the relationship between subject and object articulated by the spatial organization given by the camera, by the spatial organization indicated by the movement from one photograph to the next? How, that is, does he give us a "continuous fusion of things seen" or a representation of the world that adds up to more than the sum of its parts? It is here, within the dynamic of the photographed space, that the relation addressed by this book's title—the pivot of the world—is given form.

More than anything else, of course, *The Americans* participated in and helped to define or redefine the road trip as a genre of experience and representation. This was one of the key elements that marked its difference from the work of Frank's 1930s forebears. Walker Evans, Dorothea Lange, Margaret Bourke-White, Russell Lee, and others were, after all, on assignment when they took to the road to document specific social conditions for the government. Their travels were negotiated with their employer and determined in advance by the themes and concerns they were hired to address. In this regard, their relationship to the road bore similarities to that of a census taker or a social worker or even a traveling salesman in a way that Frank's did not. That is, their relationship to the space they photographed and the places they traveled to was driven by a clear instrumental directive and socially determined aim. Frank's, in contrast, "was almost pure intuition," he said. "I just kept on photographing. I kept on looking."[7] The Farm Security Administration (FSA) photographers were traveling first and foremost for the purposes of reportage and accordingly were much less interested in recording a diaristic view of their own experience of travel. What they thus looked for along the way were objects that filled that space: impoverished families, derelict buildings, signs of regional vernacular culture, signs of self-realization in the face of poverty and lack. Their task was clear—to formulate, convey, and catalogue an iconography of the Depression, to develop a visual catalogue for a national myth for the moment—and their approach was not dissimilar from that of any good anthropologist or sociologist out in the field gathering data, or from any good propagandist putting together bits and pieces taken from the visual world to convey a message and convince an audience. Their photographic vision was drawn in significant measure from a collective vision—a vision given by the expedient needs of their times, a vision given by their employer.

Figure 26
Dorothea Lange, Resettlement Administration photographer, in California, 1936.
Courtesy of the Library of Congress, LC-USF34-002392-E.

That there were differences in style, sensibility, and motivation among the various photographers and administrators involved in this undertaking, that some resisted and resented the mandate given them by their employer ("never make photographic statements for the government, or do photographic chores for the gov. or anyone in gov. no matter how powerful," Walker Evans promised himself just before signing on with the FSA, for example),[8] and that some of their work was retrofitted happily and successfully into this or that rubric of artistic vision after the fact (as "a path between French aesthetics and newsreels," for example)[9] does not

detract at all from the central formative fact that they were on a mission to document something. They were in search of and readily found objects to photograph, objects that would carry the meaning they were commissioned to convey.

They were in this sense more fully "windows" in ways that Frank was not. Although their look out onto the world may have been representative of a perspective and a sensibility—a politics, for example, or a sense of propriety (or lack thereof) toward the people photographed, or even an aesthetic—they were still bringing that perspective to bear on the commissioned subject at hand. Put another way, while Evans, for example, might be said to have looked out onto the world with the means of straight photography only to recoil into the aesthetic, into photographs seen as "jewels," as Frank described them, Frank himself used that same recoil to propel himself back out onto the road again.[10] The strength of *The Americans* thus is that it shifted the primary locus of attention of documentary photography from object to subject, from objects to be photographed—people, places, and things, social conditions and history as lived by the photographic subjects—to the photographer's own experience along the way. Frank's was a road photography per se, in other words, not a destination photography, and it is marked first and foremost by the interlude of passing through rather than by the solicitations typical of a visitor. "It is," one observer notes of *The Americans*, "a portrait of the artist" (not, that is, of the artist's subject), a portrait "made visible" by, among many other things, "the wary, angry or bemused looks that greet the photographer's intrusion into a scene."[11]

So it was that *The Americans* was ungenerous and antisocial, realizing its detached, narcissistic status as mirror. Above all else, it communicated its judgment, its scorn even, for the world it represented in a manner that showed no compunction about burning bridges. "I don't have any respect for anybody that's in front of my camera," Frank admitted. "I use them. I manipulate them to suit my purposes. I don't tell them the truth."[12] His was a lonely and isolated position to occupy, a position confined to "the glum avant-gardism of his own mood," in Dwight Macdonald's summary verdict.[13] Closed off from the world he was passing through and confined to the lonely side of the camera, Frank's vaunted artistic vision seemed to be strictly self-absorbed and claustrophobic, a looking out through the camera-as–window onto the world, only to find there nothing more than the narcissist's mirror, only to find no world there to be had after all, or

at least not one worthy of inhabiting. That he would eventually exile himself to a remote hamlet in Nova Scotia seems only to confirm this verdict.

This refusal of world also had a further consequence: it was inextricably and unavoidably bound up with the degradation of the conditions of representation. Made up of seemingly rushed, blurry, grainy pictures, each stolen with a glance, Frank's artistic vision embodied more perfectly than any photographic practice before it the reduction to cynicism and despair of modernist self-immolation. "The camera seems like a reflection of disapproval or disgust or disappointment or unhelpfulness, unexplainability to disclose any real truth that might possibly exist," stated a character in one of Frank's early films. Something like this critique, this doubt, this concern with the inadequacy of his descriptive system, is what led Frank to abandon photography for film.[14] It is as if the more he looked around in the world, the more he was thrown back on his inability to engage it.

That this inadequacy can be located in the social landscape itself—in *its* self-absorption, its chauvinism, its vulgarity and provincialism, in the poverty of *its* means of engagement with difference of any kind, in *its* status as self-absorbed mirror rather than window, that is, in the version modernist self-immolation given by Americans themselves and the American social landscape—is neither here nor there. Frank was still unable to engage the world he chose to document beyond the despairing level of wounded resentment; he was unable to transcend the limits of his environment. There was, for example, no immigrant's or hayseed's or postcommunist's more-capitalist-than-thou end run around American chauvinism as there would be in spades just a couple of years later in the work of artists such as Warhol, Richter, and Ruscha or the work of the Sots artists a generation later, or the Chinese neo-avant-gardes after that. In this sense, thus, Frank's avant-gardism was indeed glum. To put it schematically, his was a modernism that did not believe in the truth claim of its own doubt, a modernism that was desperately holding on to the old ideals against its own self-immolation, a modernism, that is, that neither believed in itself as a descriptive system nor in itself as a symptom of the failure or inadequacy or lack of that descriptive system.

Nonetheless, such an account of the inadequacy of Frank's descriptive system closing in on itself in response to the world he confronted is misleading, at least on its own. There is an opening outward in *The Americans*

as well, a mirror-cum-window perspective we might call it, a moment where the book breathes its freshness and openness into both subject and object and vies for the attention of the beholder with equal force as the powerfully glum sense of closure and isolation. This too is a theme that Frank returns to again and again in interviews and other statements, and it is responsible for giving *The Americans* much of the larger sense of ambition that has made it continue to seem masterful and compelling, exhilarating and rejuvenating, beyond the resentment and claustrophobia of the banal mirror image of Frank looking out onto the world only to see himself. There is no question, for example, that Frank loved his subject. "One of the great things about this country is that it is still open," he said, giving a sense that the measure of his photographic ambition somehow correlated to the measure of his photographic subject. "You can go on the road. You still have the promise that you can go out there and find something extraordinary. Europe is so small and closed, that idea doesn't exist."[15]

The most obvious way to perceive this opening, this promise of "something extraordinary," is by looking, as he indicates, to the book's central narrative conceit of the road. It is this, after all, that allowed Frank his grand and comprehensive claim to represent the nation in sum. He had traveled its highways from north to south, from east to west, we are to understand; he had seen it in whole; he could legitimately claim to characterize its people. As the viewer works through the book, from one picture to the next to the next, the cadences of the road rise and fall, stringing one roadside attraction along the way together with the next and the next and the next—"Ranch market—Hollywood," then "Butte, Montana," then "Yom Kippur—East River, New York City," then "Fourth of July—Jay, New York," then "Trolley—New Orleans"—until the whole project comes together in the unified staccato rhythm of a road trip (if without its narrative sequencing), "a sad poem," as Jack Kerouac described it in his introduction to *The Americans*, sucked "right out of America onto film."[16] There are some thirty images of cars or roadways sprinkled throughout the eighty-four pictures that make up the book, but this in and of itself is not important. The road as figure or agent of "something extraordinary" is not simple and cannot be adequately assessed through simple iconographic means. Instead, it points to two discrete possibilities, two ambitions for representation, two measures for its adequacy. On the one hand, it ties

together each picture to the next in a single phenomenal and analytical thread that creates the sense of grasping the nation in sum, of mastering an adequate representation of the large subject given in its title (not unlike any good social scientific study, it might be said—*The Nuer*, for example, or *The Savage Mind*, or, for that matter, *The Chimpanzees of Gombe*). In this sense, the road as thread or conduit or medium laid claim to representing something like a social totality.

That said, however, the road also bore a different sort of promise. It served not only as a connector but also as an opening—as a way out of town, as the open road or the road to nowhere or, more simply and abstractly, as a gap or void or blank in or on which narration or figuration can occur, that is, as the negation of that same social totality that it presumes to give form to in its role as connector. "Mr. Frank had an eye for vacant spaces in the physical—and social—landscape" is how one account describes those cleavages or fissures that open up the world he depicts beyond the social scientist's deadeningly homogeneous lexicon of symbols and signs: flags, jukeboxes, automobiles, racial and class markers, and the like.[17] Just as the road serves as binding agent tying the component pictures together into an overall plan or image, so too it serves as a gash or breach or fissure in that same hegemony, in that same means of control over the landscape: both icon and anti-icon, both figure that confirms the chauvinism of American national identity—as a symbol of both social mobility and military mobilization, for example—and a figure that opens that chauvinism outward toward other spaces and possibilities solely by the power of negation. Over and over again in *The Americans*, this second meaning heralded in the theme of vacancy or blankness or space defined by the negation of what might be otherwise filling it—in desolate stretches of highway without any cars, for example, or in faces or bodies obscured by flags and sousaphones, or in backs turned to the camera or in facial expressions rendered blank by distraction or indifference or self-absorption or in the images of bodies or cars covered over—serves as a core motif.

This is also a theme that is made emphatic by Frank's strong use of the accompanying blank page. This was a technique he learned from Evans, and it was emphatically and self-consciously at odds with the *Life* magazine version of the photographic essay that dominated the day. However, his use of it was very different from that of exemplar Evans. Where the blank opposing pages in Evans's *American Photographs* set each image off with the

distance, framing, respect, and elegance suitable for the propriety and distance of Evans's detached style—like the white cube of the modernist gallery—that blankness in *The Americans* served to signify a sign of isolation and grim dehumanization, of identity that lacks a living, vital, generous sense of community, of a collective social form that had become brittle and without the rejuvenation of fresh human connection.

Where Evans shot his photographs straight-on as portraits in a manner that often involved a negotiated exchange of looks and staged formal composition, Frank shot on the sly, with a stolen glance that did not typically allow his subjects to compose themselves. The awkwardness or smugness or self-absorption or aggression or bitterness or despair that he captures is left on its own without the consolation of context, without sympathy or explanation, without the decency or respect of a warning, and it thus enhances the sense of Frank's glum artistic vision. The paucity of generosity, in other words, is reciprocal between subject and object, and that is the point. There is no Depression given to explain the aggression and

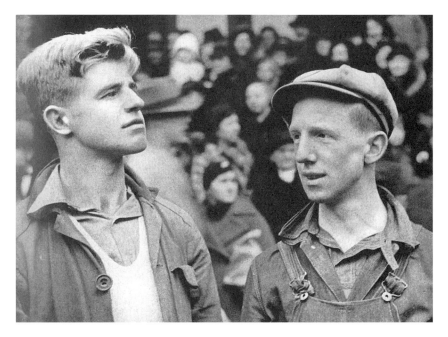

Figure 27
Walker Evans, *Faces, Pennsylvania Town, 1936*, from *American Photographs*, 1938. Permission of the Metropolitan Museum of Art, New York.

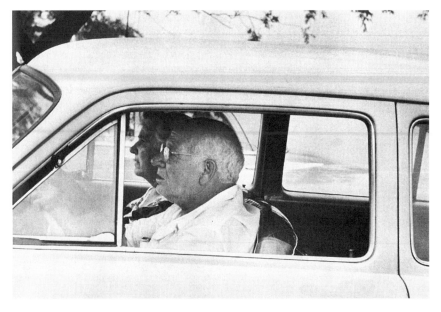

Figure 28
Detroit from *The Americans*, 1959. Copyright Robert Frank, from *The Americans*. Courtesy Pace/MacGill Gallery, New York.

malaise here, no class analysis, no war, no failed social program, no assumptions about common human decency—only pure disposition, pure coagulating of human sociality. This, of course, was the dominant theme for most of the book's initial reception. "It is a world shrouded in an immense gray tragic boredom," wrote one reviewer in 1960, "This is Robert Frank's America. God help him."[18]

That Frank's book assumed little of the social explanatory framework of the 1930s did not prevent many of his critics from falling back on red-baiting, however. "It is obvious that Mr. Frank had 1934 eyes and blinders on while shooting," said one.[19] Indeed he was "a throwback" to that which "was so important to photography in the thirties"[20]—in other words, a "propagandist"[21]—but he was so in the very different social climate of the 1950s, which "was not one in which the artist could feel at home, as he had in the 1930s."[22] Nonetheless, Frank's blindered view or gray shroud registered not only as a form of tendentiousness but also as its opposite: a blank screen or space for projection or an opening outward toward otherness, as a look toward something other than the flags, and television

screens, jukeboxes, and roadside attractions that populate the pictures. It was, in other words, a willful blindness, a tendentiousness without direction or bearing, a turning away from that immediately available to vision in a manner that is not intended to close off part of the visual field—so that he might see only his own mirror reflection—but instead to open it up to that which was not there.

We can point to what has been missed by the existing reception of *The Americans* most fully by looking again to what we might now see as period "eyes and blinders" in the account given by John Szarkowski, whose observations on Frank's work seem consistently very smart but also always representative of the limits of his own slightly later moment. Writing in 1968, for example, he noted in a manner sensitive to the changing conditions of reception that it was difficult "to remember how shocking Robert Frank's book was ten years ago. The pictures took us by ambush then." He was also perceptive about what it was in Frank's pictures that was not there in others: "We knew the America that they described, of course, but we knew it as one knows the background hum of a record player, not as a fact to recognize and confront. Nor too had we understood that this stratum of our experience was a proper concern of artists." This had all changed, of course, and in no small part, at least for the artistic domain of documentary photography, due to Szarkowski's own patronage of Frank followers such as Diane Arbus, Garry Winogrand, and Lee Friedlander. Where Szarkowski missed, however, was with his account of what Frank did with this disregarded stratum of experience previously available only as a background hum, of how he grappled with the problem of representation: "Robert Frank established a new iconography for contemporary America, composed of bits of bus depots, lunch counters, strip developments, empty spaces, cars and unknowable faces."[23] The problem for Szarkowski's account is that he abandons the strength of his own observation when he shifts his focus to the iconographic "bits" from his previous emphasis on the "background hum" of American social life.

This was so because it was the hum that Frank got right more than the bits. It was the relations between pictures and between spaces, between bits and the absence of such bits, not the individual objects or photographs themselves, that carries the force of *The Americans*. As Frank said about another series, "I like to see them one after another. It's a ride bye and not a flashy backy."[24] That is, the emphasis of the book was not on the singular

moments called up by particular photographs or particularly iconic representations of American life—that is, on decisive moments experienced as flashbacks or any other form of pointed experience that serves as a summary metaphorical expression of something larger than itself—but instead on the momentum of the "ride bye" that strings one photograph together with another and another in a metonymical sequence, on the hum that serves as background noise linking together all of the photographs in a continuous chain. "Frank brought to a close photography's quest for the decisive moment" is how one observer has characterized this resolution that Frank's followers served to reopen, if in an ironic mode: "In *The Americans*, America stood still, frozen into a frightful pose *between* moments."[25]

The quality or condition that carried this signification most was the way in which movement was registered in the photographs. This distinction has been described well by Tod Papageorge: "There is a wonderful illusion of speed trapped in his photographs, a sense of rapidity usually created not by the movement of Frank's subjects, but by the gesture he made as he framed the pictures." Indeed, "Frank seems to have felt that movement *within* the frames of his photographs would only disturb their sense, and, with a few exceptions, ignored the use of dramatic gesture and motion in *The Americans* (a fact which . . . suggests his feeling about Cartier-Bresson's work)."[26]

It is this expropriation of movement from inside the frame to outside that is the single most important quality of Frank's work for the purposes of this study. It is this that serves as Frank's bridge between window and mirror, between object and subject, this that serves as the means by which his work escapes its narcissism and opens back out onto the world. This distinction was summed up as follows by another observer: Cartier-Bresson "presented a photographic approach which suggested that intelligent camerawork could usurp for the professional the candids which so often fell into the lap of the amateur. It became a cul-de-sac, however, in that the professionals were deadlocked in a race for precision, with Cartier-Bresson in the lead." Frank "killed the grandfather of photography," is how one photographer put it. One gets "the feeling that Frank's sense of timing is based on catching a more general and unlikely gesture," that is, "a *stance* rather than a gesture."[27]

Indeed, it was this stance or attitude or bearing toward the world that stood as correlate on the photographer-subject side of the camera to the

background hum on the photographed-object side. Put more simply, there was a kind of accuracy or harmony or apparent truthfulness that registered as a correspondence between the mood or disposition of the photographer and that of the country, between subject and object, and this measure of accuracy seemed to exceed that available to iconographical or any other sort of analysis that confined itself to what was represented in the pictures.

In this regard, Frank's followers Arbus, Friedlander, and Winogrand were all indebted to Cartier-Bresson in ways that Frank was not. This can be put most simply by saying that each in his or her own way was a single-image photographer; each produced photographs that found their force and dynamism more through their internal compositions than through the relations of one photograph to the next and the next in a series; none produced a document that could claim the same large comprehension and internal coherence as *The Americans*; each found his or her ambition primarily as pasticheur.[28] Frank's larger sense of composition allowed him his generalization, his claim to characterize a nation rather than to present a series of isolated moment-as-icons held together by the artistic conceit of the photographer.

This latter approach might be said to be given the strongest expression in the work of Diane Arbus, who made a point of photographing odd*ities* and not oddity as the background hum of everyday life, but it is characteristic of the other Frank followers as well. Garry Winogrand gave the strongest posthumanist recasting of Cartier-Bresson, for example, by turning nose-picking, scowling, gawking, begging, and other indecorous gestures into decisive moments, and Lee Friedlander took Frank's road-trip iconography, his window-cum-mirror view onto the world, and made it over into a comic staging of alienation that presented itself as banal as the American social landscape being documented and thereby giving the alienation itself a kind of iconic pictorial status that reworks the window-mirror relation in a new way. Put schematically, window and mirror no longer stand at odds for Frank's followers in a manner that creates tension and anguish—but instead reconcile themselves in attitude or style.

For each of these later photographers, the formal concern of the series, of the accumulation of images that adds up to a comprehensive statement or photographic essay, is abandoned in favor of developing a photographic conceit, a way of handling the camera in the world that is no longer bothered by the tension between photographer-subject and photographed

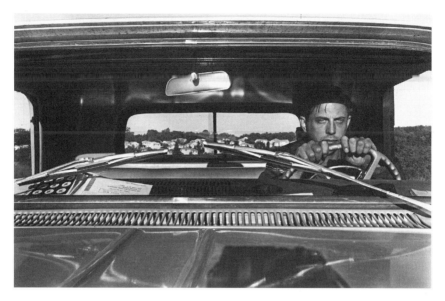

Figure 29
Lee Friedlander, *Haverstraw, New York*, 1966. Courtesy Fraenkel Gallery.

object as an anguished encounter with what photographic representation cannot achieve. Certainly, there is a heightened consciousness of the photographic means, of photographic vision—particularly in the work of Friedlander—but that consciousness is not one that is ever constituted by its own limits as a descriptive system, by its own limits as a means of relating to the world. In this way, the work of Frank's followers no longer assumed the demands given by "1934 eyes and blinders"—the demand, that is, to picture social form—as a limit condition or measure for photography as a descriptive system. In Frank's case, photography did not, could not, live up to such a measure despite its built-in desire to do so, and this registered in his work as anguish. In the work of his followers, beyond being a topic for parody and pastiche, anguish was not even a factor.

16

Psychologically, thus, Frank's relationship to the world was different from that of these immediate followers and others as well because he experienced what he photographed with less detachment and more ambivalence. "Pictures are probably closer to feelings than to thoughts" was, generally, his motto, and, among other comparisons, he would distinguish what he

did from conceptual art: "It is a little too 'brainy' for me, I don't go through those exercises too well; they tire me out because I would rather feel than think."[29] It was not any sort of feeling that he sought, of course, but one that drew a sharp defensive edge out of its ambivalence.

To get a better sense of the acuteness of this feeling, we might first look to how Frank was understood by Louis Faurer whose photograph of Frank with wife Mary was exhibited in *The Family of Man* exhibition. Faurer came to photography with his own philosophy. As he put it later, "My eyes search for people who are grateful for life, people who forgive and whose doubts have been removed, who understand the truth, whose enduring spirit is bathed by such piercing white light as to provide their present and future with hope."[30] And while we can readily see this philosophy's affiliation with *The Family of Man*, it is also not so far from Frank's own feelings as it might initially seem. The issue for Frank was simple: "I need to be plugged in to Network of Human Mayonnaise," he gushed at one point, and while Frank's desire for mayonnaise is certainly not the same thing as Faurer's for white light, both do share a longing for a sense of human connectedness.[31] For example, betraying both his desire and his symptom at another point, Frank asked himself about life in New York with the one-word query, "Sick?" and then answered, "Yes sir, it's sick all right," asking himself again, "Why do I stay here?" and answering, "Just to be in IT, to see it coming and going, to let it drive me crazy, if it hasn't driven me half crazy already."[32]

Like a lot of lonely or isolated people, Frank had a love-hate relationship with the social world, the "IT," he photographed. "It's very hard to get away from myself," he said to interviewers and others on a regular basis. "It seems, almost, that's all I have," indicating that doing just that—getting away from himself—was to the task at hand. And indeed, if we are to judge from the photographs, aside from his young wife and two children on the road with him, that does seem to be all that he had. Of course, we know otherwise from the historical record. At minimum, Frank had a rich professional life. He was a favorite of leaders Steichen and Evans, for example, he did very well on the commercial circuit despite feeling snubbed by *Life*, he was an intimate and collaborator with the likes of Kerouac and Ginsberg, and he was a neighbor, admirer, and associate of de Kooning. For someone feeling as if he was missing out on the network of human mayonnaise, he was certainly in the thick of things. "That's sort of a sad feeling," he would

say, but his sense of isolation was clearly a frame of mind or an affectation or maybe an artistic method much more than a lived reality, at least in any simple sense. That "feeling of being a stranger," he said in a theme that he has repeated over and over again, "it has to do with years of photography, where you walk around, you observe, and you walk away."[33] Indeed, we might well agree that this feeling is generally a product of the walk-away characteristic of most documentary photography more than it is a function of a particular personality, that it is a nervous condition typical of the parachuting photographer as a type. (For example, if might be as readily seen in the work of Friedlander or Winogrand or Arbus, even as we bear in mind that Frank experienced this condition differently from his followers whose work consistently demonstrated comfort, even nonchalance, with the role of outsider.)

This double-bind with identity—the longing for the bond of shared identification, for the experience of nation, on the one hand, and the sense of release from identity on the other—is exactly the experience that all three of the photographic projects under consideration in this book concerned themselves with. This was the substance of aesthetic experience that they worked with, their historically specific sense of the beautiful and the sublime, and it is what made their work seem so pressing, so necessary, and obsessive. This conflict in its dealings with identity is what gave it the sense of being overwrought and in the wake of which the capitalist realisms of the next generation would come as welcome relief. In each case, the question of how to work social form was at issue, how to find the right balance of belonging and fluidity. There is no question that for Frank, America represented the best possibility for that balance, and he found its greatest promise or potential in New York City. "My affair with New York," he said, "made me what I am," not meaning, however, that New York was exceptional in this regard; rather, he continued, "I feel the same thing about America."[34] The affective experience of that affair with "human mayonnaise" or the "IT" that made him "half crazy" was both salvation and disease, both frustrating pathology and promising cure.

This was the experience that Frank found and courted from the very beginning in America. "Dear Parents," he wrote, for example, just days after arriving in the United States still thick with all the myth-consuming, mouth-agape fervor of the young tourist coming of age on the road. "Never have I experienced so much in one week as here. I feel as if I'm in a film,"

he said, concluding with philosophical flair, "Only the moment counts."[35] And indeed, this would be the experience he would court throughout his career: the moment or instant where one experiences the ephemerality of identity, where one experiences not grounded and enduring traditions, national, religious, ethnic or otherwise, neatly packaged in a decisive moment—"Life here is very different than in Europe," he said in the same breath—but instead the passage from one moment to the next, one identity box to the next, one frame to the next.

"Life here," for Frank, seemed a much more plastic medium. The question was only about who was doing the scripting or editing, and the bulk of his efforts went into holding out space for him doing his own. His primary nemesis in this regard was *Life* magazine. "I wanted to sell my pictures to *Life* magazine and they never did buy them," he complained, "so I developed a tremendous contempt for them which helped me." In response, he said, he wanted to follow his own intuition, to do it his way, "and not make any concessions—not make a *Life* story." His was not to be one of those "god-damned stories with a beginning and an end."[36] Instead, he would take the principle of photography itself, of photography as a conduit for human mayonnaise, photography as itself being a network of relations and therefore available as a vehicle for realizing IT or the experience of self found taut with the superabundance of social form, and work it for all he could.

Part and parcel of that experience for Frank was the moment of preserving or achieving anonymity, the moment of fleeing recognition, the moment of each picture folding into the next, the moment of turning away after the click of the shutter. Frank experienced this principle with decisive force and clarity while on the road. "I feel that if I talk to the people I photograph, my concept of the photograph is lost," he reported in a letter from the road back home.[37] His concept of the photograph was one born of the promise of photography set apart from talking to people, that is, it was what Steichen called photography itself.

This dream of anonymity, of relating without really relating, was mostly an old dream, of course, the dream of identity in abstraction, of identity found in genre, class, or category, of the social itself. "It is ourselves we see, ourselves lifted from a parochial setting," Walker Evans would later sermonize reading from the gospel of William Carlos Williams. "We see what we have not heretofore realized, ourselves made worthy in our

anonymity."[38] It was a theme that Frank had taken in no small part from his mentor Evans, whose *American Photographs*, Evans himself had said, was a document about "the general run of the social mill: anonymous people who come and go in the cities and who move on the land," one that focuses on "what they look like now; what is in their faces and in the windows and the street beside and around them; what they are wearing and what they are riding in, and on how they are gesturing."[39]

This same dream of anonymity, of the general run of the social mill or social form, was also remade by Evans just a few years later in 1946, albeit now as a postwar capitalist myth for his employer *Fortune* rather than the reluctant pseudosocialist myth he had produced for his former employer. "The American worker, as he passes here, generally unaware of Walker Evans' camera, is a decidedly various fellow," read the editorial copy to Evans's spread "Labor Anonymous." As with his earlier statement, the photographic ambition was still to see detail, variation, particularity in the mass. "His blood flows from many sources," the text continued about the abstracted figure of labor. "His features tend now toward the peasant and now toward the patrician. His hat is sometimes a hat, and sometimes he has molded it into a sort of defiant signature." But this same wealth of sumptuous detail was now refigured not as value for itself but instead was valorized in no uncertain terms as capital: "It is this variety, perhaps, that makes him, in the mass, the most resourceful and versatile body of labor in the world . . . in labor, as in investment, diversification pays off."[40]

In Evans, Frank had a clear exemplar, a model for picturing social form that did not fall back on the problem of those "god-damned stories with a beginning and an end" or narrative structured around the individual. Nor did it fall back on what was "now a very dated caricature," as Evans had it in his draft version of the *Labor Anonymous* text, of " 'Labor' portrayed as a grinning—or groaning—colossus."[41] The meaning, as Evans had it instead and as Frank did following him, was in the mayonnaise, in the to and fro of social form, in feeling "as if I'm in a film," in the "IT" Frank experienced most stirringly in New York. "Evans discovered—and it has the force of an invention in photography—that the literal point of view of a photograph, where the camera stands during the making of the picture, can be so treated in an extended sequence or discourse as to become an intentional vehicle or embodiment of a cumulative point of

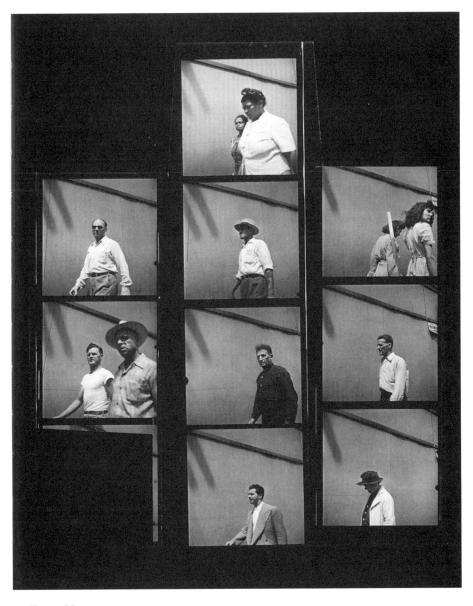

Figure 30
Walker Evans, cut contact sheet for "Labor Anonymous" spread for *Fortune* magazine, 1946. Permission of the Metropolitan Museum of Art, New York.

view, a perspective of mind, of imagination, of moral judgment."[42] There is a moment of accumulation of perspectives in this tradition, a becoming-social moment, a moment where the individual point of view accrues into the social, a moment when the outsider stands in, a moment that places the meaning of the work not in the individual photographs but in the interstices between photographs, not in the individual embodied subject but in the abstraction of the collective subject. This is what made it serial rather than a "god-damned" story, and it is there that the potential resided for the essay form to emerge.

The photographic essay arose from the editing process as much as from photography itself and the editor's slice-and-dice relation to the world made it into the photographic response. Evans described the affective dimension of this relation well: "I'm excited up to a point [then] I must enter with another part of myself with discipline and control. "He had a particular model in mind for this role: A surgeon has to be detached from human pain . . . [detachment is my] professional equipment."[43] This was not editing in the sense of tight packaging, not even in the manner that Evans attributed to August Sander—"a photographic editing of society"—but instead in the sense of being there in the process, working back and forth, of getting excited in the thick of the decisive moment and then removing oneself with discipline and control, of meaning realized only in and through the to-and-fro, engagement-and-retreat process. This is the methodological and affective core of the essay form: "We learn by experience that we meant something other than we meant to mean; and this correction of our meaning compels our knowing to go back to the proposition, and understand it in some other way."[44]

That moment of emotional distancing from one's own excited identification, the moment of abstraction, of self becoming other, served as the stock-in-trade for essayists like Evans and Frank just as it did for *The Family of Man* and as it would in turn for Bernd and Hilla Becher. That reaching across this gap between self and world was anguished for Frank, and therefore his project held onto its subjective moment, its mirror moment, its moment of the experience of inadequacy, much more resolutely than did Evans, who was more clinical, more firmly satisfied with the moment of detachment, and therefore more window and less mirror. It was this anguish, like the ecstatic moment in *The Family of Man*, that served as a marker of Frank's contribution and the critical legacy that would be taken

up subsequently by Rosler and others. In this way the spatial problem of mirrors and windows—of looking out and looking in—was brought to a head with inside seeming all the more out, raw and exposed, and the outside world of social form, of social determination, seeming all the more in, haunting the core of *The Americans'* powerful and enduring sense of self. The world was "wholly inside," as Merleau-Ponty put it, and the self "wholly outside."

17

Technically, thus, it was Frank's running away after the click of the shutter, his emotional distancing—like the surgeon in Evans's figure—more than his iconography, that was the locus of his unique and powerfully critical aesthetic sensibility. This was recognized broadly from the beginning. "Abstraction is forbidden to you, and consequently wit," was one of the ways in which *The Americans'* first publisher, Robert Delpire, gave words to Frank's critique suggesting, of course, that as a European observer, Frank had the self-distancing necessary for critical consciousness that his American subjects did not.[45] "He shows high irony towards a nation that generally speaking has it not; adult detachment towards the more-or-less juvenile section of the population that came into his view," is how Evans put it. "Irony and detachment: these are part of the equipment of the critic. Robert Frank, though far, far away from the arid pretensions of the average sociologist can say much to the social critic who has not waylaid his imagination among his footnotes and references."[46] Indeed, Frank's abstraction bypassed all pretense of academic or scientific method in favor of a strong use of figurative representation that subsumed whole to part, of subject to its trope. Epistemological consistency was circumvented by authority of poetic license, thereby exercising the metonymy that Rosler notes was lost in the lionized reception of *The Americans*. As one early critic griped, for example, Frank reduced San Francisco from its myriad particulars to "a fog-shrouded Chinese cemetery, or a grubby couple in a park (their eyes both angry and frightened)."[47]

In one sense, the gripe was fair: Frank's was not a gracious abstraction, not a mere reduction to some warm, fuzzy, and undisputed San Francisco-ness or American-ness, in other words, but instead an execution of reduction or abstraction that itself, as an action, carried a critical truth-claim about the subject at hand. The abstraction was in important ways Frank's

San Francisco—in other words, not that of the locals or the tourist board, not the city as they would choose to represent it to themselves or to others. "Never," in the words of one Swiss colleague, hedging on whether he was describing the subject depicted or Frank's representation of it, "have I seen so overpowering an image of humanity become mass, devoid of individuality, each man hardly distinguishable from his neighbor, hopelessly lost in airless space." Indeed, even when he described Frank's book as an image of a "dour mass, crafty and aggressive," it is unclear to what degree that dourness, craftiness, and aggression—or, for that matter, the amassing itself—was understood to be a quality of the subject photographed, of Americans, and to what degree it was meant to describe something brought to it by Frank himself and that served as a measure or index of the power or distinctiveness of his vision. "It will take us considerable time to separate the impression made on us by the world depicted in these photos," his old associate admitted, "from our respect for your remarkable performance."[48]

Perhaps the best way to make sense of the intersection of subject and object in *The Americans*, to appreciate the mix of Frank's aggression on one side of the camera, for example, with that of his subjects on the other, is to focus on the "background hum" that Szarkowski picked up on, or the "airless space" noted by the Swiss colleague. This was a function of his technique. As one historian notes, "Frank used fast film, and its grain, the small negatives in this tradition, and the poor lighting, and focus give nearly all his pictures a scummy tone, as though they were taken (as many were) in smoke-filled rooms."[49] Not just smoke, lighting, and grain but "meaningless blur" together with "muddy exposure, drunken horizons, and general sloppiness" contributed to the overall effect.[50] His activity seems always to have been a struggle with and against that scummy, muddy, drunken tone, a struggle with the thick atmosphere of craftiness, dourness, and aggression, a struggle to both give form to it and escape it, a struggle to breath, a struggle to find open air both in the social landscape and in his own tortured soul. He made "expeditions into the intestines of America," in the preferred metaphor of another critic, only to expel himself immediately, and it is the nervous tension of the expedition and the ecstatic release of the expulsion *together* that make the book so powerful.

The latter—the expulsion out of the world and back into the self—is the moment of freedom for Frank, and it is the dynamic combination of the

two, of entering into a fraught engagement with "human mayonnaise" only to quickly exit and thereby release the tension, that carries the beholder from one page to the next in *The Americans*, from one picture to the next in the sequence.[51] More than anything else, this is what makes Frank's technique so effective. Over and over again, as one leafs through the book, this relationship is pictured on opposing pages, with this or that bit of the "intestines of America," this or that craftily stolen glance, on one side, and the outlet from it, its negation, on the other. What is of greatest interest for our purposes here, however, is not so much Frank's technique or craft as photo-essayist, but instead the ways in which this, as his chosen motor for serial form, stands in itself as a figure, as somehow representative of his subject, somehow representative of the mix of claustrophobia and desire that he experienced as the condition of being an American. The hit-and-run, flex-and-release rhythm of Frank's book itself signifies the ambient, difficult-to-locate subject at hand, the background hum or scummy tone or drunken horizon of craftiness, dourness, and aggression.

In his application for the Guggenheim fellowship that funded the cross-country trip that became *The Americans*, Frank wrote that he sought to document with fresh European eyes "the kind of civilization born here and spreading elsewhere." That kind of civilization, American civilization, had particular qualities and characteristics, a particular structure, which was the central subject of his reportage. That structure, for Frank, was first and foremost a function of its status as melting pot. This, it should be said first, was what Frank identified with most—it was his American dream as much as it was for anyone else—and the ecstatic moment in the subjective economy of his project can well be said to be just such melting. By all accounts, he fled Europe because he hated it—"Europe is so small and closed," he said—and his strategy, his relationship to identity, was exactly opposite to that part of postwar Swiss national identity that had its origins in the wartime strategy of the réduit, or redoubt, holed up and hidden away from Hitler's expansionism. If Frank's Europe closed itself off from its own self-destructive tendencies, Frank's America held out a different promise, a different strategy for dealing with its own self-destructiveness.

Indeed, such an alternative promise might be said to be one of two long-standing dreams of persecuted groups generally in the face of their persecu-

tion and particularly so for our purposes here of Jews in the face of anti-Semitism and genocide. Frank was raised in a cultured bourgeois Jewish household, and his father was a German immigrant who was trained as an architect. Hitler's rise to power pressed itself on the family psychology as it would have for any Jewish family or one from another of the persecuted groups targeted by the Nazis: "It's forever in your mind—like a smell, the voice of that man [Hitler]—of Goering, of Goebbels—these were evil characters. Of course you're impressed. It made me less afraid and better able to cope with difficult situations because I lived with that fear. Being Jewish and living with the threat of Hitler must have been a very big part of my understanding of people that were put down or were held back."[52] A German cousin came to live with the Franks, but her parents were not allowed to pass over the border and were later killed in the Holocaust. Frank recalled the fear of his parents as they listened to Hitler on the radio: "If Hitler had invaded Switzerland—and there was very little to stop him— that would have been the end of them. It was an unforgettable situation. I watched the grownups decide what to do—when to change your name, whatever. It's on the radio everyday. You hear that guy talking—threatening—cursing the Jews. It's forever in your mind—like a smell, the voice of that man."[53] The two alternatives available to Frank at a formative moment in his life, driving his relation to the world and defining his photography, can be stated most simply as a choice between hiding and fleeing.

The ambient aggression—like a smell,—given in Nazism's broad resentment mongering and maniacal identity fixation all the way down to the airborne mass-killing methods of the camps would seep into Frank's psyche and carry forward in his work in the United States, but it did so in two opposing senses. On the one hand, what he saw and documented as he traveled around the country was that same ambient aggression he had experienced in Europe during the war, albeit in less entrenched and far less powerful forms. This was the background hum or scummy tone or drunken horizon of craftiness, dourness, and aggression that he saw everywhere. On the other hand, what he also photographed was an openness or opening that could provide a way out. "I didn't want to be part of the smallness of Switzerland," he said, "when I got to America I saw right away that everything was open, that you could do anything. And how you were accepted just depended on what you did with it. You could work to satisfy what was in you. Once I came to America I knew I wouldn't go back."[54]

Put more stridently on another occasion, he stated categorically, "Coming to America was freedom. The freedom that was given here doesn't exist in Europe."[55]

It was just such a standard American dream that he thematized in the language play of his oft-cited biographical sketch: "Grow up in Zürich—born in Zürich. November 9, 1924. become a Swiss in 1938 (?) 1947. Go to America, forget about having become a züriçois. 1950. Marry in New York. Mary is her name. two children, Pablo & Andrea. 1955. trip across the States, and Delpire publishes *Les Americains*. Ich bin ein Amerikaner."[56] What America represented to Frank was the promise of a melting pot where the heat, and with it the melting process, was never turned off, of a pot constantly rejuvenated from the outside, of identity taking on a permanently fluid state and moving easily between languages, regions, events and identifications, of identity realizable by simple synthetic declaration. What he documented was, in the first instance, he himself realizing this dream, he himself declaring himself to be "ein Amerikaner" in the truest (or most standard anyway) American form: "I feel as if I'm in a film. . . . Only the moment counts." That momentary quality—the quality that allowed him the deftness and alertness to pop into a situation with his "strong, personal, nonintellectual eye," an eye that was "very fast," as wife Mary described it—was the locus of his new-found Americanism.[57] *The Americans*, thus, despite its sharp and persistent critical tone, was in no way anti-American, at least not from Frank's perspective. Instead, its aim was to be more American than the Americans, to perform Americanism against its failure as he documented it all around him, to confront American culture become stale, American culture that had lost its youth, American culture that had become un-American, with his own fresh-off-the-boat, more-American-than-thou realization of the dream.

Failure of Americanism for Frank was simple: it was a hardening of the melting process, a congealing of the mayonnaise to a degree that no longer allowed outside to determine inside, its solidifying into what Frank perceived to be the crusty, unfilmic, European-like forms that he had escaped from in the first place. It was Americanism without a sense of youth, Americanism without a sense of being remade as in a film. Even if what he documented was the loss of self-invention, the crusting over of the immigrant's American dream, the foreclosing of the feeling of being in a film where only the moment counts, where life itself is experienced as if

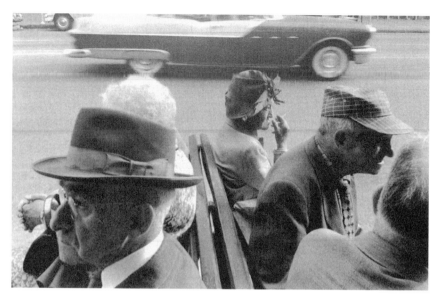

Figure 31
Robert Frank, *St. Petersburg, Florida* from *The Americans*, 1959. Copyright Robert Frank, from *The Americans*. Courtesy Pace/MacGill Gallery, New York.

it were a plastic form, was done so in a manner that enacted or exercised a version of that dream for himself along the way. In his movement from picture to picture to picture, from each roadside stop to the next, he performed and reinforced his Americanism against its failure everywhere, against the hateful and foreboding becoming-European of the Americans he encountered along the way, against the hardening of identity into the suburban white middle class and its others given by the American *réduit* experienced so forcefully in the heyday of McCarthyism.

Frank's system—formally, aesthetically, emotionally, sociologically—was built on the sensitive and critical observation of boundaries that divide people from one another. Over and over again he documented and highlighted the point of separation, the point that allowed them not to have to deal with each other. Boundaries that enclosed, veiled, protected, obscured the subjects photographed were found in flags, window frames, car covers, and turned backs as well as race, class, gender, sexuality, age, profession, politics—any sundry vehicle to delineate inside from outside, one group from another, one person from another.

Frank experienced the pressure of those boundaries acutely—this is clear in the sensitive way he returns to this theme again and again and again—but he is also clear about his aim to pass over or through those boundaries, to escape their confines. This point of tension and release, of entrapment and escape, is what his photographic vision was drawn to time and time again. The most emblematic picture is probably his best known: the trolley car in New Orleans with its row of windows boxing in white faces in the front staring down at the photographer with contempt, white children in the middle looking at him with curiosity no longer fear and not yet become judgment and black faces in the back gazing at the photographer with fatigue and open despondency. Social standing is discriminated by the boundaries in Frank's pictures as so firmly articulated as to be entrenched and the experience of the melting pot, of life on film, of human mayonnaise, of being, as Georges Bataille had it writing after the war, "stretched tight by the feeling of superabundance," is forgone in favor of the security of isolation, the security of the *réduit*, the security of identity made firm.

Frank's project was to intervene in those categories by moving quickly from picture to picture, roadside stop to roadside stop, thereby ever escaping the social divisions that he observed. He had a quick eye, his wife said, and we might say that it was quick in several ways: quick to observe but also quick to move away. Darting, weaving, jabbing, and ducking, Frank engaged with the world around him like a boxer looking for boundaries in order to renegotiate them, deftly finding an opening in his opponents' defenses and equally adroitly moving away to avoid being engaged in return. In so doing, he produced a strong sense of autonomy, his own sense of Lebensraum realized not in the name of identity but against it, not in the name of territorial expansion or protective *réduit* but instead as a "looking outside trying to look inside" that realized itself most fully and most genuinely in the experience of being on the road.

18

The road itself as an always available present opening up a means of escape from the past thus was Frank's redeemed Lebensraum, his notion of an expanded living space, his alternative to the strategy of the *réduit*. This is how he described it, probably with Walker Evans's help, when he was pitching to the Guggenheim for a second round of funding to continue the project: "The unity of this large project is achieved through visual

impact of 'the present.'"[58] That present as depicted in the *The Americans*
is defined by "a flow that overrides content and geography," as one photo
historian puts it, and its method is, generally, "to seize the most telling
form and then to allow that form to become endlessly associative and
generative."[59] But the present given in the book is not one that merely
flowed unfettered out of the past in the manner of a simple leaving town
and hitting the open road without direction or purpose. That is, it was not
a simple act of negation. Instead, Frank and Evans continued, it was a
present to be seen, a present to be experienced "in a distinct, intense
order."[60] The issue thus was in part one of balancing, of maintaining a
strong sense of order, on the one hand, and of being endlessly associative
and generative, on the other, of closed form and open form.

Frank was fully conscious of the ordering of his work through seriality
and the way that seriality served to break from existing photographic
conventions. "I had always tried to come up with a picture that really said
it all, that was a masterpiece," he wrote about his ambition early in his
career, but by "the time I applied for the Guggenheim Fellowship by the
middle '50s, I decided that wasn't it either." Instead, he continues, "I
decided that there had to be a more sustained form of visual [expression].
It would have to last longer. There had to be more pictures that would
sustain an idea or a vision or something. I couldn't just depend on that
one singular photograph anymore. You have to develop; you have to go
through different rooms."[61] It is this "distinct, intense order," this going
through "different rooms" in a particular way, with a particular cadence,
a particular rhythm or movement, that gives *The Americans* its "enormous
power," in the words of one critic, its status as "one of modern art's mag-
nificent achievements," its quality that is "at once a social epic and a
personal lament."[62] To achieve this balance or simultaneity or indistinguish-
ability between epic and lament, between the social and the personal,
between the collective ordering of life and its individual negation, Frank
had to have a way, a method, for such different identifications to carry
over from one category of experience to the next and back again. He had
to have a means for moving between the freedom and autonomy of his
existential Lebensraum and the sense of belonging of his longed-for human
mayonnaise.

That method was simple, really: it was a matter of positioning himself
in the middle so that his own instability or vulnerability became a central

component of what was photographed. This is not some simple form of self-portraiture and so is in no way Szarkowski's mirror but instead combines the scene photographed with the reaction to it into the image at hand. What continues to appeal so effectively in *The Americans* is a dynamic interrelationship between the experience of the photographer and the experience of his subject. Frank's sensitivity to this dynamic, his knowing when to click the shutter (or which image to choose in the editorial process), was born of a debt to Cartier-Bresson, certainly—it was his version of the decisive moment—but it was also different, and fundamentally so. Instead of a moment of narrative summary where the whole scene before him would coalesce in a single symbolic expression, it became instead what Martha Rosler called "meeting myself going around a corner" or the "bridge between experience and abstraction" as he strove to give full expressive form to the inadequacy of the descriptive system at hand. Frank's encounter with the subject photographed was, first and foremost, an encounter with his own inability to engage it adequately and it was the anguish born of that inadequacy that served as pivot, that drove his project from one image to the next and the next, giving it its epic dimension and its exemplary essay form.

The Photographic Comportment of Bernd and Hilla
Becher

Bernd and Hilla Becher first began their still-ongoing project of systemati-
cally photographing industrial structures—water towers, blast furnaces, gas
tanks, mine heads, grain elevators, and the like—in the late 1950s.[1] The
seemingly objective and scientific character of their project was in part a
polemical return to the "straight" aesthetics and social themes of the 1920s
and 1930s in response to the postpolitical and postindustrial subjectivist
photographic aesthetics that arose in the early postwar period. This latter
position was epitomized in Germany by the entrepreneurial, beauty-in-the-
eye-of-the-beholder humanism of Otto Steinert's *subjektive fotografie*—
" 'Subjective photography,' " wrote Steinert in his founding manifesto,
"means humanized, individualized photography"—and globally by the
one-world/one-culture humanism of *The Family of Man*.[2] While many
photographers followed Robert Frank's critical rejoinder and depicted the
seamier, chauvinistic underbelly of the syrupy universalisms advocated for
by Steichen and Steinert, the Bechers seemed simply to reject it and return
to an older, prewar paradigm.

That they were responding critically does not mean, however, that the
Bechers were not working at the same crossroads between man and
machine, human nature and human progress, that had differently con-
cerned Steichen, Steinert, and Frank (and many others at the time). "The
idea," they said once, "is to make families of objects," or, on another occa-
sion, "to create families of motifs"—objects or motifs, that is, they contin-
ued, that "become humanized and destroy one another, as in Nature where
the older is devoured by the newer."[3] Their brute oedipal definition of the
family form aside, this method of composition, of arranging pictures, is
not so different from the relations established between Steichen's motifs—
lovers, childbirth, mothers and children, children playing, disturbed

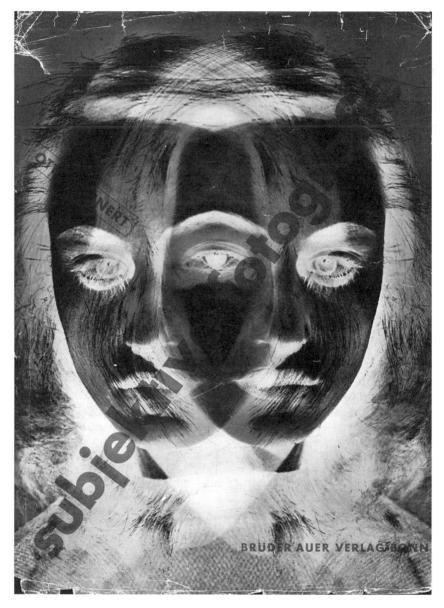

Figure 32
Otto Steinert, exhibition catalogue cover for the exhibition "Subjektive fotografie,"
1952.

children, fathers and sons, and so on—or, for that matter, is it all that different from the narrative relations established between the constituent parts of Frank's book *The Americans*, shooting from the hip as he did, fleeing from one roadside encounter to another, from one flag or political rally or civic parade or scene of squalor or expression of anomie to another and another and another. For each of these enterprises, the movement itself from image to image to image aimed to be the story more so than did the sum of the collected parts, regardless of whether it is the movement of the photographer himself or herself, or the camera, or the movement of our own eye as it skips from one photograph to the next.

Like their predecessors, the Bechers have been concerned from the beginning with what Kevin Lynch called in 1960 a "pattern of . . . sequential experiences," that is, with a process that connects one image to the next and the next and the next ("as in Nature," the Bechers said), rather than using photography to exercise the analytical powers of isolation, definition, and classification (beyond, that is, their minimalist typological schemata of water towers versus mine heads, round buildings versus square) or even detailed description and cognitive understanding. This is just to state the obvious. The Becher photographs are "not illustrations," as one observer puts it flatly, but instead do their work as photography "by means of the network of photographs." That is, what the images viewed together provide, the same reviewer continued, is "an anatomy lesson," an anatomy of the relations between constituent parts.[4]

Putting this idea of network or system or series or sequence in more historical terms, a more critical observer describes their project thus: "The Bechers are interested in the character implicit in a façade, just the way [August] Sander was in the character implicit in a face," but then adds as an afterthought, indicating the crossroads we have already begun to consider here, "I cannot help regarding these pictures as macabre monuments to human self-distortion in the name of social reason—all-too-human structures that are ridiculously social."[5] It is only in viewing these structures in the serial form given by the Bechers that both the "all-too-human" character that we might see in the regional or architectural or other distinguishable particularity of each, and the "ridiculously social" conformity of those particularities to the Bechers' own archival schema, is revealed. Working objectivity against subjectivity, one comportment against the other and then back again, the Bechers' project finds the motor of its epic

continuity in an elastic liminal bearing that bounds between a cool, mechanical, quasi-disembodied objectivity, on the one hand, and, as we shall see, a hot, subjective comportment that speaks of its own history and desire in its bearing toward the world, on the other.

Still, their project did draw its critical vitality from two prewar influences, and both would seem to locate their ambition opposite to the postwar subjectivism of Steichen and Frank—that is, strictly on the side of what was once called the New Objectivity. The first of these prewar influences was the systematic, pseudoscientific studies of Karl Blossfeldt, Albert Renger-Patzsch, and particularly August Sander whose life project of making sociological portraits of Germans from all classes and occupations provided the methodological and affective structure for the Bechers' own typological procedure and a logical alternative to the affective charge given in both the sentimental identification and scornful disidentification adopted by their humanist predecessors. The second major influence, the source for the distinctive subject matter they chose to apply Sander's system to, was the industrial iconography popular with many photographers and artists in the 1920s and 1930s. They might have had in mind one of the many well-known photographs by Renger–Patzsch, such as his *Intersecting Braces of a Truss Bridge* from 1928, for example, but it could have just as well been photography by Charles Sheeler or Margaret Bourke-White or László Moholy-Nagy or many, many others equally and less reknowned.

Just to recall a key influence from a history that is well understood by any student of the Bechers, scientific method, industrial subject matter, and the mechanical advantage of photography—to varying degrees among their machine age forebears from around the industrialized world and across the political spectrum—all drew on and supported a challenge to the perceived anachronism of aestheticism and subjectivism and promised a new place and new importance for artists in the modern world. That ambition was developed in many places—for example, by Rodchenko in 1928 when he insisted that "every modern cultured man must make war against art as against opium."[6] Not all members of the once-labeled "engineer generation" were as antipathetic to the older ideals as Rodchenko (Renger-Patzsch, for one, sought something more like reconciliation between modern life and art and set himself against such modernist polemics particularly as they were developed in Germany by Moholy-Nagy), but all did share in the claim for photography's machine age advantage,

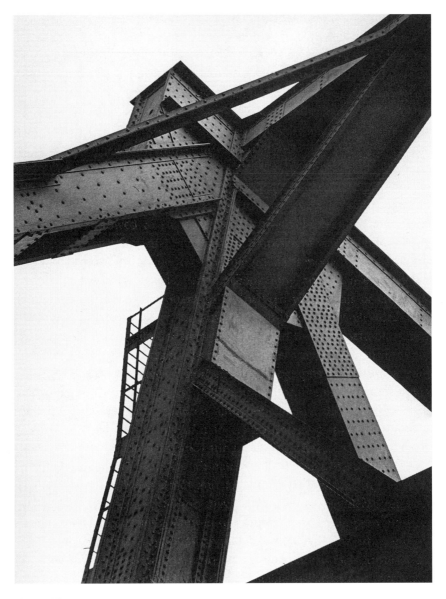

Figure 33
Albert Renger-Patszch, *Intersecting Braces of a Truss Bridge in Duisburg-Hochfeldt*, 1928.

responsibility, and entitlement.[7] All agreed that representation needed to be mechanical if it was to be modern; all agreed that art needed to be somehow sober, objective, *sachlich*, at a remove from any simple expressiveness unto itself and at a remove from any claim that the art object might be a bearer of value in and of itself.

More broadly still, of course, this tension between art as an autonomous and self-contained value, on the one hand, and modern life, on the other, has regularly given definition and distinction to the social role played by photography throughout its history. From the beginning, photography was not only a passive product or sign or symptom of modernity but also worked actively as an engine of modernization. Beginning already with its official, state-sponsored birth in 1839, both civic duty and marketplace opportunity alike were pinned to its capacity for bringing vision as an ideal and visual representation as a material resource into the workaday world of the masses, for bringing visual imagination up to speed with the ever-accelerating, ever-expanding industrial revolution and thereby modernizing the archaic, pseudoreligious, would-be aristocratic presumption of art in its new, modernist role as herald of the private life of the bourgeois subject.

This mantle trumpeted by the machine age photographers and regularly assumed for photography generally is carried forward in the Bechers' work, albeit complexly. While their career has been almost exclusively a function of the international art market and art publishing industry and the German art education system, their photographic studies regularly have been characterized as "industrial archeology" or "a contribution to the social history of industrial work" and are routinely assumed to support such extra-artistic ambitions and accomplishments. These assumptions are misleading, however: their photographs offer little social-historical or archeological interpretation, and they do not detail the particulars of design, operation, and social function that might be useful for such areas of study.[8] They have been completely upfront about this. "Things which can be interesting for technical historians," they have said, for example, "are not visually interesting for us."[9] Indeed, they often go to great lengths to ensure the absence of the sort of detail that would be of interest to technical historians or social historians or historians of any sort really. "We want to offer the audience a point of view, or rather a grammar, to understand and compare the different structures," is how they describe their ambition. "Through

photography, we try to arrange these shapes and render them comparable. To do so, the objects must be isolated from their context and freed from all association."[10] When they have tried collaborating with historians, for example, it has not worked out at all. "They wanted to write a text, and garnish their text with our photos," complained Bernd about their experimentation with such a role in the late 1960s. "They couldn't imagine that photographs could stand on their own. They wanted to give it a scientific basis," objected Hilla. "It was quite dreadful," continued Bernd. "It was a bad experience," Hilla agreed. "Working with them, we felt for the first time that we weren't free."[11]

They do employ a method, like much historical or archeological analysis, that is strict in its consistency and pure in its sense of purpose but that purpose avoids "context" and "association" by design and thus has little to offer understanding in the manner traditionally given by such extra-artistic, analytically minded aims that are the province of historians and archeologists. Their more properly artistic characterizations of the structures they photograph—"anonymous sculptures," as they termed it in 1969, for example, and "basic forms" or *Grundformen*, in 1999—suggest a more useful understanding of their project by drawing us away from the simpler, more transparent notion of representation assumed in such archeological and social historical characterizations and throwing us into the murkier waters of formal analysis and aesthetic experience.

The Bechers have emerged as a leading influence in postwar art history, not only for their own work and its interweaving with other artistic developments such as minimalism and conceptual art, but also, particularly in the plast decade, for the extension of their project by a string of extraordinarily successful students.[12] Indeed, the "point of view" or "grammar" the Bechers developed has gained a significant measure of dominance within contemporary art practice as a whole. My effort here is to read that "grammar" as embodied expression, as a form of comportment or bearing toward the world, and as a sign or symptom of a social relation, that is, as a sign or condition or component part of a social form. The distinctive orientation and determination of that photographic body language or photographic comportment, which in the Becher scholarship is sometimes said to be found midway "between distance and proximity," has taken on imposing proportions in the epic continuity of their own work and in the stilled grandeur seemingly discovered anew by their students again and

again and again in settings ranging from the magisterial all the way down the food chain of aesthetic discrimination to the banal. Indeed, comporting oneself to see the world in this way—to see it grandly regardless of whether what is being viewed is itself grand—may be said to be their legacy. "Standing before the photographs of museums and churches and mobs of tourists, we can become absorbed by the chaos of culture," one critic testifies, for example, standing in the face of a vastness of detail recorded with all that Germanic deep focus, concentrated precision, and meticulous craftsmanship. "We turn inward," the same critic continues sensitively, "breathing slowly."[13]

Considering the strong debt of this way of looking at the world, to various artistic developments of the 1920s and 1930s, its powerfully disciplined elaboration as a form by the Bechers themselves beginning in the 1950s and 1960s, and its art world success in the work of their students in the 1980s and 1990s, I will be asking how it has been able to, "at a stroke," in the words of one philosopher of comportment, "incorporate the past into the present and weld that present to a future."[14] Such an inquiry, it can be said, is the task of the historian generally: "not to moralize about remembering and forgetting"—this is Anson Rabinbach writing about the question of postwar Germans' coming to terms with their Nazi past in order to consider historical method more broadly—but instead "to identify the ways that certain metaphoric pasts can be cathected to contemporary events."[15]

The Bechers have taken up a specific past—the heroic age of industrial modernity—and rearticulated it with a new and different force in the present. They have, as Rabinbach puts it, cathected a politically and morally charged myth of the past to contemporary events. Framing this larger question about the place of the past in the present more narrowly around photography, we can ask how the Bechers have conveyed photography's heroic Enlightenment promise of rigor and transparency and progress, its grand bid to "make war against art as against opium," as Rodchenko put it, into the present. One answer to this question that we need to consider in order to get at the characteristic bearing in their work and the legacy of that bearing in the work of their students is whether the Enlightenment promise long assumed to be the distinctive charter of photography has been somehow inverted or returned to its homeland category of art, that is, to the same category it had originally taken as its oedipal foil.

In order to flesh out the details of this bearing or comportment, I will be working between three separate attitudes that each can be said to be driving the Becher project. First, I consider their *commitment* to their project and position; second, I consider the *delight* or simple pleasure given in their visual record of the objects photographed; and, third, I evaluate the claim to *enlightenment* or appeal to a universal standard given in the rigorous systematicity of their undertaking. Each of these attitudes or perspectives is given its own section in what follows, but the goal in the end is to bring all three together into a common understanding of the conviction or pleasure or truth that endows their comportment with its forceful sense of purpose, a sense of purpose that, judging from their success, seems to continue to be powerfully compelling for their own project and for the work of their successful students.

19

The most obvious feature of the Bechers' project is its disciplined commitment to a singular vision—a commitment that has been consistent over nearly half a century's duration, consistent across many different countries and regions, and consistent from each to the next of many thousands of photographs. As one critic has put it, the pattern of "rhythms and

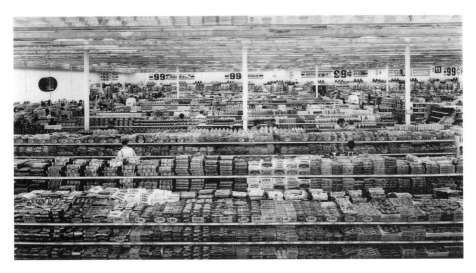

Figure 34
Andreas Gursky, *99 Cent*, 1999. © 2005 Artists Rights Society (ARS), New York.

repetitions" established between the individual pictures (and, we might add, between individual series as well) is "very much the idea of the work."[16] Such, the artists have admitted, is their goal—"to produce a more or less perfect chain of different forms and shapes." Indeed, something like this "perfect chain" or pattern of serial rhythms and repetitions is the initial impression given to the beholder when facing a Becher installation or book for the first time or when moving from one to the next of any of their ten or fifteen books—from *Water Towers* to *Framework Houses* to *Gas Tanks* to *Industrial Landscapes*, for example—or in and between any of the numerable exhibition catalogues.[17]

Their system is based on a rigorous set of procedural rules: a standardized format and ratio of figure to ground; a uniformly level, full-frontal view; near-identical flat lighting conditions or the approximation of such conditions in the photographic processing; a consistent lack of human presence; a consistent use of the restricted chromatic spectrum offered by black and white photography rather than the broad range given by color, precise uniformity in print quality, sizing, framing, and presentation; and a shared function for all the structures photographed for a given series. There is another obvious rule too, although one their project might be said to systematically ignore: their industrial history is exclusively and resolutely a history of the West. We need make only the most rudimentary comparisons to see that theirs is a project about modernization, not globalization, and so does not detail, or even allude to, the geopolitical ambitions and conflicts that drive the process.[18] They do not, for example, group the images by geographical or historical categories, which would bring a more detailed historical consciousness to bear on the material at hand, nor do they depict or generally otherwise consider the workers and others involved with the structures they represent, and they do not arrange the pictures in a manner that would chronicle the development of their project. The term they generally use to describe their method is *typological*, and they freely state that it has "much to do with the 19th century," that is, they say, with "the encyclopedic approach" used, for example, in botany or zoology or, we might add, various psychophysiological approaches used in medicine and criminology.[19] Indeed, we might say more broadly, their system is based precisely on the nineteenth-century principle of the archive—on its "dry compartmentalization," as Allan Sekula has described it—that so concerned Michel Foucault and the waves of Foucauldians that followed him.

Figure 35
Follower of Sir Francis Galton, composite photograph of twelve Boston physicians, from *McClure's Magazine*, 1894.

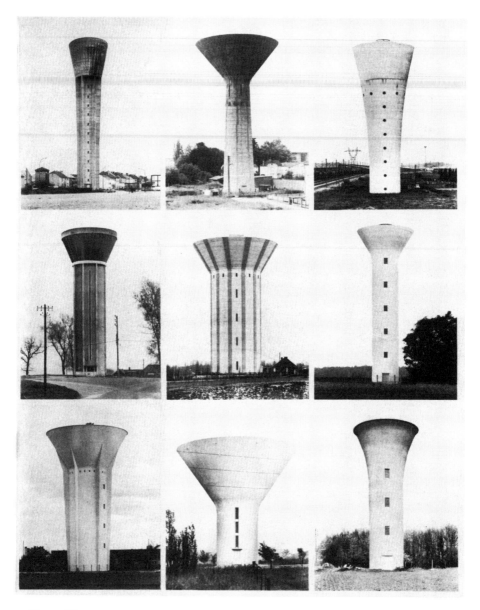

Figure 36
Bernd and Hilla Becher, Watertowers, from *Bernhard und Hilla Becher: Typologien industrieller Bauten 1963–1975*, 1977. Courtesy Sonnabend Gallery, New York.

While an individual Becher photograph seen on its own without attribution could be mistaken easily as the sort of transparent illustration used in trade journals or annual reports, for example, or in books on the history or design of industrial architecture, the same photograph seen in its intended setting alongside tens or hundreds of nearly identical others could not support any similar instrumental goal. While it is true that it is "only through their participation in a system of presentation, under the model of the archive, that the single images gain a significance which is larger than their particular instances," as one observer puts it, the kind of significance given by this systematization is different.[20] Unlike similar approaches used in botany or zoology, for example, the cumulative effect of the typological method as it is applied in the Bechers' life project does not provide greater knowledge of the processes or history of their subject. Instead, the use of rhythm and repetition endows the buildings they photograph with the "anonymity" or abstract form they seek (by divorcing meaning from original purpose and everyday social function) rather than with scientific specificity and, in turn, allows us to read them ahistorically and extrasocially and appreciate them as autonomous aesthetic objects or "sculpture."

This distinctive method of cultivating aesthetic response is consistent with the 1920s and 1930s project of aesthetic appropriation of scientific or systemic method, but it is also different. Perhaps the most significant measure of difference between the Bechers and their forebears is artistic ambition. At those moments when it was most full of itself, the "New Vision" (as it was called in the preeminent artistic slogan of the day) was to render intelligible and help propagate a new social order based on mass production, mass politics, and mass media. This mission offered artists a sense of social significance that the profession had not enjoyed since its days in the court. Suddenly, as one memoirist has recounted in a conventional piece of critical wisdom from the period, "the artist was deprived not of his social acceptance but of his isolation. This social isolation had been a by-product of the Industrial Revolution, as typical and pernicious as slums, mechanization and unemployment. . . . Montmartre, Schwabing, Bloomsbury, and Greenwich Village were expressions as typical of nineteenth century mentality as Wall Street, Lloyds of London, La Bourse, and Das kaiserliche Berlin."[21] At its grandest, artists of the industrializing world in the 1920s and 1930s believed that by taking up photography as a

medium, industry as a theme, and science as a method, they were abandoning the bohemian ghettos and would, once again, occupy positions at the center of social life by working as designers and propagandists for the emerging political class.

What gave artists renewed confidence and ambition was a new understanding of patronage that had been made possible by the revolutions of the 1910s. Instead of decorating the private mansions of individual bankers or businessmen, artists were hired by revolutionary governments in Russia and Mexico and patronized by communist parties in much of the rest of the industrialized world to make art that spoke about and addressed itself to the working masses. This vision took root in the 1920s with artists fancying themselves as Taylorist engineers or planners and was gradually retooled by the 1930s for duties on the other side of the labor-management divide as artists came to see themselves in the figure of the industrial worker. This new sense of significance and anticipation of an emerging audience and market quickly impressed itself on most of the developing movements of the period regardless of whether the political conditions existed to actually support such ambition. At the heart of this transformed self-consciousness was the assumption that the world was being remade through mass production and mass politics and artists, as the engineers and laborers of visual form, were to be key players developing the mass culture that would drive both fronts of modernization.

A rich sense of this anticipated social role was given in a series of statements by the Russian-born, Berlin-trained, New York–based, precisionist-turned-social realist Louis Lozowick on the changing status of the artist in the Soviet Union. "To say that art has been encouraged in the Soviet Union is to make a true but tame statement about the actual situation," he reported in 1936 to his peers at the First American Artists' Congress in New York. "Of course art has been encouraged," he continued. "Artists are considered part of the vast army of workers, physical and mental and as such an indispensable factor in the socialist reconstruction of the country. Full members in trade unions, the artists carry insurance against sickness, accident and unemployment. They are consulted on every issue that vitally affects the country. When we read, for example, of such vast projects as the ten year plan for the complete rebuilding of Moscow, the most gigantic scheme of city planning in history, we are not surprised to find artists actively cooperating."[22]

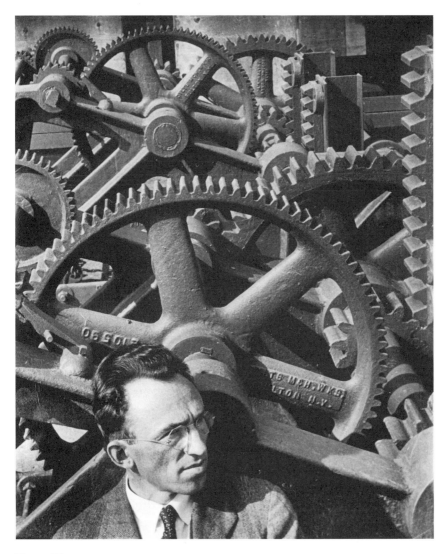

Figure 37
Ralph Steiner, *Louis Lozowick before Erie Canal Lock Gears*, 1929. Courtesy Murray Weiss.

Still today the Bechers' work (and its legacy in the art of their successful students) makes reference to this phantasm from the prewar past. Unlike their artist-cum-engineer-cum-worker predecessors, however, the Bechers' sensibility relies on melancholy rather than visionary innovation or allegiance with the revolutionary class to make its point. Tied to the loss of an idealized past, their work gains its emotional power, its expressive force as art, from the extent to which it conveys that sense of loss to the beholder. Their photographs present us with a transformed image of the avant-garde ambitions of the 1920s and 1930s. In their view, the great industrial structures that served as monuments to the "gigantic schemes" of collective life, monuments to technological, social, and political modernization, have aged and are now empty of all but memory of the ambition they once housed. Likewise, their postwar rehashing of the "New Vision" is now drained of all but memory of the heroic affect that went along with artists' sense of their own "indispensable" contribution. The Bechers have stated their position outright: "We don't agree with the depiction of buildings in the 20s and 30s. Things were seen either from above or below which tended to monumentalize the object. This was exploited in terms of a socialistic view—a fresh view of the world, a new man, a new beginning."[23]

This postwar critique of the New Vision and related artistic ambitions of the prewar past is generally consistent across an entire generation of artists and intellectuals whose historically distinct form of criticality continues to serve as a foundation for the range of critical perspectives available to us today. We do not have to go far for such testimony. Witness, for example, Michel Foucault in one of his most-cited essays. We "know from experience," he writes, "that the claim to escape from the system of contemporary reality so as to produce the overall programs of another society, of another way of thinking, another culture, another vision of the world, has led only to the return of the most dangerous traditions . . . to the programs for a new man that the worst political systems have repeated throughout the twentieth century."[24] The Bechers, like many of their contemporaries, have made an obsession of this disagreement with the past. By returning to those views again and again and again for nearly half a century with even greater sobriety, even greater assiduousness, even greater industry than the *Neue Sachlichkeit* that inspired them, by shooting the grand icons of the machine age "straight-on" so they do not, they have

claimed, "hide or exaggerate or depict anything in an untrue fashion," by committing themselves to an ethic of representation free of bogus political elevation or degradation, they realize one leg of their generation's post-modern affect.[25] In so doing, the Bechers' commitment sits wedged between a passionate, trance-like fascination with the great progressive democratic ambitions of modernism and an equally ardent renunciation.

Such is the Bechers' burden, their ethic: an ideological commitment to a form of representation that is somehow free of ideology, free of a "socialistic view" or the view of any other doctrine or ism. But such commitment is really only one part of what is given by their strong sense of order, by the "rhythms and repetitions" that form their project, and so now we turn to the second part: the unmistakable delight taken in the play of form.

20

The promise of the aesthetic as a realm of experience separate from the instrumental thinking of daily life has served many different purposes over the years since it was first elaborated by the Enlightenment philosophers. It has given rise, for example, to the ideal of a public sphere of proto-political discourse independent of undue influence from church, state, and, later, the marketplace. Where art was "claimed as a serviceable topic of discussion through which a [newly] publicly-oriented subjectivity communicated with itself."[26] So too, the aesthetic has long given rise to the contrary ideal of a bohemian preserve where a delicately cultivated, aristocratic balance of taste and tastelessness, convention and transgression, sentiment and suspicion suffers the brute indifference and smug naiveté of its bourgeois audience.

The Bechers' transformation of the iconography and methodology of social ambition from the 1920s and 1930s into "anonymous sculptures" relies just as much as their forebears on this counterpoint between aesthetic and instrumental worldviews, but they do so oppositely. Theirs is no war against the opiate of the elite, as Rodchenko had advocated. They have made themselves and their audience into connoisseurs of an industrial past, providing us all with opportunity for unexpected visual delectation, with opportunity to delight in the play of fine distinctions and subtle variations between the appearances of many different structures that all perform the same instrumental function.[27] They offer their audience, as one viewer has testified, for example, the opportunity to delight in

"differences in composition, rhythm and formal solutions where an ordinarily distracted eye would see only indifference and standardization." "I love Bernd and Hilla Becher's work," this enthusiast writes; it is "genuinely great art, the kind that has no need to have its name protected by being placed in a museum, because it already belongs to our collective memory."[28] In the words of another viewer, the Bechers' work is said to allow us "to regard a single line of rivets as equally significant a marking as a full-blown mannerist conceit."[29] In so doing, they revitalize the old aestheticist claims about taste and tastelessness by exercising those claims on the turf of instrumental reason, that is, by making art out of industry.

One interpretation of their contribution, one that has deep roots in modernist critical theory, might argue that such connoisseurship repre-

Industriebauten 1830-1930

Figure 38
Bernd and Hilla Becher, cover *Industriebauten, 1830–1930*, 1967. Courtesy Sonnabend Gallery, New York.

sents nothing more than the aestheticization of politics, nothing more than the transformation of a publicly oriented sensibility into a rarefied product aimed at an elite market that ambivalently and obsessively draws succor from an earlier, more political moment for its legitimation. "Their work is a fraud," a certain school of critic might once have alleged, "a mere *neo*-avantgarde." Andreas Huyssen, for example, has made a broader statement that might be torn from its original circumstance and retrofitted to this concern, particularly if we grant the Bechers nothing more than their disaffected pastiche of the past. "The obsessive attempts to give utopia a bad name," he writes, "remain fundamentally ideological and locked in a discursive battle with residual and emerging utopian thinking in the here and now."[30] A more open-handed interpretation, however, might see that same act of aestheticization as in its own way liberating, as both cathartic and invigorating, as an attempt to serve equally two pressing and contradictory concerns: to both remember and let go of a failed political program and failed attempt to upgrade artists' social status in the name of the possibility for other, more viable investments. As such, the unexpected finery afforded by the Bechers, the part of their work that declares itself to be art in the most conventional decorative or ornamental sense, the systemic delight in the play of form, might well be valued (even, perhaps, by that group one critic has labeled "the last partisans of the avant-garde") as something more than mere decadence or self-indulgence or anti-utopianism: that is, as a form of esotericism, a refuge from political cynicism for an age in which such refuge is unavailable.[31]

This question about the place of the aesthetic in the Bechers' work can also be phrased in more general terms: How is it that we move beyond the critical negation of failed political attachments from the past? How can old commitments—the old "socialistic views," for example—be rendered sympathetic beyond their inadequacy, heroic beyond their failing, forward looking beyond their obsolescence, cherished beyond not being believed?[32] The issue here is one of political memory, of a "talking cure" for false consciousness, of how the political past is negotiated within our sense of the present and how that settlement inhabits the realm of the aesthetic. In the light of such a question, the Bechers' mastery of their craft and the obsessiveness of their fascination—their tight, standardized formal rigor and their fixed commitment to a grueling, lifelong study—might be prized precisely for the way the aesthetic appeal of its form can serve to dislodge

Figure 39
Louis Lozowick, *Tanks #3*, Smithsonian American Art Museum.

an earlier political ideal from its place under the weight of protracted repression and anxiety in the present in order to be reseated in a position of simpler, less freighted distinction in the past. The distinguishing beauty of their work thus would not be found in the way it shares our period's still-vital critical distance from the old utopianisms, the old "programs for a new man" and the like—at least not on its own—but instead in its seemingly indefatigable preservationist impulse, in its attempt to hold on to and find delight in the great beleaguered promise of the modernist past over and above the critique of that past that is still vital in the present.

It is the fantasy life of this work, its capacity to take delight in an opening in the past that leads forward into the future, its way in which "certain metaphoric pasts can be cathected to contemporary events," as Anson Rabinbach termed it, then, that might be said to have sustained it and driven its rhythm and repetition onward, maintaining its commitment to producing nearly the same picture over and over and over again for almost half a century. Bernd Becher was clear about his fascination in a 1969 interview. "These things are so full of fantasy there is absolutely no sense in trying to paint them; I realized that no artist could have made them better," he said. "This is purely economic architecture. They throw it up, they use it, they misuse it, they throw it away."[33] A term the artists return to periodically is *nomadic architecture*. The structures are "not like the pyramids," they have said; they are not "for eternity."[34] Their vision is of an architecture free of the burden of culture, free of the burden of identity, free of the burden of eternity. "An Italian gasometer does not look Italian and a Chinese blast furnace does not look Chinese," they have said, and it is this form of looking that is so appealing; it is this form of looking, this comportment, that delights.[35]

The strongest reference for identity thinking for anyone growing up in Germany during the war would be the construction of Germanness and its others, and this was as formative for the Bechers as for any others of their generation. "The industrial world is completely divorced from" such identity thinking, from Nazism, Bernd has said. "It has absolutely nothing to do with ideology. It corresponds more to the pragmatic English way of thinking." As the artists note, their nineteenth-century approach itself, like the structures they photograph, is drawn from "the soul of industrial thought." Method and subject matter, form and content, serve as

reciprocal homologous support for each other. Just as with industry, so photography in their hands is assumed to be "by its very nature free of ideology."[36] This sense of freedom, this delight in the industrial as an alternative to ideology, is the engine sustaining their distinctive photo graphic comportment.

All the end-of-ideology claims that developed in the 1950s like the Bechers' were born of similar assumptions. Each arose with a theory of ideology based on the principle of identity—as in Nazi ideology, for example, or communist ideology—and any cultural development that weakened or diluted identity was understood to do so as well to the ideology that sustained that identity. As Raymond Aron put it the same year the Bechers embarked on their project, for example, ideology was supposed to draw its authority from "the longing for a purpose, for communion with the people, for something controlled by an idea or a will."[37] This identity-thesis was embraced across a wide political spectrum from Aron leftward, and in many respects it continues to form our own moment now. But it is important for our purposes to recall how this model of ideology was different from that first developed by Marx, which, after all, was the model that subtended the ambitions of the engineer generation and that, in principle, was returned to in the postwar critical rejoinder of the Bechers.

What the modernists of the 1920s and 1930s had wanted was a kind of materialist foothold that would sustain the progressive development of identity—in social planning, in the machine, in their productivism itself— and could hold its own against the vagaries of taste in a world increasingly dominated by consumerism. Such consumerism was a big part of the modernity of artists like Rodchenko, Moholy-Nagy, Renger, and others, of course, but as a group they had no aspiration for an anti-aesthetic per se (as would later be the case with pop art and other developments in the 1960s, for example), no aspiration to abandon the claims of science, no aspiration for negation that rested on its own laurels. In the Marxian schema that they had inherited, the very moment that ideology in its identity-based sense is said to be negated is itself the turning point into ideology proper or the moment when, as the *Communist Manifesto* put it famously, "all that is solid melts into air, all that is holy is profaned," and identity is given over to process, social relations are given over to relations between things, and politics is given over to economics. "All fixed, fast-

Figure 40
Ed Ruscha, one of a dozen or so blank page spreads from *Nine Swimming Pools and a Broken Glass*, 1968. Artist's book. © Ed Ruscha

frozen relations, with their train of ancient and venerable prejudices and opinions are swept away," the manifesto continues, "all new-formed ones become antiquated before they can ossify."[38]

This type of ideology is given not by propagandists and ideologists—in an important sense, there can be no such thing as a capitalist Goebbels—but is always given instead right in the technology. "Modern Industry never views or treats the existing form of production process as the definitive one," Marx wrote. That is, it can never be established as doctrine. As such, he continued, it is "revolutionary" and opposed to all earlier modes of production. "By means of machinery, chemical processes and other methods, it is continually transforming not only in the technical basis of production, but also the functions of the worker and the social combinations of the labor process," Marx continued; it "incessantly throws masses of capital and of workers from one branch of production to another."[39] This movement is the "nomadic" quality of modern industry that the Bechers rely on to make their point—it is this, they say, that is "like nature"—and their ambitious project speaks equally to Marx's account of

industry as progressive social change as it does to his account of it as bearer of false consciousness, alienation, and exploitation.[40]

The Bechers work this boundary between promise and threat differently, however: their project provides a systematic manner of viewing the world that wagers its own system of value, and thereby its distinctive form of autonomy, against its architectural subject. Where the architecture promises pure instrumentality, they provide a purity of aesthetic form. As such, while their work makes its own claim to be free of ideology, its own claim to being apolitical, it does so differently than does the industry they photograph. Their method as artists is to pit one modern form against another, to pit the nomadism of aesthetic delight against the nomadism of industry, to pit the (idealistic, German) soul of aesthetic experience against the (pragmatic, English) "soul of industrial thought." In so doing they have produced a full-blown nineteenth-century archive exactly in the manner that Foucault would describe. It is an archive not of bodies but of machines, however, not of the formal, physiognomic variations of deviance but of industriousness, not of those discarded by modernity but of that modernity has shed of itself.[41] The delight offered by their art—in its machinic rhythms and repetitions, in the play of form across the registers of its objectivity and systematicity—is therefore realized only *against* the revolutionary promise of the modern industry it depicts. It is a view of industrial history as if it were nature, as if it were an organic process unto itself, as if it were a slide show or a picture book flipping from one image to the next and the next and the next. The structures "come and go almost like nature," they have said. "This was interesting for us."[42]

21

Art and industry thus stand opposed in the Bechers' work in a manner different from, even contrary to, their machine age forebears. Put schematically, their project is one of aestheticizing industry rather than industrializing art. This, it might be said, is the other leg of postmodernism in their work—the way in which it engages in the play of signification with diminished concern for its attachment to some properly material reality. This is also the way in which their work plays with and transforms the *Neue Sachlichkeit* legacy of documentary photography with its "socialistic view," its core critical materialist mandate of author-as-producer reportage. "The paradox," insisted Daniel Bell in 1960, is that the end-of-ideology genera-

Feinkohlentürme

Kokerei »Eschweiler Reserve«, Eschweiler bei Aachen, 1858

Kokerei »Eschweiler Reserve«, Eschweiler bei Aachen, 1868

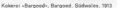

Kokerei »Coedely« bei Pontypridd, Südwales, 1912

Kokerei »Bargoed«, Bargoed, Südwales, 1913

Kokerei in Blaenavon, Südwales, um 1912

Figure 41
Bernd and Hilla Becher, page spread from *Industriebauten, 1830–1930*, 1967. Courtesy Sonnabend Gallery, New York.

tion—the Bechers's generation, the generation of the 1950s, that is, the last generation that still openly subscribed to some vestige of the Enlightenment project—"wants to live a 'heroic' life but finds the image" of such heroism "truly 'quixotic.' "[43]

But this turn away from modernism's politicized vision of industry, from its heroism that was not yet quixotic, is in no way the whole story. Art and industry also rely on a common foundation in the Bechers' work, and it is this that can be said to be its continued embrace of modernism, its faith in the power of representation to reveal and comprehend the hidden material conditions of the world it addresses, its faith in the project of

Figure 42
Ed Ruscha, spread from *Nine Swimming Pools and a Broken Glass*, 1968. Artist's book.
© Ed Ruscha

Enlightenment. Although the Bechers' work distances itself from most of the affective attachments of the engineer-cum-worker ideal of their fore-bears, it does share with that ideal (in a manner that is fully modern) faith in the more abstract aim of system. Their work cares little for the mimick-ing of the consumer world and the consumer's vision that emerged as a program side-by-side with theirs in the various pre-pop and pop move-ments of the 1950s and early 1960s. In this way, their serial form, their comportment between distance and proximity, is very different from that of many of their contemporaries such as Andy Warhol, Ed Ruscha, and Gerhard Richter, with whom they are often compared. Like these others, theirs is a cool vision, detached from maudlin sentiments of all kinds, political or otherwise, but, unlike them, that detachment is not founded on irony, and the pleasure taken in their project is not the consumer's pleasure of expenditure without return, of process without aim. Indeed, it might be said, if there is one thing the Becher project is more than any-thing else, one thing that distinguishes it from the core critical motif of their pop-culturalist contemporaries, it is the apparent earnestness with

which it embraces systematicity, the way in which it holds onto modernism's seriousness of purpose and concentration of aim even as it abandons the purpose or aim itself.

What then has this residual modernist ideal of systematicity meant for the Bechers and their audiences, and what might it mean for us now? What, in the end, is the value of their archive? What is the value of their old-fashioned artist-cum-engineer modernism? Certainly it has taken on the form and weight of the ethical principle of commitment, as argued above. Certainly, too, it has provided occasion for aesthetic experience or delight. But these standards on their own are abstract forms and empty of historical content, empty of any claim for why such an ethic or such an aesthetic might appeal or serve its constituency and its time. The historical promise of systemic form had been clear enough for their machine age forebears: it was to carry the new vision, the society planned by artists. It was to be scientific management raised to the level of social engineering through its visual forms. Its promise, in short, was that it would produce, as the Bechers have said disapprovingly, "a socialistic view—a fresh view of the world, a new man, a new beginning."

From our latter-day perspective, it is important to remember that this critique is really a product of the generation of the Bechers and Foucault and did not emerge immediately after the war but instead arose only in the 1950s. In the earlier postwar period, the old prewar project for a new man was actually revitalized and given a new mission, if only for a moment. Against the fluctuating political passions aroused by the emerging anti-communist bunker culture of the late 1940s and early 1950s, many public intellectuals came to approach the question of political subjectivity with a renewed sense of urgency and purpose. Much-discussed statements by public intellectuals like Norman Cousins and Albert Einstein set the tone in the United States and paralleled the more immediately pressing self-scrutiny in Germany institutionalized in the reeducation program and developed in a more philosophical manner by intellectuals such as Karl Jaspers. "Brainwork is not all this requires," Jaspers wrote in his lecture "The Question of German Guilt." "The intellect must put the heart to work, arouse it to an inner activity which in turn carries the brainwork."[44] The concept of heartwork permeated the discussion across the postwar world. "Our poisoned hearts must be cured," is how Camus put it, we must "remake our political mentality."[45]

Photographers once again assumed a special role for this reconstruction, this production of a new, new vision and new, new man. Such was the mission adopted programmatically by Edward Steichen for *The Family of Man*, for example, and it was the mandate assumed by Otto Steinert for his *Subjektive Fotografie*. "As the most widely-spread vehicle of expression up to the present day," he wrote, "photography is called upon to mold the visual consciousness of our age. And as the pictorial technique most generally comprehensible and most easily accessible to lay hands on, it is particularly fitted to promote the mutual understanding of the nations."[46] Like Steichen's aim to illustrate common human experience in an iconography of joy and suffering, loss and gain, so Steinert sought a discursive means to represent human commonality by invoking a subjectivized experience of vision, even when industry was the subject at hand.

In a significant sense, the search for a "visual consciousness of our age" promoted by Steichen and Steinert, like the heartwork called for by Cousins, Einstein, Jaspers, and Camus, was similar to that of the war consciousness that it promised to move beyond, at least structurally. In both cases—in the wartime German *Volk*, for example, and in the postwar *Family of Man*—the primary ideological goal was to produce a powerful and passionate sense of belonging, to produce the affective experience of nation. The structure of the social bond in both cases thus was based on the principle of identity or passionate attachment to a shared sense of self, even if the later attachment was to be built around shared guilt. It was a social form generated through ideological means of the first, identity-driven variety discussed above rather than by the second, Marxian account. The structural correspondence of wartime and postwar approaches to political subjectivity was an insight not lost on the Bechers' generation and one that motivated their rejection of the one-world, hearts-of-men model.

There are, of course, other possible levers for generating a "visual consciousness of our age" than that of the passionate attachments of one-world nationalism, like that of Steichen, or the passionate indulgences of a one-world subjectivism, of the experience of interiority itself as the medium of commonality, like that of Otto Steinert. On the idealistic end of the spectrum, for example, there is the old philosopher's dream of collectively generated enlightenment or communicative reason developed through the search for shared interest and the principle of common human reason. More soberly, perhaps, and far closer to our own experience now,

Figure 43
Otto Steinert, *Kraftwerk Bexbach*, 1953.

there is the capitalist's dreamworld of individual interest, or a fluid collective economy of individual wagers, risks, investments, losses, and gains brought into commerce through the market logic of exchange. However, the Bechers' own practice and the model of sociality it promises is not vested in either of these systems. Neither collectivist nor individualist, they work the principle of systematicity with equal passion, equal commitment and delight, to their own alternative "rhythms and repetitions," that is, to their own distinctive aesthetic ends.

Through this differential setting of form against content, aesthetic against instrumental aims, the Bechers return us to the original Enlightenment promise of the aesthetic—one lost on any simple account of the delight given in their work that would see it as unexpected beauty without philosophy, as delight without reason. That promise, in Kant's

formula, is the development of "the faculty for judging an object . . . *without any interest.*"[47] Judgment, in the Bechers' work, assumes the abstract form of a concept that allows aesthetic response to take place in a manner similar to cognition but through which, as Kant says, "no thing is actually cognized."[48] The experience of their work is thus realized as satisfaction (or dissatisfaction) in the object without any specific individual aim or instrumental purpose being satisfied (or frustrated), without any notion of individual interest or collective will. The experience produced, the delight that conveys satisfaction, thus is generalized and endowed with the presumption of universality or, in Kant's terms, "common sense."[49]

It is this experience of universality that the Bechers' project courts and posits as its systemic aim; it is this experience that serves as an alternative "visual consciousness of our age" different from the collective passions of political identification, partisan or otherwise, and different from the common individual interests of the consumer. The key to their system, to the particular form of social value they produce, lies in the fact that the objects they photograph are "anonymous." The Bechers give us modern industry in a manner that disavows its social, political, historical, and economic value and, in so doing, makes it available anew via an alternative category—aesthetic value or value *"without any interest."* This is a particular form of delight, philosophically distinct from other sorts of visual pleasure, and it conjures up a particular comportment, one that carries both the promise and the burden of social consequence. By creating the circumstances for such experience using aging industrial structures still resonant with the memory of all their great modern ambitions, the Bechers create a powerful sense of that disavowal of instrumental value, that purposiveness without purpose, as Kant named it, as *loss,* as the experience of *no interest* where interest was once housed, of *no passion* where passion once resided. In so doing, they give us a fully elaborated neo-Kantian judgment made melancholy, a fully developed archive structured around an absent ideal, and the great promise of Enlightenment is recovered in all of its original glory but now on the foundation of its own lost materialist soul. They incorporate "the past into the present and weld that present to a future," and they do so "at a stroke," as Merleau-Ponty put it, that is, in and through their bearing toward the world, through their standpoint midway between distance and proximity, through their gaze that looks neither up nor down but instead "straight-on" so that it does not "hide or

exaggerate or depict anything in an untrue fashion." The final question—
the one that only we can evaluate—concerns the ongoing vitality of this
comportment now, the present truth of this myth of the past that it asks
us to cathect as the basis of our future.

22

Like being and anguish in the previous two chapters, the comportment of
the Bechers' photographs is an embodied relationship to the world, a mode
of being in, or, perhaps better, a mode of being *with* the world more than
it is a mode of representing it. In this way, comportment itself becomes an
ethical or critical position in the Bechers' work just as photographic being
or the experience of "photography itself" did for *The Family of Man* and as
photographic anguish or the experience of producing oneself as a solitary
observer, "turning away after the click of the still-camera shutter," did for
Frank. If the experience of *The Family of Man* was one of losing oneself,
losing one's identity in the mix of what Frank characterized with both
longing and contempt as "human mayonnaise," the experience of losing
oneself in a depersonalized human generality, and if the experience that
Frank himself cultivated was one of escaping from the burden of particular-
ity by other means, that is by leaving town, by fleeing from identity, from
typecast particularity into an anguished and desocialized distinction, into
an introverted and friendless particularity, then the experience given by
the Bechers was more subtle and more complex. Theirs was one of mea-
sured, calculated relations with the world around them, not of merging
into it or fleeing from it, and so the affective and aesthetic charge of their
work is always tempered, nuanced, qualified, and guarded. The tension
that drives their work is a matter of simultaneously holding onto a com-
mitment and indulging in a visual delight without allowing either the
ethical impulse or the desire to get the upper hand. To put this another
way, their work is driven by both its impulse to commonality and systema-
ticity and its impulse to difference as the beholder moves from one picture
to the next and the next and the next, delighting in the differences made
available by the systemic arrangement along the way. It was this tension
between the general and the particular, between commitment and delight,
that has kept their camera "straight-on," as they have said, never fatiguing
from its resolve or aim, staying true to its original comportment over the
course of nearly fifty years.

The Bechers' comportment thus might be understood, finally, in three ways, only two of which we have considered so far. In the first instance already considered, it is a simple and consistent pattern of behavior in the sense of personal bearing or carriage or demeanor or deportment, in the sense of the angle of their camera, their distance from the subject they photograph and a host of other easily describable formal properties that register their embodied relation to the world. Such a formal analysis also opens itself up readily to the second conventional understanding of comportment: that is, as behavior or bearing or carriage in its proper sense, in the sense of good or appropriate or measured behavior or conduct, in the sense of the cultivated manners and staid conventions of bourgeois propriety. The thrill or delight or appeal of the Becher project was, after all, born out of conformity to a precise set of rules of conduct.

Proper comportment in this sense has always been a vehicle for social grace, a means for ease of movement in and through the world. Such ease is achieved by the measured self-containment and proper distance of good manners, by the propriety and predictability that becomes available only by closely attending to and assimilating a standardized set of rules of behavior, by rigorously maintaining the proper level of emotional engagement (between distance and proximity) from the world.

In this way, the Becher undertaking is very different from both *The Americans* and *The Family of Man*, neither of which allowed any measure of such distance or propriety and both of which gush within their own affective registers without reserve. Yet all three also shared a common cause, and this will speak to the third quality of comportment in the Bechers' work, the one we have not really addressed properly yet: in all three projects, photography was asked to represent its own place or bearing or identity in the world separate from other forms or expressions of sociality, to produce the experience of what Steichen called "photography itself." By comporting itself as photography qua photography—by opening out from one discrete view to the next and the next and the next without any one view displacing the other, that is, by its strong adherence to the serial form of the photographic essay—the Becher project, like *The Family of Man* and *The Americans* had each done differently before it, realized its own identity, its own version of photography as nation. All three projects did this consciously and expressly against the old forms of sociality realized in the rituals, customs, and procedures of citizenship or economic exchange

or religious devotion, that is, against the threat of renewing the old nation-alisms that had enabled the atrocities of World War II.

Like any identity or any nationalism, this was a form of abstraction. The Bechers' work bears the discomfort of living in a historical moment rife with contradiction and threat and comports that discomfort into an inde-pendent social form, an alternative mode of collective self-knowing, to that provided by the old political subjectivities given in other abstractions—the figures of the citizen, for example, or the consumer. Like the strong sequenc-ing of photographs in *The Family of Man* and *The Americans*, they lay out a "pattern of sequential experiences," as Kevin Lynch termed it, a way of moving through and interacting with the world with balance, poise, and equanimity. This investment in comportment was different from the investments of *The Family of Man* and *The Americans*, but all three projects shared the vision of photography as a medium of sociality, as a modeling agent for social form. In each instance, a new form of political subjectivity was given expression, a new dream of nation rendered, and it was done so only in the play between pictures.

The Bechers' and the other projects studied here have not generally been understood in terms of this dream of a new man even though such a dream has often been assumed to be housed in photographic form, if generally by other means than those studied here. This assumption was essential in myriad ways to the heady prewar days of the "New Vision," but it was also in evidence in the photographic theory for the period studied here. For example, this was an enduring, if somehow overwrought, theme developed at length by theorist and promoter Karl Pawek when he characterized the "new photographic style today" in 1959 as follows: "The old camera" of the prewar era "was not inside the space of the world it recorded, it was always positioned outside that world, somewhere in the infinite. The modern camera," the camera that emerged after the war, "has its place right among the subjects it photographs." What he had in mind was some-thing much more like Steinert's project than that of the Bechers, or more like *The Family of Man*, but his analysis and its affinity with the Becher comportment is clear. "There is no variation in levels between the modern camera and our world," he insisted, putting a fine point on what he had in mind: the modern camera did not look up to monuments of modernity or down onto a rational social plan but instead positioned itself on the ground, in the flux of social experience as a participant observer.[50] Indeed,

he would say later (while introducing his 1964 exhibition that raised the question that Steichen's project had presumed to answer, "World exhibition of photography on the theme What is man?"), both the problem addressed by photography and its opportunity alike arose precisely at the subject-object split or split between participant and observer: "In modern photography objective and subjective elements are mingled in such a way that the objective elements do not exclude the subjective, and the subjective elements do not place the objective in question."[51]

This was photography's historically specific contribution, insisted Pawek, as it is "no easy problem to understand for our contemporary mentality which tends to turn either towards a one-sided theory of immanence or towards an equally one-sided empiricism." Photography's role was ultimately to be philosophical: "The radical split of reality into Descartes' *res extensa* and *res cogitans*, in the external world as in thought, is transcended anew on the terrain of modern photography. This is one of the points where photography is revealed to be the instrument of a new epoch. It is for these reasons too that photography is such an exciting affair, because its own 'conditions' are identical to those of a new epoch in intellectual history."[52] That new epoch described by Pawek, we can see in retrospect, was the epoch first and foremost of phenomenology as a leading intellectual-historical development—both in the sense of an origin point in time, the moment of Merleau-Ponty's *pivot* (rather than Husserl's withdrawal from time, the *epochē*), and in the sense of a historical period—and it is the epoch that has concerned us here.[53] Photography's conditions were "identical" with its contemporary intellectual history because it was enacting a relationship to the world that philosophy was attempting to describe.

23

The question to conclude with, thus, is the one we began with: the manner in which serial photography inscribes a point of view or a grammar constitutive of political subjectivity, the manner in which it creates the lived experience of social form. To put this another way, we can ask whether the movements of body and machine required to take a picture can become conventionalized and therefore shift from being not only the instrumental movement necessary to perform an operation to something that takes on the cultural expressiveness and conventionality of comportment.

Photography as a technology poses a special case generally with two related properties in this regard. The first property is the function of the camera as "one of the organs of [man's] activity, which he annexes to his own bodily organs," as Marx described it for technology generally, or an "extension of man" in Marshall McLuhan's terminology or, more narrowly, a "caméra-stylo" in Alexandre Astruc's auteurist manifesto.[54] Each of these accounts assumes that a new, embodied form of expressiveness is made possible with the mechanical extension of the human apparatus. The camera moves about the world pointing its lens this way and that in a kind of dance that is itself expressive of feeling and meaning and that expression is indexed or inscribed in photographs and film. The new vision enabled by photographic technology, thus, is a *pas de deux* between subject and object—or a *pas de trois* between photographer-subject, photographed object, and beholding audience—a dance that is defined only in the interaction of elements, not by the identity of any one of the elements themselves.

The second property that must be considered in concert with the first is the status of the photograph as a unitary representative of a slice of space-time and its implicit and often explicit reference to all other photographs as equivalent units. This parceling of the world that Bergson and others rejected so vociferously, and that film did so much to cover over, carried its own distinct meaning and promise by allowing each individual image or frame to be perceived as a building block for a larger aggregate form.

This second property can be brought together with the first by considering that aggregation as itself a form of inscribed movement or gesture, as elements brought together within a larger dance or embodied performance of the camera. Such, of course, is very similar to frames brought together in a film or notes brought together in a musical composition, but we can also distinguish the different possibilities available to still photography conceived of and responded to as an aggregate form. In particular, we can point to the ways that the movement of the camera lens is performed, indexed, and returned to the beholder as a process of distancing from the self, of becoming other to oneself, that is, of becoming identified with what used to be called the "image world" or with photography as such. This is achieved first and foremost because serial photography holds onto the separation of frames and does not allow each to be displaced by the next in an overarching, overdetermining narrative (or just temporal) schema.

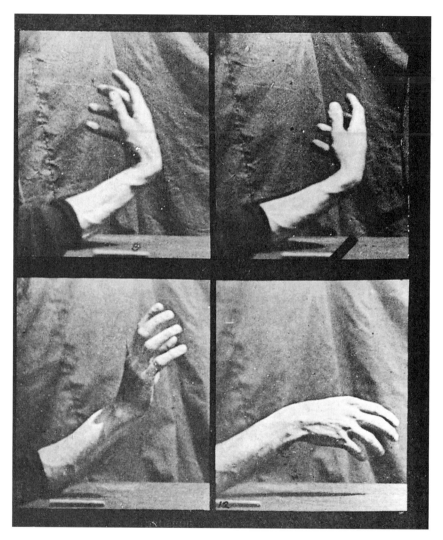

Figure 44
Eadweard Muybridge, *Movement of the Hand; Beating Time*, ca. 1884–1887, detail of frames 5, 6, 11, 12. George Eastman House, Rochester, N.Y.

The experience of these hard partitions is the moment of abstraction differentiated as photographic being and photographic anxiety above in Chapters 1 and 2, and here described as the boundary and point of tension between distance and proximity, between particularity and generality, in the Bechers' photographic comportment.

To return again to our foundational example, we can look to Muybridge's sequencing and the *pas de trois* that takes place between the movement of the photographer (or movement from camera to camera to camera in a camera bank), the movement of the photographed subject, and the movement of the beholder from one frame to the next and the next and the next. There are many things for the beholder to identify with a sequence like this—the movement of the hand beating time, for example, or the vantage point of both camera and eye at tabletop height. But we might focus most closely on the staccato rhythm of the movements between frames that is emphasized by the (human or machine) gesture of depressing the shutter release button over and over again, the sound of the shutter releasing and the consequent framing of individual images. Experiencing photography's decisive moment in this way is at once an experience of a discrete view and that same discrete view opening out to another and another and another in a series that is, at least potentially, without end.

This balance or tension between the particular and the general, between the systematic rigors of representation and the play of delight indulging in the differences of form is the governing characteristic of the photographic comportment considered here. Like a salute or a hand held to heart for a national anthem or hands held together in prayer, the comportment given by the camera's movement through space is a medium capable of expressing cultural coding, and with that, it is a medium for realizing a social bond. The bodily movement of the photographer, particularly when considered in relation to the movement of the photographed subject, on the one hand, and the photograph's beholder, on the other, is itself a form that has a history and means different things at different times.

"In modern times," wrote Hegel, the individual finds the abstract form of knowledge "ready-made." The scientific, rationalistic view of the world pervades modern understanding and in so being the experience of knowledge is codified as abstraction rather than revelation. Thus, "the task nowadays" for understanding in response to such ready-made and abstract forms of understanding, especially including identity, the "fixed thought"

Kühltürme

·Friedrichshütte·, Herdorf, Kr. Altenkirchen, 1922 Zeche ·Victoria Mathias·, Essen, um 1930

Kraftwerk ·Bargoed·, Südwales, um 1920 Kraftwerk bei Lydney, Forest of Dean (England), 1924 Grube ·Penallta·, bei Caerphilly, Südwales, 1935

Figure 45
Bernd and Hilla Becher, page spread from *Industriebauten, 1830–1930*, 1967. Courtesy Sonnabend Gallery, New York.

which "the 'I' itself is" (or, for our purposes, the self-understanding given by nation), "consists not so much in purging the individual of an immediate, sensuous mode of apprehension, and making him into a substance that is an object of thought and that thinks, but rather in just the opposite, in freeing determinate thoughts from their fixity."[55] This was the great modernist aim that gave rise to the Becher comportment, just as it did for Frank's *Americans* and *The Family of Man*: to free determinate thoughts from their fixity, as Hegel termed it, or to free embodiment from self-consciousness and voluntarism. The goal for Hegel and the tradition that

followed, however, was never to evade such determination altogether. The question was only how or where to find the right balance.

This is the point where all three projects studied here can be distinguished from their postmodern followers. None would say with Gerhard Richter, for example, that "I do not pursue any particular intentions, system or direction. I do not have a programme, a style, a course to follow. . . . I like things indeterminate and boundless, and I like persistent uncertainty."[56] Instead each held firm to the promise of a system or program even as they experienced the world as boundless, as marked by persistent uncertainty. It is this peculiar rigor, this commitment to contradiction, to negation as a way of being in the world that never languished in its own criticality, that opened their undertaking to the distinct period promise first named by Merleau-Ponty "the pivot of the world."

Epilogue: Art and Objecthood

The limit condition for the experience given here as the pivot of the world changed following its brief period of fluorescence in the 1950s. If the point where it had previously lost its vitality had been various kinds of humanism—the humanist temporality of film that closed the gap in lived experience opened up by the scientific photography of Muybridge and Marey, for example, or the humanist spatiality of the documentary tradition beginning with Lewis Hine that eliminated the distance between our half and the other half, between subject and object, by rendering objectification only as a violation, only as a reduction of humanity rather than as also always its enlargement—the new limit that emerged circa 1960 was different. Instead of an overcompensating subjectivization, the new relation to the world that began in earnest with pop and the camp sensibility generally undercut the pivot back and forth between subject and object by settling into the moment when subjectivity is given up rather than reifying the moment that it is gained. This is the moment when identity is reduced to that which is repeatable, the moment when subjectivity falls away in the interstitial gap between pictures or objects or ideas and all that remains is the residue or backwash of an empty category, the moment when all that remains is the droll half-life of a "subject position."[1]

Like the *durée* of the earlier limit, this later snare would also be defined by, as Michael Fried described it in 1967, a "presentment of endless, or indefinite, *duration*."[2] This was identity abstracted and objectified rather than naturalized and humanized—it was Andy Warhol's vaunted role of "the Nothingness Himself" rather than the in-the-moment expressive subject of action painting, for example, or objecthood in Fried's terminology rather than subjecthood—but it was an identification equally locked into its own narrative step nevertheless.[3] The older humanist and newer

Figure 46
Dan Graham, filming *Body Press*, 1970–1972. Courtesy Marion Goodman Gallery, New York.

posthumanist limits are not unrelated, and in retrospect we can see how the period studied here—the period in which those limits were momentarily surpassed—would serve as a transition from one to the next, from one ideology to the next, from the old modernist longings for universal, transhistorical rootedness to postmodernism's drive for differential, ahistorical rootlessness.

Understood in this way, *The Family of Man*, *The Americans*, and the Becher project can seem equally defined by either older or newer limits depending on the frame of reference. The Bechers, for example, who are regularly and rightfully associated with Warholian objecthood, are also regularly and happily cast as documentarians drawing out the individual integrity and common humanity embedded in the design of each and every building they photograph. So too, *The Family of Man* has been understood typically and correctly as a kind of extreme humanism and also understood equally legibly and valuably as "a universally exchangeable 'abstract equivalent' of its worldly referent," that is, as homologous to "the circulation function of paper currency."

This confusion is related to a larger sense of uncertainty about the reemergence of the prewar avant-garde ambition of art into life—the ambition for art to take on specific social purpose above and beyond its ambition as art qua art—beginning in the 1950s. This uncertainty has been at issue generally, for example, in any account of the neo-avant-garde as a distinct phenomenon, in any account of site specificity as an artistic aim, and for artistic developments beginning around 1960 that incorporated the exhibition context and beholding subject into the work itself—in Dan Flavin's light fixtures shining out onto gallery and beholder, for example, or Robert Morris's mirrored boxes reflecting gallery and beholder back to themselves, or Dan Graham's semitransparent, semireflective glass walls and structures and video explorations, or in Daniel Buren's stripes marching out the gallery door into the street, or in Hans Haacke's transparent poll boxes that give back to the museum and gallery visitor the demographics of their social and political values.

Each of these and many others found its edge, its claim to be effective or innovative as art, by bringing both beholder and art institution into the picture and, in so doing, both activating the beholder within the work and implicating the institutional conditions of beholding, making it subject to critical appraisal.[4] Art's promise of autonomy and the reality of its social

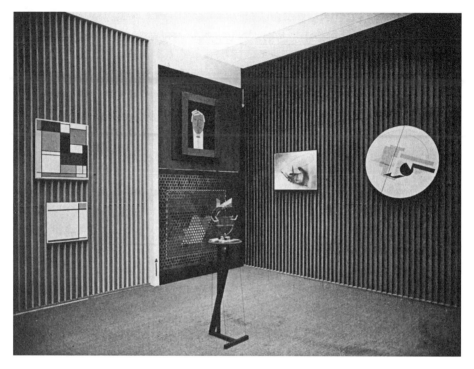

Figure 47
Alexander Paul Walther, installation shot of El Lissitsky's *Raum für konstruktive Kunst,*
Internationale Kunstausstellung, Dresden, 1926. Getty Research Institute.

form intertwined in self-reflexivity. As one typical period account had it,
"The human presence and perception of the spatial context have become
materials of art."[5] In so doing, the beholder no longer loses herself in the
illusionistic, other-worldly space of art but instead finds herself in the real
life setting of the institution of art.

 Such parallels between neo- and historical avant-gardes are often drawn
to Lissitsky's demonstration rooms from the mid–1920s. Like a Flavin
installation, say, or a Morris or a Graham or a Haacke, the beholder was
asked to experience herself as an art-viewing subject by having her position
relative to the object reflected back to her. Entering into Lissitsky's room
and moving about in it—moving to take in one of the Mondrians, say,
then the Gabo centerpiece, then one of Lissitsky's own easel paintings, one
of his *Prouns*—gave definition to the art by registering the effect of

movement on perception. The viewer is not only temporalized in period Bergsonian fashion but "activated," as Lissitsky himself said (and it has been repeated since), and was no longer passively consuming one artwork complete unto itself after another and another—each with its own equivalent but separate values and pleasures, its own reassuring integrity of meaning, its own framed-in aesthetic experience—but instead is made over into the agent of synthesis or integration for the experience of art viewing.

In the Lissitsky rooms from the 1920s, as with the installation examples from the 1960s and after, this was sometimes experienced as a startling, even embarrassing interpellation, which, as it has been acutely observed, "corporealizes precisely by undoing one's presumed bodily integrity."[6] The experience of beholding given by these installations is denaturalized by rendering it both separate from and interdependent with the object that is being beheld and the attitude of perception in which one loses oneself in the object is suspended by making the beholding itself into an object of art. In so doing the beholder finds a place in what is being said, a place that both exposes her to her own gaze (and thereby implicating her in her own judgment) and empowers her with her own presence in the truth that the institutional setting authorizes as art. In a very material sense, thus, this might be seen to be the moment addressed in this book, that is, the moment of the pivot of the world. The beholder finds herself in the position of being both subject beholding and object beheld and is thereby invited to pivot back and forth between the two.

Such a conclusion, however, would be drawn too quickly. The limits of the parallel between historical and neo-avant-garde forms of self-reflexivity can be made more pressing and thereby open up the more subtle and more expressive distinction that this book has tried to highlight by invoking other heroic figures from the old school—John Heartfield, say, or Gustav Klutsis or even Lissitsky himself in his more propagandistic mode—and imagining their later, sharpened sensibility projected forward in neo-avant-garde form. It was with such politicized (Stalinized, we might say) extensions of the original movement into the space of the beholder, after all, that the social and historical assumptions of modern art's promise of significance and futurity would come most fully to the foreground. The mission of art into life was realized when art became propaganda.

So too, at the moment when the avant-garde turned away from the laboratory model a new critical self-consciousness emerged. "While they spoke with the most withering contempt of the 'uselessness' of old art," as one period commentator described it, "it did not take very long for everyone, including the constructivists themselves, to perceive that their own works were precisely the same kind of 'useless' esthetic objects of no immediate practical value whatever."[7] Indeed, this was certainly what Lissitsky himself meant when he spoke about the shift in role from the model of the laboratory engineer or designer or constructor to that of the "active collaborator." The work of artists now, he said, will "actively raise the general standard of living," concluding in the high Hegelian mode of the moment that doing so "is the dialectic of our development, which comes by way of the negative to the positive."[8] Or, as he put it retrospectively in 1932, "we fought against 'art,' we spat at its 'altar'—and we got what we wanted." Now, he continued, "we need no new art monasteries and sacred groves, but, even flying through a storm as we are, . . . to carry our offspring to term."[9] That offspring was some version of art-into-life, some yet-to-be-fully realized constructivism-cum-productivism or art become industrial design or advertising or propaganda.

This radically instrumentalized notion of art into life thus can be said to have been latent in Lissitisky's demonstration rooms, at least by his retrospective account. Art was given its vitality by the promise of moving out beyond the ideal world contained by the picture frame into the gallery, into the experience of the beholder, into life. Once released into the world from the confines of the frame, art's ideal would need to withstand the test of the real, where it would stand or fall by the work-a-day standard of social change. This has always been the measure of an avant-garde so it will not be controversial to note that Lissitsky and comrades eventually came around to this test (whether they did so of their own volition or not) while their neo-avant-garde heirs did not.

As any aficionado of either will tell you there is a real, palpable loss of humanity or vitality or artistic value in the shift from Lissitsky the constructivist to Lissitsky the propagandist, from faktura to factography, or, more generally, from art conceived as a laboratory activity to what later came to be called with due disdain "political art." Indeed, when the ambition of art into life realizes its aim in instrumentality, when it abandons the unaffiliated perceptual experimentation available in the studio, gallery and museum

and attempts to stake its claim in the world as advertising or design or as propaganda, it fails by the criteria that justify its claim to be art. Typically this has been in exactly the ways that Clement Greenberg, Michael Fried, and others were concerned about. It fails the test of honesty or integrity or truth-to-experience by compromising in the name of the exigencies of life rather than holding firm to the unrealizable ideals of art.

So it was that art into life was destined from the beginning to become thin or flat or tinny or hollowed out from the inside by pegging representation not to something immediately of its own experience—opticality, for example—but instead to an idea or agenda or cause. In so doing, it was also doomed to swing recklessly from one false ideal to another, from pure art to the selfless instrumentality of pure life or pure world if it was to hold onto its status as art. However, these inevitable failures do not mean that its reach toward life, toward advertising and design and propaganda, was not itself the source of its dynamism or vitality, its claim to authenticity and relevance, however flawed. Art into life has always been modernism's attempt to free itself from the fantasms of subjecthood and objecthood—from the phenomenological redoubt of antiart as much as from the dreamy interior world of art—even as it threatened to find itself trapped in the ideological confines of flat, overbearing, and unreflective instrumentality.

While art into life is one modernist measure of value, so too is the opposite standard that assesses art's capacity to open up its own "presumed bodily integrity" by questioning its presuppositions about life. Any canonical piece of propaganda could do to show how such ideological presumptions and presuppositions can be shored up in a work of art. We might consider Heartfield's posters or *AIZ* covers, for example, or Lissitsky's own contribution to the Soviet propaganda of the 1930s, or, for that matter, any of the myriad examples of advertising developed by artists throughout the last century. However, to hold onto Lissisky's 1920s formulation and ask simply, *How do these forms activate (or pacify) the beholder?* puts the question too bluntly. It is not wrong-minded, but it obscures the issue at hand by jumping too quickly from the realm of the beholder's experience to the realm of social form and the sort of ambition studied in this book becomes, once again, lost in the middle.

To be made more useful, the question can be qualified by asking, *Activated (or pacified) by what, exactly—by what sort of system or institution or apparatus*

or body of understanding? In the end, after all, the instrumental ambition to activate the beholder cannot be divorced from the aims of propaganda. This is certainly the case for the three projects studied here and any understanding of their place in history would fall woefully short without adequate attention to the "distinct ideological cast" that Hilton Kramer and many others since found in *The Family of Man* or the "socialistic view" that the Bechers squared their vision against or the "1934 eyes and blinders" attributed to Frank. Of course, like the policy of propaganda "without the 'propaganda' tone" of their period, all three projects defined themselves first and foremost against ideology but that does not mean that they did not hold onto propaganda as a form to make their case.

There are many varieties of propaganda, of course, but what they all share as an aim is to establish a reciprocal relationship between the beholder and the social form they are propagating. Propaganda does its work, it convinces, by producing a shared bond or sense of identification between individual and collective forms, between citizen and state for example. Both components must be there for it to gain an affective foothold in the psyche of its beholder. The image must give the individual some sense of control of the collective and the collective must assume some control of the individual. This can be done in a lot of ways: through the kind of typological representations of workers, soldiers, farmers, and the like that give beholders clear social categories through which they can realize their participation in collective life, for example, or through an image of a leader or institution that represents the interests and investments of its constituency. The beholder is activated by interpellation to an assigned role in the political apparatus, and the apparatus is given an assigned role in the beholder, filling out her being with collective meaning and purpose. The critical question for propaganda is not whether individual and collective identifications interpenetrate each other—this is unquestionably and inevitably the case if it is doing its job at all—but instead the degree to which there is real or only apparent reciprocation between the two forms, the degree to which the individual can realize autonomy in and through the collective, the degree to which suitable political principles are realized through its form.

This is where Lissitsky's demonstration rooms and the related projects from the 1960s differ most significantly from the photographic projects studied here. Rather than state or history or progress or leader—rather than the social in any recognizable form—the beholder is assigned a position

within a delimited self-reflexive relation. Subject mirrors object and object subject for sure, but there is little or no conflict or contradiction as the beholder beholds himself beholding, and the pressure of subject-object contradiction is given an easy out on the common ground of antiart or antisubject, on the common ground of objecthood. The beholder was indeed activated, as Lissitsky claimed in the 1920s before he changed direction to "actively raise the general standard of living," but only in the most mechanical way.

There is no question that this approach has had a significant effect. The presumed bodily integrity that is undone is the integrity of subjectivity in both its individual sense (that gives focus to desire) and its collective sense (that brings with it a sense of belonging). What is corporealized in their stead is subjectivity conceived without desire or belonging: subjectivity as objectood or the radically reduced subjectivity of subject positionality. Lissitsky moved out of this phase quickly and forcefully (and not only because he was pressured to do so), but the art of the 1960s did not. This may be its most lasting legacy. With art holed up in a phenomenological redoubt and closed off from the movement of judgment that would contradict its experience of objecthood, the conflict that had once driven modernism's effort to reorganize life at the most basic affective registers addressed by art was reduced to the micropolitical and affectively desiccated dimension of death-of-the-author identity politics.

Modernism had its own limits, of course, no more or less than postmodernism. When it succeeded, the contradiction between social and individual, between ideal and real, between object and subject, was both actively in opposition and actively seeking resolution, even if that resolution was always beyond reach. Modernism sold itself short not when it was in contradiction with itself but instead when it fell into the trap of one extreme or the other—into the lackluster solipsism of "self-expression" or the disaffected rationalism of instrumental reason—that is, when it fell out of contradiction into the deadening circular reasoning of either art or life. It was contradiction itself that was modernism's reality and its vitality and it could be experienced meaningfully only when the phenomenological moment of encounter with the world prior to the closure of judgment cast itself as being never fully compatible with the judgment that followed. That moment provided an opening in the misguided coherence of bounded bodily integrity for sure, but it did not substitute objecthood or subject positionality for the longing and anguish of subjectivity itself. Instead, it

opened subjectivity to its objective other and therefore to the dream of autonomy realized through progressively expanding collective belonging.

The promise of phenomenology as a theory has always been based on the possibility of transcendence for the moment it describes, the possibility that such an embodied experience of the world could be shared, could be collectivized, could be made over into a system, a philosophy, an ideology, an identity, could itself serve as ground for the experience of nation. There are various debates, critiques and suspicions surrounding this question, of course, but the concern has never been whether that transcendence itself is available but rather how so and to what end it might be used.[10] The phenomenological model of experience, in other words, was never to be an end in itself. Its goal was not to be able to say, "I feel, and that relieves me of the burden of identity and ideology," but instead to ground the production of identity and ideology in experience rather than in staid or formulaic belief structures, on the one hand, or in the flat negation of those structures, on the other. "I experience each and every moment anew," it promises, "and as I turn from one picture to the next, from one moment to the next, a new world, a new system, a new approach is born."

It is this very modern promise of autonomy or enlightenment that would seem to be increasingly threatened by our changing world, particularly the growing influence of economic and political structures that have only a minimal connection to any meaningful electorate. Objecthood may well be the model of identity best suited for globalization in its current form. Whether this proves to be true or not, objecthood limits itself to a defensive posture, a falling back on a default form of political subjectivity, one that is unwilling to take on the ideological labor that was the backbone of modernity's democratization. The specter from the past that the photographic projects studied in this book can remind us of is what it means to struggle to reconcile contradiction rather than simply giving in to it as a reified condition of social life.

In this regard, Daniel Boorstin's seemingly overdrawn diagnosis of "the monotony within us, the monotony of self-repetition" as a period malaise might have more purchase than originally imagined. The threat of monotony is not simple boredom or alienation in any narrow, individual-overcome-by-tawdry-mass-culture sense, however, but instead in the expansive sense first used by Marx. Alienation, by this understanding, is a

limit to social imagination, a limit to historical consciousness, a restricted capacity to understand one's own meaning and being as it is housed in social form. Monotony thus would be the affective register of our ideology, a posthumanism no different in function than the sentimentality and nervous ailments of the humanisms of old.

Whether this is so or not, the art historical record tells us that something significant shifted. When the experience of the world considered in this study became narcissistically attached to its own objecthood and abandoned its claim on subjectivity, art's role as a figure of the political sacrificed its ability to use the experience of serial form as an opening back out onto world, an opening back out onto the experience of autonomy in system and identity and ideology and nation. Already in that small affective shift, it might be said, the once powerful aim of class consciousness was reduced to identity politics and the mighty dream of enlightenment was reduced to globalization. The photographic projects studied here were not there yet—the movement from one picture to the next and the next and the next was still vital and exciting and had not yet taken on the monotony of reified social form—but if we judge from the recent history of art it seems safe to say that we are mostly so now. Certainly, there is no way to relive this prehistory, no way to effectively call up its peculiar ambition and make it our own, but we might look back on it from our redoubt and understand more fully what it means to say that its experience of photography as nation is an experience-of-world gone by.

Notes

Prologue

1. Daniel J. Boorstin, *The Image; or, What Happened to the American Dream* (New York: Atheneum, 1962), pp. 257–258.

2. "Photography, by enabling any mechanically adept amateur to produce a kind of 'original'—that is, a unique view of an unrepeatable moment of what is really out there—confuses our sense of what is original and what is a copy of experience. . . . We live willy-nilly in a world where every man is his own artist." Ibid. p. 70

3. Irving Howe, "Notes on Mass Culture," *Politics* (Spring 1948): 123.

4. "The double nature of humanism," writes Terry Eagleton, is "the defiant boast of the modern ('I take value from myself alone!') and its hollow cry of anguish ('I am so lonely in this universe!')." Terry Eagleton, *The Ideology of the Aesthetic* (London: Blackwell, 1990), p. 72.

5. See my "Andy Warhol's Red Beard," *Art Bulletin* (September 2001): 527–547, for a more extended discussion of camp and my "Conceptual Work and Conceptual Waste," Michael Corris, ed., (in *Conceptual Art: Theory, Myth, and Practice* (Cambridge: Cambridge University Press, 2003) for a more extended discussion of the legacy of productivism.

6. This seems true, at least now in retrospect, even during the triumphal period between 1989 and 2001 at "the end of history." The victorious consumer model still held within it the memory of its others that it assumed it had triumphed over even if those memories existed only in the form of old statues of Lenin and comrades turned into trophies-cum-trinkets for the capitalist class.

7. This does not mean, however, that those attempts do not continue to persist as so many utopianisms and dystopianisms, as so many bad memories and delusional expectations for what the world might have been or what it might still be that serve as forms of justification and release for the existing forms of political subjectivity.

Rather, it means that they are available to perform a different service because of their marginal status, that they are available as placeholders and foils and, insofar as they support the existing systems of relations, they must necessarily seem farfetched.

8. Theodor Adorno, "Progress" (1962), in *Critical Models* (New York: Columbia University Press, 1999), p. 144.

9. Milton Friedman, *Capitalism and Freedom* (Chicago: University of Chicago Press, 2002 [1962]), p. 201.

10. This has been the dominant critical reception of *The Family of Man*. See the discussion of this reception in Chapter 1. This project aims only at opening up the moment of the transition from one form of political subjectivity to another, not questioning the validity of the transition itself.

11. Max Horkheimer and Theodor W. Adorno, *Dialectic of Enlightenment* (New York: Continuum, 1976), p. 4.

12. Albert O. Hirschman, *The Passions and the Interests: Political Arguments for Capitalism before Its Triumph* (Princeton: Princeton University Press, 1977), p. 43. For a further development of Hirschman's thesis, see Charles Taylor, "Modern Social Imaginaries," *Public Culture* 14, no. 1 (2002): 91–124.

13. Fredric Jameson is characteristically and consistently insightful on this point of tension. "In general," he writes in his 1998 *Brecht and Method* using a different metaphorical schema (but one that will indicate some of the direction of this project, particularly when we get to the chapter on the Bechers), for example, "the struggle between modernist and postmodernist ideologies can be characterized as that between a fetishization of visible reservoirs of energy—machines whose stored labor is still apparent, and to be explosively reactivated, as with the combustion engine—and a ceaseless transmission of electronic signals whose relationship to human energy is problematic and which, rather, offers itself as an immense new element in which human actors might immerse themselves." *Brecht and Method* (London: Verso, 1998), p. 178.

14. Kevin Lynch, *The Image of the City* (Cambridge, Mass.: MIT Press, 1960), pp. 91, 115. For a detailed account of the related urban theory of the Situationists, see Simon Sadler, *The Situationist City* (Cambridge, Mass.: MIT Press, 1998).

15. Prasenjit Duara, *Decolonization: Perspectives from Now and Then* (New York: Routledge, 2004), p. 2.

16. For a good account of one version of this ideological function, see the discussion of period style in Daniel J. Sherman, "Post-Colonial Chic: Fantasies of the French Interior, 1957–62," *Art History* 27 (November 2004): 770–805, for example, in this passage: "But association style did something rather different: it glorified the 'origin',

or at least the notion of an originary culture, while obliterating the more troubling context of transmission, the period in which an object existed primarily for and by its exchange value. In this way the fact of its presence in a home, its domestication, so to speak, provided a new form of use value, albeit an entirely factitious one. The designers promoting association style sought not so much to rewrite history as to assign to it the reassuring blurriness of an image kept permanently out of focus. The fantasy of association reduced actual conflict to the harmless clash of objects, easily reconcilable by a perceptive eye, and provided a concise narrative of harmony, reconciliation and shared humanity. The pictured interiors shunted aside awkward questions about the objects' origins and uses, masking the violent complex of power and knowledge that had brought them to their new homes in the West. Only in the shared imaging of private space could ethnographic objects testify solely to their possessors', and by extension the nation's, taste and status as forward-looking citizens of the world. At the same time, such display needed to take on the public dimension afforded by magazine illustration in order to smooth the transition from empire to a new imagined community of transnational cultural sophistication" (pp. 799–800).

Introduction

1. Hans Kohn, *The Idea of Nationalism: A Study in Its Origins and Background* (New York: Macmillan, 1951 [1944]), pp. 19, 22.

2. "Whatever elation there is in the world today," wrote Cousins, "is severely tempered by a primitive fear, the fear of the unknown, the fear of forces man can neither channel nor comprehend. This fear is not new; in its classical form, it is the fear of irrational death. But overnight it has become intensified, magnified. It has burst out of the subconscious and into the conscious, filling the mind with primordial apprehension" *Saturday Review of Literature*, August 18, 1945, p. 5, quoted in Paul Boyer, *By the Bomb's Early Light: American Thought and Culture at the Dawn of the Atomic Age*, Chapel Hill: UNC Press, 1994 [1985], p. 8.

3. Albert Einstein, "The Real Problem Is in the Hearts of Men," *New York Times Magazine*, June 23, 1946, pp. 7, 42–43.

4. See Hans J. Morganthau, "The Influence of Reinhold Niebuhr in American Political Life and Thought," in Harold R. Landon, ed., *Reinhold Niebuhr: A Prophetic Voice in Our Times: Essays in Tribute*, (Greenwich, Conn.: Seabury Press, 1962).

5. Niebuhr in Harry R. Davis and Robert C. Good, eds., *Reinhold Niebuhr on Politics: His Political Philosophy and Its Application to Our Age as Expressed in His Writings* (New York: Scribner, 1960), p. 246. See also, for an example among Niebuhr's prolific writing during the period, Reinhold Niebuhr, *The Self and the Dramas of History* (New York: Scribner, 1955).

6. Louis Althusser, "The International of Decent Feelings," in *The Spectre of Hegel: Early Writings* (London: Verso, 1997), p. 22.

7. Frantz Fanon, "Introduction," *Black Skin, White Masks* (New York: Grove Press, 1967), pp. 9–10.

8. Frantz Fanon, *The Wretched of the Earth* (New York: Grove Weidenfeld, 1968), pp. 312, 316.

9. Jean-Paul Sartre, preface to ibid., p. 30.

10. Jean-Paul Sartre, *Anti-Semite and Jew* (New York: Schocken Books, 1965), pp. 30–31.

11. Jean-Paul Sartre, *Critique of Dialectical Reason: Theory of Practical Ensembles* (London: NLB, 1976).

12. In *Painting Photography Film*, for example: "In the photographic camera we have the most reliable aid to a beginning of objective vision. Everyone will be compelled to see that which is optically true, is explicable in its own terms, is objective, before he can arrive at any possible subjective position. This will abolish that pictorial and imaginative associative pattern which has remained unsuperseded for centuries and which has been stamped upon our vision by great individual painters." László Moholy-Nagy, *Painting, Photography, Film* (Cambridge, Mass.: MIT Press, 1987), p. 28.

13. László Moholy-Nagy, "The Contribution of the Arts to Social Reconstruction," in Richard Kostelanaetz, *Moholy-Nagy* (New York: Praeger, 1970), p. 21.

14. This was a theme that developed across the prevailing political spectrum. There were, in other words, competing paradigms of what 1944 Republican presidential candidate Wendell Willkie had called and popularized through, among other institutions, the Museum of Modern Art, "One-Worldism." See Willkie's statement on this in Willkie, *One World* New York: Simon and Schuster, 1943. Or we might use Willkie supporter Clare Booth Luce's critical characterization of 1948 Progressive Party presidential hopeful Henry Wallace's competing late Popular Front version of the global narrative—"globaloney." The difference of opinion that emerged during the war and continued to be worked out through the 1950s turned on how the new world order and the new global subject would be formed. Roughly put, the question was this: Was the medium to be high or low, culture or commodities, the exchange of ideas about the nature of man or about the relative merits of washing machines? The one side of this difference of opinion might be fairly labeled "neoliberal," the other something like "social-humanist." In the 1940s the terms of this opposition were as yet only emergent, and attention was directed much more to first the opposing sides of the war and then the opposing sides of the cold war. "One world, yes," Wallace warned in his 1948 Progressive Party acceptance speech that took Truman's

"betrayal" of the New Deal as its main theme, one world "frozen in one fear." "Betrayal by Old Parties," Philadelphia, July 24, 1948.

15. The term apparently emerged first in the French Communist Party organ *L'Humanité* on November 8, 1949, as part of a larger outcry in 1949–1950 over the aggressive marketing of Coca-Cola in France after the war. One American newspaper points to the poles of this struggle: "You can't spread the doctrines of Marx among people who drink Coca-Cola. . . . The dark principles of revolution and a rising proletariat may be expounded over a bottle of vodka on a scarred table, or even a bottle of brandy; but it is utterly fantastic to imagine two men stepping up to a soda fountain and ordering a couple of Cokes in which to toast the downfall of their capitalist oppressors." Quoted in Richard F. Kuisel, *Seducing the French: The Dilemma of Americanization* (Berkeley: California, 1993), p. 63. The Wilder film draws on a rich sense of history generally. In a particularly inspired choice, it leads with gangster cum G-man now cum globalizing executive James Cagney.

16. This was a position on Americanism that defined the early postwar period. "Today," Greenberg wrote famously in 1939, setting up the argument that would come to dominate after the war, "we no longer look toward socialism for a new culture. . . . Today we look to socialism *simply* for the preservation of whatever living culture we have right now." Clement Greenberg, "Avant-Garde and Kitsch," in John O'Brian, ed.,*Clement Greenberg: The Collected Essays* (Chicago: University of Chicago Press, 1986), 1: 22. In 1951, even a committed observer like Louis Aragon would still see the impact of Americanization only in cultural terms, beginning his diatribe with the great markers of the prewar account—"A Ford automobile, the civilization of Detroit, the assembly line," and then moving on to more contemporary symbols, "the atomic danger, encircled by napalm"—as the problem, but only as a threat to the sanctity of French culture: "Here is the symbol of this subjugation to the dollar applauded even in the land of Molière; here is the white lacquered god of foreign industry, the Atlantic totem that chases away French glories with Marshall Plan stocks. . . . The Yankee, more arrogant than the Nazi iconoclast," he concludes, again returning to the clichés of the 1920s, "substitutes the machine for the poet, Coca-Cola for poetry, American advertising for *La Légende des siècles*, the mass-manufactured car for the genius, the Ford for Victor Hugo!" *Les Lettres françaises*, 28 June 1951, quoted in Kuisel, *Seducing the French*, p. 41.

17. Jürgen Habermas, *The Structural Transformation of the Public Sphere: An Inquiry into a Category of Bourgeois Society* (Cambridge, Mass.: MIT, 1989 [1962]), pp. 29, 34 (translation modified).

18. Alexandr Rodchenko, "Against the Synthetic Portrait, for the Snapshot," in Charleo Phillips, (ed.), *Photography in the Modern Era: European Documents and Critical Writings, 1913–1940* (New York: Metropolitan Museum of Art, 1989), p. 241.

19. Quoted by Frances Stonor Saunders, *The Cultural Cold War: The CIA and the World of Arts and Letters* (New York: New Press, 1999), p. 23.

20. For one historical overview of the development and consequences of this contradiction, see Perry Anderson, "Internationalism: A Breviary," *New Left Review* 14 (March–April 2002): 5–25.

21. Lionel Trilling, "A Novel of the Thirties," 1966, quoted by Michael Denning, *The Cultural Front: The Laboring of American Culture in the Twentieth Century* (London: Verso, 1996), p. 3.

22. Edward Steichen, statement about *The Family of Man* in *Picturescope: Newsletter of the Picture Division, Special Libraries Association* 3, no. 2 (July 1955): 7.

23. O. N. Solbert, "Edward Steichen and *The Family of Man*," *Image: Journal of Photography of the George Eastman House* 4, no. 2 (February 1955): 14.

24. Karl Marx, *The Grundrisse* (New York: Harper and Row, 1971), p. 92.

25. Friedrich Schiller, *On the Aesthetic Education of Man* (New York: Ungar, 1954), p. 63.

26. Theodor Adorno, *Aesthetic Theory*, trans. Robert Hullot-Kentor (Minneapolis: University of Minnesota Press, 1997), pp. 244–245.

27. For one thoughtful account of neoliberal political subjectivity, see Wendy Brown, "Neo-Liberalism and the End of Liberal Democracy," *Theory and Event* 7, no. 1 (2003): http://muse.jhu.edu/journals/theory_and_event/voo7/7.1brawn.htm/

28. It should be noted that photography went through its own version of art's reaction to technological change. Ulrich Keller provides a good summary of this history: "Let me explain something that happened around 1900," he offers to some colleagues in a published symposium on August Sander. "The big commercial studios largely went bankrupt at this time because the lower end of the clientele, the mass clientele, no longer patronized them. People went to department stores and had pictures taken there for a fraction of the price that was charged in the studios. The other thing, of course, was the introduction of the Kodak camera in the 1880s; amateur photography came along, which again affected the lower end of the market. You took your own family pictures. . . . All this meant that around 1900 a lot of people . . . changed styles and began to provide something to upper-middle-class clients—a personalized, intimate picture, often a gum-bichromate print, that amateurs could not make with a Kodak camera and that you could not buy in a department store." In *August Sander: Portraits from the J. Paul Getty Museum* (Los Angeles: Getty, 2000), p. 106.

29. Related claims for the progressive emergence of photography's hegemony have been made by many, although typically at a further remove from the correspondence between aesthetic and social value given in Benjamin's account. For example,

Martin Jay draws on Rosalind Krauss to assert the following conclusion: "At the very moment that photography had finally achieved the exalted status it now enjoys it was subtly contributing to the very category of the aesthetic. What makes it so critical a phenomenon in our time—apart, of course, from its roles in surveillance and the spectacles of daily life—is its unique mixed status at the cross-roads of many different practices and discourses. As such, it has truly come of age, not because it has been comfortable domesticated in the tradition of respectable genres of art, but rather because of its subversion of that very tradition. If, in the past century, music was supposed to be the standard to which all other arts were to aspire, in the one to come, the curious hybrid we call photography is as good a bet as any to assume that exemplary role." Martin Jay, "Photography and the Mirror of Art," *Salmagundi* 84 (Fall 1989): 20–21.

30. Werner Graeff, "Es kommt der neue Ingenier," *G* 1 (1923): n.p.

31. Michael Jennings, "Agriculture, Industry, and the Birth of the Photo-Essay in the Late Weimar Republic," *October* 93 (Summer 2000): 23. There are other relevant studies as well. Carol Armstrong, for example, has built a study that works against the decontextualization of the individual photograph: "So accustomed are we to seeing photographic imagery together with some form of text or other, so much do we take it for granted, that the verbal framing of the photograph seems natural, even invisible. . . . It is all but swallowed into the image, interiorized within it, indivisible from it. . . . It is my aim, therefore, to reinscribe the nineteenth-century photograph in its textual surround, and if art history and the art museum have removed it from its album series or book pages, to reinsert it there." *Scenes in a Library: Reading the Photograph in the Book, 1843–1875* (Cambridge, Mass.: MIT Press, 1998), pp. 1, 3. See also the thoughtful history of the photographic essay as it developed in its commercial form in Glenn G. Willumson, *W. Eugene Smith and the Photographic Essay* (Cambridge: Cambridge University Press, 1992), pp. 5–30.

32. For more on this theme, see among other texts Jean Starobinski, *Montaigne in Motion*, trans. Arthur Goldhammer (Chicago: University of Chicago Press, 1985).

33. Theodor W. Adorno, "The Essay as Form," in *Notes to Literature* (New York: Columbia University Press, 1991), 1: 6.

34. Adorno, *Aesthetic Theory*, p. 131.

35. Theodor W. Adorno, *Negative Dialectics*, trans. E. B. Ashton (New York: Continuum, 1987), p. 15. The philosophical concept and critical value assumed to reside in the essay form did not originate with Adorno, of course; it is itself the core modern dialectical conceit, and he took it primarily from Hegel's *Logic* (p. 43): "What logic is cannot be stated beforehand," was how Hegel himself had put it; "rather does this knowledge of what it is first emerge as the final outcome and consummation of the whole exposition"; it "has its genesis in the course of the exposition and cannot therefore be premised." Truth, according to this philosophical tradition, can

be found only in movement, in the interstices between concepts and not in the concepts themselves. "We learn by experience that we meant something other than we meant to mean; and this correction of our meaning compels our knowing to go back to the proposition, and understand it in some other way." However, this other way did not mean that the impulse or movement between concepts was itself an independent, positive entity either—Being or Time or Vitality, for example—but instead was itself dependent on and (dialectically) determined by those concepts. The "goal" of philosophy as opposed to other forms of understanding, wrote Hegel, was conceptual, analytical, ratiocinative "plasticity": its aim is not to give accurate form to experience with a precise concept or exact rendering but to realize its truth in the experience of the form of thinking, of reasoning itself. Hegel, *Phenomenology of Spirit*, (New York: Oxford University Press, 1979) p. 39.

36. Ibid., p. 9.

37. Ibid., pp. 6–7.

38. Ibid., p. 13. This is the foundation of dialectics as a whole. Witness the first page of the introduction to *Hegel's Logic*: "The Notion of logic has its genesis in the course of the exposition and cannot therefore be premised." *Hegel's Logic: Being Part 1 of the Encyclopedia of the Philosophical Sciences*, trans. William Wallace (Oxford: Clarendon Press, 1975 [1830]), p. 43.

39. Alan Trachtenberg, *Reading American Photographs: Images as History, Matthew Brady to Walker Evans* (New York: Hill and Wang), p. 259.

40. Henry Luce, "The Camera as Essayist," *Life*, April 26, 1937, pp. 6–7.

41. Allan Sekula, "The Traffic in Photographs," *Art Journal* 41, no. 1 (Spring 1981): 15, 22.

42. This is Trachtenberg quoting Eisenstein to shore up his account. He glosses Eisenstein as so: "Any grouping of images within the book can be taken as an example of Evans's adaptation of the montage device, which can be restated as a dialectical process of thesis giving rise to counter-thesis, together producing as feeling and/or idea an unseen, unstated synthesis." He then goes on to make the social implications of his analysis clear: "By making us perceive in each successive image the presence of a changing society and its history, and our implication in what and how we perceive, Evans practiced a political art of the photograph, not a program of reform but social observation and critical intelligence." "A Dialectic Approach to Film Form," in *Film Form: Essays in Film Theory* (New York: Harcourt, Brace and World, 1949), p. 49, quoted in Trachtenberg, *Reading American Photographs*, pp. 259, 285.

43. This conflation is true of even the most learned and thoughtful accounts of early film. Leo Charney, for example, in an otherwise very interesting and productive account, reads Marey and Muybridge as only making visible the structure of

film-as-representation: "Muybridge and Marey . . . anticipated the soon-to-emerge aesthetic of cinema in a simple and schematic manner: Both men used new technologies to re-present continuous motion as a chain of fragmentary moments . . . both efforts made clear that in the constitution and reconstitution of movement, it is never possible to reconstitute the whole movement." Leo Charney, "In a Moment: Film and the Philosophy of Modernity," in Leo Charney and Vanessa R. Schwartz, eds., *Cinema and the Invention of Modern Life* (Berkeley: University of California Press, 1995) p. 290. See also his *Empty Moments: Cinema, Modernity and Drift* (Durham: Duke University Press, 1998).

44. Mary Ann Doane, *The Emergence of Cinematic Time: Modernity, Contingency, The Archive* (Cambridge, Mass.: Harvard University Press, 2002), pp. 22, 230.

45. This characteristic element of film is the subject of Deleuze's books on cinema and the turning point of his distinction between what he calls the classical "movement-image" and the modern "time-image" of cinema: "The so-called classical cinema works above all through linkage of images, and subordinates cuts to this linkage. . . . Now, modern cinema can communicate with the old, and the distinction between the two can be very relative. However, it will be defined ideally by a reversal where the image is unlinked and the cut begins to have an importance in itself. . . . It is a whole new system of rhythm, and a serial or atonal cinema, a new conception of montage." Each is its own image or "system of rhythm" or ordering principle which comes to the beholder as a pregiven method, as a principle of time. Gilles Deleuze, *Cinema 2: The Time-Image* (Minneapolis: University of Minnesota Press, 1989), pp. 213–214.

46. Theodor W. Adorno, "Intention and Reproduction," in *Minima Moralia: Reflections from a Damaged Life* (London: Verso, 1974), p. 142.

47. Lisa Cartwright has this exactly right, I think, but looking at the problem from the other side. The "greatest importance" of the film motion study, she writes, is "its function as an intertext between popular and professional representations of the body as the site of human life and subjectivity. . . . The film body of the motion study is thus a symptomatic site, a region invested with fantasies about what constituted 'life' for scientists and the lay public in the early twentieth century . . . and contributed to the generation of a broad cultural definition of the body as a characteristically dynamic entity—one uniquely suited to motion recording technologies like the cinema, but also one peculiarly unsuited to static photographic observation because of its changeability and interiority." *Screening the Body: Tracing Medicine's Visual Culture* (Minneapolis: University of Minnesota Press, 1995), p. 12. What concerns us here is the loss resulting from that move to naturalism.

48. Gilles Deleuze, *Cinema 1: The Movement-Image* (Minneapolis: University of Minnesota Press, 1986), p. 29.

49. For more on this, see, for example, Mark Antliff, *Inventing Bergson: Cultural Politics and the Parisian Avant-Garde* (Princeton, N.J.: Princeton University Press, 1993).

50. Umberto Boccioni in "Fondamento plastico" (1913) quoted by Marta Braun in *Picturing Time: The Work of Etienne-Jules Marey (1839–1904)* (Chicago: University of Chicago Press, 1992), p. 311. Bergson can be quoted endlessly on this topic. "That which is commonly called a *fact* is not reality as it appears to immediate intuition," he insists, for example, in his brilliant *Matter and Memory*, "but an adaptation of the real to the interests of practice and to the exigencies of social life." Henri Bergson, "Introduction" in *Matter and Memory*, trans. Nancy Margaret Paul and W. Scott Palmer(London: George Allen and Unwin, 1950), pp. 238–239. Philosophy, like science itself and the scientific or pseudoscientific photography of Muybridge and Marey, carves out discrete concepts, facts, and images from the continuous flow of experiential reality: "Scientific thought, analyzing this unbroken series of changes, and yielding to an irresistible need of symbolic presentment, arrests and solidifies into finished things the principal phases of this development. It erects the crude sounds heard into separate and complete words, then the remembered auditory images into entities independent of the idea they develop." *Matter and Memory*, p. 154.

51. Bergson, "Introduction," pp. 238–239.

52. Ibid., p. 154.

53. Ibid.

54. Ibid., p. 77.

55. That naturalism is evident everywhere in Bergson's writings—for example, here: "Take a complex thought which unrolls itself in a chain of abstract reasoning. This thought is accompanied by images that are at least nascent. And these images themselves are not pictured in consciousness without some foreshadowing, in the form of a sketch or a tendency, of the movements by which these images would be acted or played in space,—would, that is to say, impress particular attitudes upon the body, and set free all that they implicitly contain of spatial movement. Now, of all the thought which is unrolling, this, in our view, is what the cerebral state indicates at every moment. He who could penetrate into the interior of a brain and see what happens there, would probably obtain full details of these sketched-out, or prepared, movements." Ibid., p. xvii.

56. Adorno was characteristically clear on issues subtending this debate: "In the concept of *le temps durée*, of lived duration, Bergson tried theoretically to reconstruct the living experience of time, and thus its substantial element that had been sacrificed to the abstractions of philosophy and of causal-mechanical natural science. Even so, he did not convert to the dialectical concept any more than science did.

More positivistically than he knew in his polemicizing, he absolutized the dynamic element out of disgust with the rising reification of consciousness; he on his part made of it a form of consiousness, so to speak, a particular and privileged mode of cognition. He reified it, if you will, into a line of business. In isolation, the time of subjective experience along with its content comes to be as accidental and mediated as its subject, and therefore, compared with chronometric time, is always 'false' also. Sufficient to illustrate this is the triviality that, measured by clock time, subjective time experiences invite delusion." *Negative Dialectics*, pp. 333–4.

57. The Bergsonian position continues to be a mainstay in aesthetic position taking by artists of all varieties. Witness, as just one example among countless, Bill Viola in the following interview:

"*Q*: Do you think that your work offers something that is intentionally excluded from mainstream popular culture?

"*A*: Yeah, I think that one of the driving engines of not just filmmaking and media imagery today in the larger culture, but in so many facets of culture is . . . time. You can look at conventional training in film as a study in the economics of time: How do you tell this story in a means that is economical, that propels the story forward, that doesn't sit there, and when the sun goes down you don't turn the camera toward the window and watch it go down for half an hour? That's one of the reasons that Andy Warhol's films were so extraordinary, because he just turned the camera on the Empire State Building for eight hours. It sounds like a gimmicky thing, but if you ever watch that or one of his other films, it's incredibly palpable, and strange. I think that the whole notion, since the development of the mechanical clock in the 14th century, of time being portioned and cut up into identical units day and night, doesn't accurately describe our inner experience. Anyone who's ever been awake at 3 o'clock in the morning and goes through their daily life at 3 o'clock in the afternoon knows damn well that awake at 3 in the morning is not the same as 3 in the afternoon at your job. So that subjective sense of self, of space, of time, has been diminished in the great push that civilizations and societies have had to universalize and quantify experience through the scientific method." Doug Harvey, "Extremities: The Video Passions of Bill Viola," *LA Weekly*, January 24–30, 2003, <http://www.laweekly.com/ink/03/10/features-harvey.php>.

58. Etienne-Jules Marey, preface to Charles-Louis Eugène Trutat, *La photographie animée* (Paris: Gauthier-Villars, 1899), p. ix, quoted in Marta Braun, "The Expanded Present: Photographing Movement," in Ann Thomas, *Beauty of Another Order: Photography in Science* (New Haven, Conn.: Yale University Press, and Ottowa: National Gallery of Canada, 1997), p. 175.

59. In this regard, film's strong temporal structure subordinating the details of its composition to its overall formal principle can be said to be similar to the dominance of spatial structure given by Renaissance linear perspective. In the latter, in lieu of the beholder being addressed by and adapting herself to the singular

expressive temporality of film, he is interpellated by a single dominant expressive spatiality. Like the strong time of film, linear perspective's rigid system of space attempts to render the experience of representation equivalent to the experience of experience itself. Its realism is rigorously mimetic rather than analytical, or, rather, its analysis conforms rigidly to, and thus is subordinated by, its mimesis.

60. Sam Roberts, "Giving Hardship and Poverty a Human Face," *New York Times*, January 29, 1995, p. 28. For this critique, see in particular the forceful accounts by Sally Stein, "Making Connections with the Camera: Photography and Social Mobility in the Career of Jacob Riis," *Afterimage* (May 1983): 9–16, and Maren Stange, "Jacob Riis and Urban Visual Culture: The Lantern Slide Exhibition as Entertainment and Ideology," *Journal of Urban History* 15, no. 3 (May 1989): 274–303. See also Stange's *Symbols of Ideal Life: Social Documentary Photography in America, 1890–1950* (Cambridge: Cambridge University Press, 1989).

61. Quoted in Vicki Goldberg, "Looking at the Poor in a Gilded Frame," *New York Times*, April 9, 1995, sec. 2, p. 1.

62. "No work yet published—certainly not the official reports of the charity societ- ies—shows so vividly the complexion and countenance of the 'Down-town Back Alleys,' 'The Bend,' 'Chinatown,' 'Jewtown,' 'The Cheap Lodging-houses,' the haunts of the negro, the Italian, the Bohemian poor, or gives such veracious picture of the toughs, the tramps, the waifs, drunkards, paupers, gamins, and the generally grue- some population of this centre of civilization." Quoted in Keith Gandall, *The Virtues of the Vicious: Jacob Riis, Stephen Crane, and the Spectacle of the Slum* (New York: Oxford University Press, 1997), p. 61.

63. Jacob Riis, *The Making of an American* (New York: Macmillan, 1968 [1901]), pp. 265–266, quoted in Stange, *Symbols of Ideal Life*, p. 26.

64. Rather than relying on the various devices outlined above to cultivate a shared sense of humanity, Riis had his own set of methods for obtaining his particular view. The technological breakthrough underlying those methods was the fast-burning flashlight powder that became available in 1887. Riis's own account of this project, already complete with all the pictorial trappings, was first given in a newspaper article, "Flashes from the Slums: Pictures Taken in Dark Places by the Lightening Process." A "mysterious party has lately been startling the town o' nights," the article reported. "Somnolent policemen on the street, denizens of the dives in their dens, tramps and bummers in their so-called lodgings, and all the people of the wild and wonderful variety of New York night life have in their turn marveled at and been frightened by the phenomenon." *New York Sun*, February 12, 1888. The problem Riis had faced with the older, slower-burning artificial illumination was that his subjects would have opportunity to pose or otherwise alter the scene he hoped to photo- graph. Driven away by bands of "angry women, who pelted me with brickbats and stones on my retreat, shouting at me never to come back" when he showed up with camera in hand or having to cope with children who "know generally what they

want and they go for it by the shortest cut" with a "determination to be 'took' the moment the camera hove into sight, in the most striking pose they could hastily devise" each presented the photographer with a "most formidable bar to success." Jacob A. Riis, *The Children of the Poor* (New York: Arno Press, 1971 [1892]. Surprise visits, often late at night, startling his subjects with instant "flash" illumination, and a quick retreat before the brickbats came flying, thus provided the core elements of Riis's methodology and the necessary solution to these restrictions.

65. Lewis F. Fried, *Makers of the City* (Amherst: University of Massachusetts Press, 1990), p. 41.

66. Jacob A. Riis, *How the Other Half Lives: Studies among the Tenements of New York* (New York: Penguin, 1971 [1890]), p. 9.

67. Marx, *Grundrisse*, p. 105.

68. Paul M. Sweeney, *The Theory of Capitalist Development: Principles of Marxian Political Economy* (New York: Oxford University Press, 1942), p. 15.

69. Quoted in Fried, *Makers of the City*, p. 17.

70. Riis, *Making of an American*, p. 370. Quoted by Fried, *Makers of the City*, p. 16.

71. E.g., Stange, *Symbols of an Ideal Life*, p. 26.

72. Jacob A. Riis, "People Who Disappear," *New York World*, June 4, 1883, quoted in Fried, *Makers of the City*, p. 37.

73. Jacob A. Riis, "Pestilance Nurseries, *New York World*, June 11, 1883, quoted in Fried, *Makers of the City*, p. 37

74. Riis, *How the Other Half Lives*, chap. 2, section 5.

75. Ibid., chap. 25: "How the Case Stands," para. 29.

76. Steichen, *A Life in Photography*, n.p.

77. Adorno, "The Essay as Form," p. 23.

78. Merleau-Ponty, *Phenomenology of Perception*, p. 406.

79. T. J. Clark, Foreword to Anselm Jappe, *Guy Debord* (Berkeley: University of California Press, 1999), p. x.

Chapter 1

1. Allan Sekula, "The Traffic in Photographs" *Art Journal* 41 (1981): 15–25.

2. See Max Kozloff, "American Painting during the Cold War," and Eva Cockcroft, "Abstract Expressionism, Weapon of the Cold War," in Francis Frascina, ed., *Pollock and After The Critical Debate* (New York: Harper and Row, 1985); Serge Guilbaut, *How*

New York Stole the Idea of Modern Art: Abstract Expressionism, Freedom and the Cold War (Chicago: University of Chicago Press, 1983); Ann Gibson, *Abstract Expressionism, Other Politics* (New Haven: Yale University Press, 1997).

3. Even its academic domain has seemed to shift from the history of photography proper into the broader area of investigation represented by American and cultural studies. This shift is given its most forceful representation in the through and thoughtful study by Eric Sandeen, *Picturing an Exhibition: The Family of Man and 1950s America* (Albuquerque: University of New Mexico Press, 1995).

4. Christopher Phillips, "The Judgment Seat of Photography," *October* 22 (Fall 1982) 46.

5. Jaques Barzun, *The House of Intellect* (New York: Harper, 1959), p. 28.

6. Theodor W. Adorno, *Aesthetic Theory*, trans. Robert Hullot-Kentor (Minneapolis: University of Minnesota Press, 1997), p. 272.

7. "In this its derangement," Hegel continues, "consciousness declares individuality to be the source of this derangement and perversion, but one that is alien and accidental. It is the heart, however, or the individuality of consciousness that would be immediately universal, that is itself the source of this derangement and perversion, and the outcome of its action is merely that *its* consciousness becomes aware of this contradiction. For the True is for it the law of the heart—something merely *intended* which, unlike the established order, has not stood the test of time, but rather when thus tested is overthrown. . . . This its Notion becomes by its own action its object; thus the heart learns rather that its self is not real, and that its reality is an unreality." G.W.F. Hegel, *Phenomenology of Spirit*, trans. A.V. Miller (New York: Oxford University Press, 1977), p. 226.

8. Hilton Kramer, "Exhibiting the Family of Man: 'The World's Most Talked About Photographs," *Commentary* 20 (October 1955): 367.

9. See Leon Anthony Arkus, "*The Famly of Man*: An Introduction to the Autumn Exhibition," *Carnegie Magazine* 30 (June 1956): 186.

10. Here is how Susan Sontag describes this turn: "The Arbus photographs convey the anti-humanist message which people of good will in the 1970s are eager to be troubled by, just as they wished, in the 1950s, to be consoled and distracted by a sentimental humanism." Susan Sontag, *On Photography* (New York: Dell, 1978), p. 33.

11. "Masscult and Midcult," *Partisan Review* 27 (Spring 1960): 600.

12. Sandeen, *Picturing an Exhibition*, p. 99.

13. Kramer, "Exhibiting the Family of Man," p. 365.

14. Quoted in Sandeen, *Picturing an Exhibition*, p. 122.

15. Walter L. Hixson, *Parting the Curtain: Propaganda, Culture and the Cold War, 1945–1961* (New York: St. Martin's Press, 1997), p. 83.

16. Fredric Jameson, *A Singular Modernity: Essay on the Ontology of the Present* (London: Verso, 2002), p. 136.

17. Ultimately, of course, these two are inseparable. Adorno: "The effect of works of art and of intellectual configurations generally is nothing absolute or ultimate that can be adequately determined by recourse to the recipients. For the effects are contingent on countless mechanisms of dissemination, social control, authority and finally the social structure itself within which the interrelations of effects can be observed." "Thesen zur Kunstsosoziologie" [1967], quoted in Ales Debeljak, *Reluctant Modernity* (New York: Rowman & Littlefield, 1998), p. 16.

18. That stretch may be taken as a figure for the more complex process of political abstraction I describe in this book as a whole. Lévi-Strauss's 1956 description of the social function of the family form gives a sense of the last gasp of the old model that *The Family of Man* helped to displace: "Social life imposes on the consanguineous stocks of mankind an incessant traveling back and forth, and family life is little else than the expression of the need to slacken the pace at the crossroads and to take a chance to rest. But the orders are to keep on marching. And society can no more be said to consist of families than a journey is made of the stopovers which break it down into discontinuous stages. They are at the same time its condition and its negation." The social form studied here, it might be said, is defined by the dialectical sythesis of just this condition and its negation. Claude Lévi-Strauss, "The Family," in Harry Lionel Shapiro, ed., *Man, Culture and Society* (New York: Oxford University Press, 1956), p. 285.

19. Immanuel Kant, *Perpetual Peace* (New York: Bobbs-Mervill, 1957), p. 17.

20. Carl Schmidt, *The Concept of the Political* (Chicago: University of Chicago Press, 1996 [1932]), p. 53.

21. Sandeen, *Picturing an Exhibition*, p. 122.

22. The literature on the social psychology of Nazism and postwar Germany alone should suffice as an example. See, for example, the foundational studies from the 1960s by the Mitscherlichs: Alexander Mitscherlich, *Society without the Father: A Contribution to Social Psychology* (New York: Harcourt, Brace and World: 1968); and Alexander and Margarete Mitscherlich, *The Inability to Mourn: Principles of Collective Behavior* (New York: Grove Press, 1975). These, of course, build on earlier studies, particularly Wilhelm Reich's 1930 *Mass Psychology of Fascism* (New York: Farrar, Straus and Giroux, 1980). See also more recent studies, such as Eric Santner, *Stranded Objects: Mourning Memory, and Film in Postwar Germany* (Ithaca, N.Y.: Cornell University Press, 1990); Ernesto Laclau, *Emancipation(s)* (New York: Verso, 1996); Judith Butler, *The Psychic Life of Power: Theories in Subjection* (Stanford: Stanford

University Press, 1997); and Savoj Zizek, *The Ticklish Subject: The Absent Centre of Political Ontology* (London: Verso, 1999). A foundational text in this genre is Ernst H. Kantorowicz, *The King's Two Bodies: A Study in Mediaeval Political Theology* (Princeton, N.J.: Princeton University Press, 1957).

23. "I stood in one spot for about twenty minutes and photographed the people as they looked at the section devoted to parents and babies." Edward Steichen, *A Life in Photography* (New York: Wit Allen, 1963), ch. 13, n.p.

24. Jean-François Lyotard, *Phenomenology* (Albany: State University of New York Press, 1991 [1954]), p. 34.

25. Christian Boyer paraphrasing Foucault quoted by Mike Davis in *Beyond Blade Runner: Urban Control: The Ecology of Fear* (Westfield, N.J.: Open Media, December 1992), <http://www.cs.oberlin.edu/~pjaques/etext/davmurbancont/index.html>.

26. This conceptual account of governmentality or, more broadly, the management of bodies through knowledge rather than force, has played a central role in the most sophisticated and productive accounts of the intersection of photography and social form. As one historian of photography put it in the introduction to her thoughtful book, for example, "My argument proposes that documentary, a central mode of communication, has assisted the liberal corporate state to manage not only our politics but also our esthetics and our art." See Maren Stange, *Symbols of Ideal Life* (Cambridge: Cambridge University Press, 1989), p. xv.

27. "What Is Enlightenment?" in Paul Rabinow, ed., *The Foucault Reader* (New York: Pantheon, 1984), p. 46.

28. Sekula, "Photography Between Labor and Capital," in Benjamin H. D. Buchloh and Robert Wilkie, eds., *Mining Photographs and Other Pictures, 1948–1968: A Selection from the Negative Archives of Shedden Studio, Glace Bay, Cape Breton* (Halifax, N.S., Canada: Press of the Nova Scotia College of Art and Design, 1983), p. 194. For one example of how this association between photography and archive has become a broad interpretive frame, see the special issue of *Visual Resources* edited by Cheryl Simon, "Following the Archival Turn: Photography, the Museum, and the Archive" (Vol. 18, no. 2, 2002).

29. Allan Sekula, "The Body and the Archive," *October* 39 (Winter 1986): 10.

30. Allan Sekula, "Between the Net and the Deep Blue Sea (Rethinking the Traffic in Photographs)," *October* 102 (Fall 2002): 22.

31. Michel Foucault, *Archaeology of Knowledge* (New York: Pantheon Books, 1982), p. 46.

32. Daniel J. Boorstin, *The Image; or, What Happened to the American Dream* (New York: Atheneum, 1962), p. 178.

33. Indeed, Muzak might well be taken to be a figure of the end point of this ideo-logical reduction, of form or data dispersed to a general experiential condition or a kind of amniotic fluid. Muzak, according to the vulgarized McLuhanism of one industrial psychologist, for example, is "synomorphic with the modern world and interrelated with all matters of time and place: Muzak helps human communities because it is a nonverbal symbolism for the common stuff of everyday living in the global village." (James Keenan speaking on "The Eco-Logic of Muzak" to Muzak's Scientific Board of Advisers in 1967, quoted in Joseph Lanza, *Elevator Music: A Surreal History of Muzak, Easy Listening and Other Moodsong* (New York: Picador, 1994), p. 150.)

34. Adorno, "Picture-Book Without Pictures," *Minima Moralia: Reflections from Damaged Life* (London: Verso, 1984), pp. 140–41 (emphasis added).

35. Sekula, "Between the Net and the Deep Blue Sea," p. 26.

36. Jürgen Habermas, *The Structural Transformation of the Public Sphere: An Inquiry into a Category of Bourgeois Society* (Cambridge, Mass.: MIT, 1991).

37. Karl Marx, *The Grundrisse* (New York: Harper and Row, 1971), p. 258.

38. Ibid., p. 409.

39. Karl Marx, *Capital: A Critique of Political Economy* (London: Penguin Classics, 1992), p. 447.

40. Clement Greenberg, "Avant-Garde and Kitsch," in John O'Brian, ed., *Clement Greenberg: The Collected Essays* (Chicago: University of Chicago Press, 1986), 1: 6.

41. Jacques Ellul, *The Technological Society* (New York: Vintage, 1964 [1954]), p. 412.

42. Sandeen, *Picturing an Exhibition*, p. 59.

43. Penelope Niven, *Steichen: A Biography* (New York: Clarkson Potter, 1997), p. 621.

44. Ibid., p. 622.

45. Ibid., p. 620. Such a rejection of the artistic qualities of photography had been central to Steichen's work for a long time. In 1969, he summed up the shift in his work that had happened long before: "When I first became interested in photo-graphy, I thought it was the whole cheese. My idea was to have it recognized as one of the fine arts. Today I don't give a hoot in hell about that. The mission of photography is to explain man to man and each man to himself." Ibid., p. 688.

46. Newhall interviewed by WXXI-TV, Rochester, N.Y., 1979, transcript pp. 27–28, quoted in Phillips, "Judgment Seat of Photography," p. 40.

47. "Museum of Modern Art Plans International Photography Exhibition," press release, Museum of Modern Art, New York, January 31, 1954, p. 1.

48. *Baltimore Morning Sun*, March 6, 1955, quoted in "The Controversial Family of Man," *Aperture* 3, no. 2 (1955): p. 17.

49. Hilton Kramer, "Exhibiting the Family of Man: 'The World's Most Talked About Photographs," *Commentary*, 20, no. 4 (October 1955): 365.

50. Phoebe Lou Adams, "Through a Lens Darkly," *Atlantic* 195, no. 4 (April 1955): 69, 70.

51. Herbert Bayer, "Fundamentals of Exhibition Design," *PM* (December–January 1939–1940): 17, quoted in Phillips, "Judgment Seat of Photography," p. 43.

52. Ralph Steiner, in *PM*, May 31, 1942, quoted in Phillips, "Judgment Seat of Photography," p. 45.

53. It was this quality, Steichen goes on to note, that had so impressed the MoMA board of directors, which in turn led him to be brought in to run the photography area (over the advice of established advisers like Newhall and Adams). Edward Steichen, "Photography and the Art Museum," *Museum Science* (Bulletin of the Rochester Museum of Arts and Sciences) (June 1948): 69, quoted in Phillips, "Judgment Seat of Photography," p. 43.

54. Edward Steichen, "Introduction," *The Family of Man* (New York: Museum of Modern Art, 2000 [1955]), n.p.

55. See Rapaport Brooke Kamin, *Vital Forms: American Art and Design in the Atomic Age, 1940–1960* (New York: Abrams, 2001).

56. "By 'Others' we do not mean everyone else but me—those over against whom the 'I' stands out. They are rather those from whom, for the most part, one does not distinguish oneself—those among whom one is too. . . . The world is always the one that I share with Others. . . . We take pleasure and amuse ourselves as they take pleasure; we read, see and judge about literature and art as they see and judge; likewise we shrink back from the 'great mass' as they shrink back; we find 'shocking' what they find shocking. The 'they' which is nothing definite and which all are, though not as sum, prescribes the kind of being of everydayness." Martin Heidegger, *Being and Time* (New York: Harper and Row, 1962), pp. 118, 126–127.

57. Although it has been associated with other postwar contexts, particularly the losers of World War II.

58. See Phillips, "Judgment Seat of Photography."

59. Carl Sandburg, "Prologue," *The Family of Man* (New York: Museum of Modern Art, 2000 [1955]), n.p.

60. O. N. Solbert, "Edward Steichen and the Family of Man," *Image: Journal of Photography of the George Eastman House*, 4, no. 8 (February 1955): 14.

61. Barbara Morgan, "The Theme Show: A Contemporary Exhibition Technique," *Aperture 3*, no. 2 (1955): 24–25.

62. For one later adoption of the "enemy within" construct, see Robert F. Kennedy, *The Enemy Within* (New York: Da Capo Press, 1994 [1959]). For the popularization of the organization concept, see William H. Whyte, *The Organization Man* (New York: Doubleday, 1956).

63. Sandeen, *Picturing an Exhibition*, p. 150.

64. Ibid., p. 153.

65. *Saturday Review of Literature*, August 18, 1945, p. 5, quoted in Paul Boyer, *By the Bomb's Early Light: American Thought and Culture at the Dawn of the Atomic Age* (Chapel Hill: UNC Press, 1994 [1985]), p. 8.

66. Louis Althusser, "The International of Decent Feelings," In *The Spectre of Hegel: Early Writings* (London: Verso, 1997), p. 23.

67. Sandeen, *Picturing an Exhibition*, p. 123.

68. It is evident in many of the first-person narrative accounts of the bomb, in a wide range of political cartoons, in much of the Beats' writings and was commemorated and parodied in Stanley Kubrick's famous film subtitled, *How to Stop Worrying and Love the Bomb*. It was also central to the work of many of the pop artists, such as Claes Oldenburg's 1967 article, "America: War & Sex, Etc.," Arts Magazine 41, no. 9 (Summer 1967): 32–36. and his 1969 monument *Lipstick Ascending* as well as in James Rosenquist's famous *F-111*.

Walter Matthau plays the role of political scientists like Herman Kahn who had written in 1960: "I have tried to make the point that if we have a posture which might result in 40 million dead in a general war, and as a result of poor planning, apathy, or other causes, our posture deteriorates and a war occurs with 80 million dead, we have suffered an additional disaster, an unnecessary additional disaster that is almost as bad as the original disaster. If, on the contrary, by spending a few billion dollars, or by being more competent and lucky, we can cut the number of dead from 40 million to 20 million, we have done something vastly worth doing! The survivors will not dance on the streets or congratulate each other if there have been 20 million men, women and children killed; yet it would have been a worthwhile achievement to limit casualties to this number. It is very difficult to get this point across to laymen or experts with enough intensity to move them to action. The average citizen has a dour attitude toward planners who say that if we do thus and so it will not be 40 million dead—it will be 20 million dead. Somehow the impression is left that the planner said that there will be only 20 million dead. To

him is often attributed the idea that this will be tolerable or even astonishingly enough, a desirable state! . . .

"Despite a widespread belief to the contrary, objective studies indicate that even though the amount of human tragedy would be greatly increased in the postwar world, the increase would not preclude normal and happy lives for the majority of the survivors and their dependents." Herman Kahn, *On Thermonuclear War* (Westport, Conn.: Greenwood Publishing Group, 1978 [1960]).

69. Paul Goodman, *Growing Up Absurd* (New York: Vintage, 1962), p. 209.

70. Kramer, "Exhibiting the Family of Man," p. 367.

71. Elias Canetti, *Crowds and Power* (New York: Seabury Press, 1982), p. 18.

72. Dorothy Norman, response to questionnaire "The Controversial Family of Man," *Aperture* 3, no. 2 (1955): 16.

73. Steichen, *A Life in Photography*, chapter 13, n.p.

74. Walker Evans, "The Reappearance of Photography," *Hound and Horn*, 5, no. 1 (October–December 1931), reprinted in Alan Trachtenberg, *Classic Essays on Photography* (New Haven: Leete's Island Books, 1980), pp. 188, 185. Evans criticized the Steichen of 1931 harshly: "Steichen is photography off its track in our own reiterated way of technical impressiveness and spiritual non-existence" (p. 186).

75. That is, again, Alan Trachtenberg borrowing from Eisenstein: "The book skips and jumps, building up a sense of composite reality only partially represented in each image. . . . What the pictures say, they say in and through the texture of relations which unfold—continuities, doublings, reversals, climaxes, and resolutions." Trachtenberg, *Reading American Photographs*, pp. 258–259.

76. Evans, "Reappearance of Photography," p. 188.

77. Steichen, *A Life in Photography*, chapter 13, n.p.

78. Steichen, *The Family of Man*, p. 4.

79. *Rocky Mountain Telegram*, February 6, 1955, quoted in "The Controversial Family of Man," p. 18.

80. Beaumont Newhall, "Photography as Art in America," *Perspectives USA* 15 (Spring 1956): 133.

81. *New York Times Magazine*, January 23, 1955, quoted in "The Controversial Family of Man," p. 17.

82. Edward Rosskam, "Family of Steichen," *Art News* 54, no. 1 (March 1955): 34.

83. "A Preview of the Family of Man Exhibition," *Minneapolis Institute of Arts Bulletin*, 44, no. 3 (May 1955): 19.

84. Hannah Arendt, *The Origins of Totalitarianism* (New York: Harvest Books, 1973), p. 460.

85. Edward Steichen interviewed by Wayne Miller in James Nelson, ed., *Wisdom: Conversations with Elder Wise Men of Our Day* (New York: Norton, 1958), pp. 42, 43.

86. It underlay Hannah Arendt's recoil in her studies *The Human Condition* and *The Origin of Totalitarianism*, and it welled up right to the surface in Dwight Macdonald's writings of the period. "Man lives in history but is not at all comfortable there," he said in 1949. "Even at best—by which I mean in a smallish, integrated community like the ancient Greek city state—there is always a desperate struggle between what individual man wants and what happens to him as a result of living in society. . . . And at worst—by which I mean the big-scale, industrial-bureaucratic societies in which the peoples of USA, USSR, and most of Europe toss and twist—there is not even a struggle: the individual 'citizen' (what a mockery!) has about the same chance of determining his own fate as a hog dangling by one foot from the conveyor belt of a Chicago packing plant." Gregory D. Sumner, *Dwight Macdonald and the Politics Circle: The Challenge of Cosmopolitan Democracy* (Ithaca, N.Y.: Cornell University Press, 1996), p. 221.

87. Ibid., p. 215.

88. John Stanley, "Love and Praise," *Commonweal*, July 1, 1955, p. 333.

89. Aurthur A. Goldsmith, Jr., "The Family of Man," *Popular Photography* (May 1955): 88, 147.

90. Aline B. Saarinen, "The Camera versus the Artist," *New York Times*, February 6, 1955.

91. André Malraux, *The Voices of Silence*, trans. Stuart Gilbert (Princeton, N.J.: Princeton University Press, 1978), p. 30.

92. *San Diego Union*, February 27, 1955, quoted in "The Controversial Family of Man," p. 17.

93. Kramer, "Exhibiting the Family of Man" pp. 365–366.

94. "Steichen, 80, Will Visit Russia with Sandburg," *New York Herald Tribune*, March 27, 1959.

95. Hegel, *Phenomenology of Spirit*, p. 39.

96. George Duhamel quoted by Walter Benjamin in "The Work of Art in the Age of Mechanical Reproduction," in Hannah Arendt, ed., *Illuminations*, trans. Harry Zohn (New York: Schocken Books, 1969), p. 238.

Chapter 2

1. John Szarkowski, *Mirrors and Windows: American Photography Since 1960* (New York: Little, Brown and Co., 1978): p. 20. "Documentary? That's a very sophisticated and misleading word. And not really clear. You have to have a sophisticated ear to receive that word. The term should be documentary style. An example of a literal document would be a police photograph of a murder scene. You see, document has use, whereas art is really useless. Therefore art is never a document, though it certainly can adopt that style." Walker Evans in an interview with Leslie George Katz, *Art in America* (March–April 1971), reprinted in Walker Evans *Incognito* (New York: Eakins Press Foundation 1995), p. 18.

2. William S. Johnson, ed., *The Pictures Are a Necessity: Robert Frank in Rochester, NY 1988* (Rochester, N.Y.: George Eastman House, 1989), p. 72.

3. Rolling over Szarkowski's hard-won typological distinction probably unaware. W. S. Di Piero, "Ahead of His Moment," *New York Times*, April 27, 2003. James M. Zanutto, "An Off-Beat View of the U.S.A.," *Popular Photography* (May 1960): 105.

4. Quoted in Lili Corbus Bezner, *Photography and Politics in America* (Baltimore: Johns Hopkins University Press, 1999), p. 178.

5. ". . . and some way of beckoning people along to a similar understanding, if only in an 'as if' mode." "The Pleasure of Difference: A FEED Dialogue on Art and Critical Practice," *FEED Magazine* (September 1999): http://www.feedmag.com/art/dialog-intro.html

6. Robert Freeman, "Comment," *Living Arts Magazine*, no. 1 (1963): 81.

7. Frank in Dennis Wheeler, "Robert Frank Interviewed," *Criteria* 3, no. 2 (1977): 7.

8. Quoted in Jeff L. Rosenheim, "The Cruel Radiance of What Is," *Walker Evans*, (Princeton: Princeton University Press, 2000), p. 73.

9. Hambourg, *Walker Evans*, p. 20.

10. "Robert Frank" in Eugenia Parry Janis and Wendy MacNeil eds., *Photography within the Humanities* (Danbury, N.H.: Addison House Publishers, 1977), p. 58. Here is one account of how that recoil functioned for Evans: "While often portrayed as a neutral documentarian of the American scene, Evans in fact intended to offend not only the polite Victorian sensibilities of people like his parents but also the 'smugly rich,' the pretentious scene makers of the art world, do-gooders of the Communist crowd, and any other identifiable group of bêtes noires. In all those circles Evans the man moved quite comfortably, but with a residue of free-floating negativity; the uniquely subdued, dispassionate tone (and some might argue the chilling effect) of his photographs came from this sustained and critical refusal to join." Eklund, "Exile's Return," in *Walker Evans*, p. 39.

11. Robert Silberman, "Outside Report: Robert Frank," *Art in America* (February 1987): 132. It might be said that this is the singular moment of the document becoming art, as, for example, in Lionel Trilling's account of the image of a defensive Allie Mae in *Let Us Now Praise Famous Men*. "One of the finest objects of any art of our time," he writes, "with all her misery and perhaps with a touch of pity for herself, [she] simply refused to be an object of your 'social consciousness.' She refuses to be an object at all. Everything in the picture proclaims her to be all subject." In so doing, of course, the photographer is also interpellated as a subject, as was the theme of *Let Us Praise*, and in so doing Evans recasts himself from documentarian to artist-subject. Lionel Trilling, "Greatness with One Fault in It," *Kenyon Review* 4 (Winter 1942): 100–101, quoted in Rosenheim, "The Cruel Radiance of What Is," p. 90.

12. Frank in Dennis Wheeler, "Robert Frank Interviewed," *Criteria* 3, no. 2 (1977): 7.

13. Dwight Macdonald, review of Frank's "The Sin of Jesus," *Esquire* (November 1961): 63.

14. Statement in *Me and My Brother* (1968), by Peter Orlovsky's brother Julius, a catatonic and silent for much of the film, when asked by Frank to say something to the camera. Quoted in Robert Silberman, "Outside Report: Robert Frank," *Art in America* (February 1987): 133.

15. "A Frank View of the 'Mountain,'" *Los Angeles Times*, March 11, 1988.

16. Jack Kerouac, Introduction to Robert Frank, *The Americans* (New York: Scalo, 1998).

17. "America the Dark: Photography (Robert Frank, National Gallery of Art, Washington, D.C.)," *Economist (U.S.)*, November 5, 1994, p. 88.

18. John Durnial, "An Off-Beat View of the U.S.A.," *Popular Photography* (May 1960): 104.

19. Ibid.

20. "Guggenheim Fellows in Photography," *U.S. Camera* (1958): 89.

21. Charles Reynolds, "An Off-Beat View of the U.S.A.," *Popular Photography* (May 1960): 105.

22. Quoted in Bezner, *Photography and Politics in America*, p. 18.

23. "This iconography has become a common coin," he continues, "used now perhaps too easily as a substitute for observation." Printed as the back cover statement on the 1968 edition of *The Americans* (Millerton, N.Y.: Aperture, Museum of Modern Art, 1968), quoted in William S. Johnson, "History—His Story," in Johnson, *The Pictures Are a Necessity*, p. 45.

24. Robert Frank, Mabou, December 27, 1977, quoted in *Robert Frank: An Exhibition of Photography: 1945–1977* (Santa Cruz: Mary Porter Sesnon Art Gallery University of California, 1978), n.p.

25. Jno Cook, "Robert Frank: Dissecting the American Image," *Exposure* 24, no. 1 (Spring 1986): 33.

26. Tod Papageorge, "Walker Evans and Robert Frank: An Essay on Influence" (New Haven, Conn.: Yale University Art Gallery, 1981), p. 5. See William Stott *Documentary Expression and Thirties America* (Chicago: University of Chicago Press, 1986), p. 84, for discussion of shooting on the run or from the hip.

27. Cook, "Robert Frank," p. 40.

28. I will not argue this here beyond noting Winogrand's regular claim to be making the picture more stable by tilting the camera (by lining up a strong vertical with the edge of the frame, for example), Friedlander's frequent play with composition in various ways including his clever and often humorous introduction of self-portraiture, and Arbus's strong frontal and frequently symmetrical compositions.

29. Robert Frank, "Letter from New York," *Creative Camera* 62 (August 1969): 272. Frank in Wheeler, "Robert Frank Interviewed," p. 7.

30. Elizabeth Royte, "Training Wheels," *Smithsonian* 3, no. 4 (July 2002): 21.

31. Frank in Wheeler, "Robert Frank Interviewed," p. 7.

32. Frank, "Letter from New York," p. 272.

33. Frank interviewed by Susan E. Cohen and William Johnson and published in Johnson, "History—His Story," p. 61.

34. Frank interviewed by Susan E. Cohen and William Johnson and published in Johnson, "History—His Story," pp. 32–33.

35. Quoted in Sarah Greenough and Philip Brookman, *Robert Frank: Moving Out* (Washington D.C.: National Gallery of Art, 1995), p. 26.

36. Frank in "Robert Frank" in Janis and MacNeil, *Photography within the Humanities*, p. 56.

37. Letter apparently Frank to Evans, undated, without greeting or sign-off, Evans archive, Metropolitan Museum of Art, 1994.260.6(18).

38. "Sermon with a Camera" *New Republic*, October 12, 1938. *Walker Evans*, (New York: Museum of Modern Art, 1971), p. 16.

39. Walker Evans, draft introduction to American Photographs, Evans archive, 1994.250.57(11).

40. Text from Evans's "Labor Anonymous" spread in *Fortune* magazine, November 1946: 152–153.

41. Quoted in Jeff L. Rosenheim and Douglas Elklund, *Unclassified: A Walker Evans Anthology* (Zurich: Scalo and New York: Metroplitan Museum of Art, 2000), p. 189.

42. Trachtenberg, *Reading American Photographs*, p. 250.

43. Goell interview, 1971, p. 19. quoted by Hambourg, *Walker Evans*, p. 23.

44. Hegel, *Phenomenology of Spirit* (New York: Oxford University Press, 1979), p. 39.

45. Quotes from Alain Bosquet's "Petits Télégrammes aux Américains," used in 1958 Delpire edition of *Les Américains*.

46. Walker Evans, "Robert Frank," *U.S. Camera* (1958): 90.

47. William Hogan, "Photo Coverage of the Ugly American," *San Francisco Chronicle*, January 27, 1960, p. 25.

48. Gotthard Schuh, "Robert Frank," *Camera* 36, no. 8 (1957): 339–340.

49. William Stott, "Walker Evans, Robert Frank and the Landscape of Dissociation," *ArtsCanada* (December 1974): 84.

50. Arthur Goldsmith, "An Off-Beat View of the U.S.A.," *Popular Photography* (May 1960): 104.

51. Durnial, "An Off-Beat View of the U.S.A.," p. 104.

52. Frank interviewed by Susan E. Cohen and William Johnson and published in Johnson, "History—His Story," p. 27.

53. Ibid., p. 26

54. Ibid., p. 28.

55. Frank in Brian Wallis, "Robert Frank: American Visions," *Art in America* (March 1996): 78.

56. *Robert Frank*, 2 (Millerton, N.Y.: Aperture, 1976), p. 92.

57. "Mary Frank," in Eleanor Munro, *Originals: American Women Artists* (New York: Simon and Schuster, 1979), quoted in Johnson, "History—His Story," p. 39.

58. Undated statement in Frank's (and Evans'?) hand, drafted to request a continuation of Guggenheim funding, Evans archive, 1994.260.6(19).

59. Jonathan Green, *American Photography: A Critical History 1945 to the Present* (New York: Abrams, 1984), p. 90.

60. Undated statement in Frank's (and Evans'?) hand.

61. Frank interviewed by Susan E. Cohen and William Johnson and published in Johnson, "History—His Story," p. 38.

62. Leo Rubinfien quoted in David B. Cooper, "Robert Frank and American Politics," *Robert Frank and American Politics* (Akron: Akron Art Museum, 1985), p. 5.

Chapter 3

1. For a useful account of the early development of their project, see Virginia Ann Heckert, "A Photographic Archive of Industrial Architecture: The Work of Bernd and Hilla Becher" (master's thesis, University of California, Santa Barbara, 1987), pp. 9–12.

2. Steinert, subjective fotografie, 1952, quoted in Manfred Schmalriede, " 'Subjektive Fotografie' and Its Relation to the Twenties," in *Subjektive fotografie: Images of the 50's* (Essen: Museum Folkwang, 1984), p. 22.

3. Bernd Becher in conversation with Jean-François Chevrier, James Lingwood, and Thomas Struth, in *Another Objectivity: June 10–July 17, 1988, Institute of Contemporary Arts, London* (London: Institute of Contemporary Arts, 1988), p. 57. Bernd and Hilla Becher quoted in an exhibition statement for "Distance and Proximity (Germany), Bernd & Hilla Becher/Andreas Gursky/Candida Hofer/Axel Hutte/Simone Nieweg/Thomas Ruff/Jorg Sasse/Tomas Struth/Petra Wunderlich," <http://www .photosynkyria.gr/98/ex/ex48_en.html>.

4. R. H. Fuchs, "Bernd and Hilla Becher," in *Bernd und Hilla Becher* (Eindhoven: Van Abbemuseum, 1981), n. p.

5. Donald Kuspit, review, *Artforum* 28 (April 1990): 170.

6. Alexander Rodchenko, "Against the Synthetic Portrait, for the Snapshot," in Christopher Phillips, ed. *Photography in the Modern Era: European Documents and Critical Writings, 1913–1940* (New York: Metropolitan Museum of Art, 1989), p. 241.

7. Werner Graeff, "Es kommt der neue Ingenier," *G* 1 (1923): n.p.

8. Asked why their work exists in an art context rather than being made available in public archives for research purposes, they responded, "We did offer it to the government but they weren't interested. The work is about visual considerations, therefore it was only natural to show it in art galleries." See Angela Grauerholz and Anne Ramsden, "Photographing Industrial Architecture: An Interview with Hilla and Bernd Becher," *Parachute* 22 (1981): 18.

9. Bernd Becher in *Another Objectivity*, p. 61.

10. Liliane Touraine. "Bernd and Hilla Becher: The Function Doesn't Make the Form," *Artefactum* (April–May 1989): 9.

11. Bernd and Hilla Becher interviewed in Ulf Erdmann Ziegler, "The Bechers' Industrial Lexicon," *Art in America* (June 2002): 98.

12. For example, Thomas Ruff, Thomas Struth, and Andreas Gursky, now sometimes collectively known as "Struffsky."

13. Michael Kimmelman, "Where Truth Dare Not Meet Your Gaze," *New York Times*, February 7, 2003.

14. Maurice Merleau-Ponty, *The Phenomenology of Perception* (New York: Humanities, 1962), p. 392.

15. Anson Rabinbach, "Response to Karen Brecht, 'In the Aftermath of Nazi Germany: Alexander Mitscherlich and Psychoanalysis—Legend and Legacy,'" *American Imago* 52 (1995): 322–323.

16. Robert A Sobieszek, "Two Books of Ultra-Topography," *Image* 14 (1971): 12.

17. Bernd and Hilla Becher, "Anonymous Sculpture," *Art and Artists* 5 (1970): 56.

18. Here is how they dealt with this issue in an interview: "Q: If you got a tip-off now about a certain industry in Korea, would you get in a plane and go photograph there?" "B: It's not a case of photographing everything in the world, but of proving that there is a form of architecture that consists in essence of apparatus, that has nothing to do with design, and nothing to do with architecture either." "H: The question can also be answered by restricting oneself—if one must restrict oneself—primarily to the early industrialized countries, so that the whole historical span can be seen. Certain things are found in England, because that goes back the furthest, and in Belgium, France and Germany, up to a certain point even Italy." "B: And the USA." "H: Of course, there especially one finds things that are highly interesting—for example, the grain elevators. You can't do without them. But you don't necessarily have to have grain elevators in Korea." Bernd and Hilla Becher interviewed in Ziegler, "The Bechers' Industrial Lexicon," p. 140.

19. Ziegler, "Industrial Lexicon," p. 97.

20. Gregorio Magnani, "Ordering Procedures: Photography in Recent German Art," *Arts Magazine* 64 (March 1990): 81–82.

21. Sibyl Moholy-Nagy, *Moholy-Nagy: Experiment in Totality*, 2nd ed. (Cambridge, Mass.: MIT Press, 1969 [1950]), p. 2.

22. Louis Lozowick, "Status of the Artist in the U.S.S.R.," in *Artists against War and Fascism: Papers of the First American Artists' Congress* (New Brunswick, N.J.: Rutgers University Press, 1986), pp. 162–163.

23. Grauerholz, "Photographing Industrial Architecture," p. 18.

24. Michel Foucault, "What Is Enlightenment?" in Paul Rabinow, ed., *The Foucault Reader* (New York: Pantheon, 1984), p. 46.

25. Grauerholz "Photographing Industrial Architecture," p. 18.

26. Jürgen Habermas, *The Structural Transformation of the Public Sphere: An Inquiry into a Category of Bourgeois Society* (Cambridge, Mass.: MIT Press, 1989), pp. 29, 33–34 (translation modified).

27. For an extended analysis using this character of the Bechers' work to argue for the redemption of "the name of art" in the wake of the anti-aestheticism and politicization of functionalism, see Thierry de Duve, *Basic Forms* (New York: te Neues, 1999).

28. de Duve, *Basic Forms*, pp. 15, 9.

29. Luc Sante, *The New Republic*, July 3, 1995, p. 29.

30. Andreas Huyssen, *Twilight Memories: Marking Time in a Culture of Amnesia* (New York: Routledge, 1995), p. 86.

31. Thierry de Duve, *Kant after Duchamp* (Cambridge, Mass.: MIT Press, 1996), p. 455.

32. Among other attempts to take up this enterprise, see Andrew Hemingway, *Artists on the Left: American Artists and the Communist Movement, 1926–1956* (New Haven, Conn.: Yale University Press, 2002).

33. "Beauty in the Awful," *Time*, September 5, 1969, p. 69.

34. Glenn Zorpette, "Dynamic Duos: How Artist Teams Work," *Art News* (Summer 1994): 166.

35. Lynda Morris, *Bernd and Hilla Becher* (London: Arts Council of Great Britain, 1974), n.p.

36. Ziegler, "Industrial Lexicon," p. 143.

37. Raymond Aron, *The Opium of the Intellectuals* (New York: Doubleday, 1957), p. 46.

38. Karl Marx and Frederick Engels, *The Communist Manifesto* (London: Verso, 1998), p. 38.

39. Karl Marx, *Capital: A Critique of Political Economy* (New York: Penquin, 1992), 1: 617.

40. *Another Objectivity*, pp. 60–61.

41. As with modern industry, we know best from Foucault that modern thought has realized its social power by being similarly nomadic. Earlier, premodern modes were essentially conservative, while modern "systems of dispersion" or *discourses* and the epistemological architecture they produce—*archives*—are inherently revolutionary by being based on "neither a configuration, nor a form" (that is, on neither

structural nor mimetic representation of the object of study), but instead on a process or "a group of rules that are immanent in a practice." Foucault, *Archaeology of Knowledge* (New York: Pantheon Books, 1982), pp. 37, 46. Foucault's three introductory examples of this modern form of knowledge-as-system were sexuality, "penality," and *art* (p. 41). The Becher archive is just such a discourse in its "densest and most complex," self-instituting form. "History, Discourse, Discontinuity," *Salmagundi* no. 20 (Summer-Fall 1972), p. 241. That is, it is what Foucault called an "art with its own normativity," a procedure of discursive organization that develops its own autonomous standards of valorization separate from the objects it organizes and maintains its value as a group of rules immanent in a practice rather than as a configuration or form. Foucault, *Archaeology of Knowledge* (New York: Pantheon, 1982), p. 41.

42. Hilla Becher in *Another Objectivity*, p. 57.

43. Daniel Bell, *The End of Ideology: On the Exhaustion of Political Ideas in the Fifties* (Cambridge, Mass.: Harvard University Press, 1988 [1960]), p. 301.

44. Karl Jaspers, *The Question of German Guilt* (New York: Dial Press, 1947), p. 16.

45. Albert Camus, "Defense of Intelligence," in *Resistance Rebellion and Death* (New York: Knopf, 1961), p. 61.

46. Otto Steinert, *Subjektive Fotografie; ein Bildband moderner europäischer Fotografie* (Bonn: Brüder Auer, 1952), p. 5.

47. Immanuel Kant, *Critique of the Power of Judgment* (New York: Cambridge, 2000), p. 96.

48. Ibid., p. 57.

49. Ibid., pp. 122–123.

50. Karl Pawek, "Do We Have a New Photographic Style Today?" in Wolf Strache, ed., *The German Photographic Annual: 1959* (New York: American Book Publishing, 1959), p. 19. See also <http://www.uturn.org/Essays/SUBPHOTOpdf.pdf>.

51. Karl Pawek, "The Language of Photography: The Methods of This Exhibition," in *World Exhibition of Photography on the Theme What Is Man? 555 Photos by 264 Photographers from 36 Countries* (Hamburg: Gruner & Jahr, 1964), n.p.

52. Ibid.

53. Pawek as a theorist is a good limit case for this question about political subjectivity that has served as the driving concern throughout this book.

54. Alexandre Astruc, "The Birth of a New Avant-Garde: La Camera-Stylo," in Peter Graham, ed., *The New Wave* (New York: Doubleday, 1968). Marshall McLuhan, *Understanding Media: The Extensions of Man* (New York: Continuum, 1962).

55. Hegel, *Phenomenology of Spirit* (New York: Oxford University Press, 1979), pp. 19–20.

56. Brandon Taylor, *Avant-Garde and After: Rethinking Art Now* (New York: Abrams, 1995), p. 10.

Epilogue

1. For an account of the historical emergence of this embrace of an empty subject position as a tactic, see my "Andy Warhol's Red Beard," *Art Bulletin* (September 2001): 527–547.

2. Michael Fried, "Art and Objecthood," *Artforum* 5 (June 1967): 22.

3. Andy Warhol, *The Philosophy of Andy Warhol: From A to B and Back Again* (New York: HBJ, 1975), p. 7.

4. For a thoughtful and sustained account of this development, see Miwon Kwon, *Site-Specific Art and Locational Identity* (Cambridge, Mass.: MIT Press, 2002), particularly Chapter 1.

5. Jennifer Licht writing in her 1969 catalogue *Spaces* cited by Julie H. Reiss in *From Margin to Center: The Spaces of Installation Art* (Cambridge, Mass.: MIT Press, 1999), p. 96.

6. Maria Gough, "Constructivism Disoriented: El Lissitsky's Dresden and Hannover *Demonsrationsräume*," in Nancy Perloff and Brian Reed, eds., *Situating El Lissitsky: Vitebsk, Berlin, Moscow* (Los Angeles: Getty Research Institute, 2003), p. 113.

7. Benjamin H. D. Buchloh, "From Faktura to Factography," *October* 30 (1984): 82–119. Louis Lozowick, "Eliezer Lissitzky," *Menorah Journal* (April 1926): 176; Louis Lozowick, "A Decade of Soviet Art," *Menorah Journal* (March 1929): 247; Louis Lozowick, "El Lissitzky," *Transition* (November 1929): 285.

8. El Lissitsky, "Ideological Superstructure" (1929), in Sophie Lissitsky-Küppers, ed., *El Lissitsky: Life, Letters, Texts* (Greenwich, Conn.: New York Graphic Society, 1968 [1967]), pp. 372–373.

9. El Lissitzky, letter to Jan Tschichold, September 29, 1932, translated in Perloff and Reed, *Situating El Lissitzky*, p. 213.

10. This takes us directly into debates about phenomenology that are not of primary concern for a historical study such as this one both from within and without of the domain of phenomenology proper—to Derrida, for example, whose own program of deconstruction emerged first as a critique of Husserl—do not Husserl's analyses, he asked in 1967 continuing an inquiry first begun in 1953, "conceal a metaphysical presupposition?" (Jacques Derrida, *Speech and Phenomena, and Other Essays on*

Husserl's Theory of Signs [Evanston, Ill.: Northwestern University Press, 1973), p. 4.]—or to Adorno who defined his undertaking around the same question: "Husserl's programme deals with a 'sphere of being of absolute origins,'" he complained at length in 1956, "safe from that 'regulated, methodically cultivated spirit of contradiction,' which Hegel once called his procedure." Theodor Adorno, *Against Epistemology: A Metacritique: Studies in Husserl and the Phenomenological Antinomies* (Cambridge, Mass.: MIT Press, 1983), p. 3. But this division might be seen not so much as one that gives us the boundary of phenomenology defined by its critics but instead as one that speaks to a tension within phenomenology itself, one that Derrida and Adorno alike draw on to develop their own programs. To put it simply, both critique Husserl's idealism in a manner akin to Husserl's heir Merleau-Ponty who, as one commentator describes his innovation, carries forward the phenomenological reduction but "strips it of Husserl's Cartesian constructivist element," that is, of the always "already constructed solipsist subject who thinks itself emptily." Bettina Bergo, "Afterword: Philosophy as *Perspectiva Artificialis*: Merleau-Ponty's Critique of Husserlian Constructivism," in Maurice Merleau-Ponty, *Husserl at the Limits of Phenomenology*, ed. Leonard Lawlor with Bettina Bergo (Evanston, Ill.: Northwestern University Press, 2002), p. 163. Here is Husserl himself on this: "The 'I' that I attain in the *epochē*, which would be the same as the 'ego' within a critical reinterpretation and correction of the Cartesian conception, is actually called 'I' only by equivocation—though it is an essential equivocation since, when I name it in reflection, I can say nothing other than: that it is I who practice the *epochē* . . . ; it is I who stand above all natural existence that has meaning for me, who am the ego-pole of this transcendental life, in which, at first, the world has meaning for me purely as world. . . . Even though I have not [explicitly] 'presupposed' it as a ground, it still has validity for me, the 'I' of the *cogito*, through constant self-verification, together with everything that it is for me, in particular details sometimes objectively and legitimately so, sometimes not, and together with everything that it is for me, in particular details sometimes objectively and legitimately so, sometimes not, and together with all sciences and arts, together with all social and personal configurations and institutions, insofar as it is just the world that is actual for me. There can be no stronger realism than this, if by this word nothing more is meant than: 'I am certain of being a human being who lives in this world, etc., and I doubt it not in the least.' But the great problem is precisely to understand what is here so 'obvious.' The method now requires that the ego, beginning with its concrete world-phenomenon, systematically inquire back, and thereby become acquainted with itself, the transcendental ego, in its concreteness, in the system of its constitutive levels and its incredibly intricate [patterns of] validity-founding. At the onset of the *epochē* the ego is given apodictically, but as a 'mute concreteness.' It must be brought to exposition, to expression, through systematic intentional 'analysis' which inquires back from the world phenomenon. In this systematic procedure one at first attains the correlation between the world and transcendental subjectivity as

objectified in mankind." Edmund Husserl, *The Crisis of European Sciences and Transcendental Phenomenology: An Introduction to Phenomenological Philosophy.*" Evanston, Ill.: Northwestern University Press, 1970, pp. 184, 187.

In short, Merleau-Ponty, just as Derrida and Adorno do differently, holds firm to the negative moment of the phenomenological reduction and never allows it to settle into a positivity or ideality, into a "solipsist subject who thinks itself emptily," into an abstract form that asserts itself as an *Ur*-object of scientific inquiry. Like Derrida and Adorno, Merleau-Ponty, the same commentator continues, refuses "to presuppose the *central activity* of a constituting ego—whether in history or in daily practices"—that the reduction is assumed to lay bare. Instead, she concludes, "the reduction is without end." Bergo, "Afterword," pp. 165, 163. "The new motif of returning to the ego, once it had entered history," Husserl writes describing this constituting ego, "revealed its inner strength through the fact that in spite of falsifications and obfuscations it introduced a new philosophical age and implanted within it a new *telos*." Husserl, *The Crisis of European Sciences* (Evanston: Northwestern University Press, 1970), pp. 80–81. Or, put into the words of Merleau-Ponty himself, the reduction is "reflection suspending the natural attitude in order to reach meanings *not* as objects or even as abstract constructions"—as did Husserl in his resolution to what he called the "the crisis of European sciences"—but, he continues, "in the precise sense of different 'beginnings of inquiry.'" Maurice Merleau-Ponty, "The Philosopher and His Shadow," in *Signs* (Evanston, Ill.: Northwestern University Press, 1964), p. 161.

The transcendental egological truth of Husserl's *epochē* is the experience of oneself outside oneself as an object. What is activated is the "constituting ego" of the beholder experiencing himself interpellated self-reflexively as such. This is the trap, the redoubt, the moment of the Husserlian "metaphysical presupposition," as Derrida termed it, the moment where the epochē founders in contradiction. It is also the moment in which the subject comes to think his or her own subject positionality. "The doctrine that everything is mediated, even supporting immediacy, is irreconcilable with the urge to 'reduction,'" Adorno wrote. "In the schools deriving from Husserl," he continued, meaning Heidegger and his followers, "this theme quickly enough turned against all labor and effort of the concept, and thus bore the brunt of inhibiting thought in the middle of thinking." Adorno, *Against Epistemology*, pp. 4–5. This is the moment guarded vigilantly against by Adorno's negative dialectics, Derrida's deconstruction and Merleau-Ponty's reworking of the epochē to never come to a conclusion, to a final and absolute reduction, but instead to be a perpetual return to the "beginnings of inquiry."